WWW.LANNOO.COM
Register on our website for
our newsletter with new publications
as well as exclusive offers.

COPY & CASE SELECTION
An Bogaerts @BOGAERTSAN

COPY-EDITING
Lisa Holden

BOOK DESIGN
Superset WEARESUPERSET.BE

COVER IMAGE
Signe Bay @SIGNEBAY

If you have any questions or comments
about the material in this book, please do not
hesitate to contact our editorial team:
REDACTIEKUNSTENSTIJL@LANNOO.COM

© Lannoo Publishers, Belgium, 2020
D/2020/45/226- NUR 450/454
9789401469180

TABLE STORIES

TABLES FOR
ALL OCCASIONS

An Bogaerts

Lannoo

YOU'VE GOT TO BREAK FREE

by AN BOGAERTS

Welcome, come in, take off your jacket and take a seat at one of my tables. What are you looking for today? A little romantic elegance? Some boho chic? Or maybe a more minimalistic table, nothing too fussy? I can offer you all of them in this book. But let me present you with today's specialty: a different perspective. A chance to wow your guests. To welcome them as if they were kings and queens, to feed them with memories that will last forever. A table is so much more than a plate, some cutlery, and two glasses. It is the one thing that sets the tone for a romantic lunch, a family picnic, a gathering with friends, or a wedding celebration. It is the most subtle way to tell someone: 'You are so very welcome here.'

Promise me you won't put this book down after I tell you that I'm no expert in setting the perfect table. You can ask anyone who has had the privilege (ahem) of being invited to one of my dinners. My husband can cook, in fact he's fantastic. But as far as my tables go, it has been kind of disappointing, if I say so myself. I have a thing with napkins: that definitely speaks to my advantage. And I love beautiful tableware. But since we are in the process of renovating our beloved seventies house, our beautiful tableware is packed up in the basement.

Actually when I come to think of it: the best tables I created in the last few years were inspired by Spiderman and unicorns. Not quite the stylish input you were hoping for, I guess. Don't get me wrong: I have composed the most breathtaking tablescapes, organized the most instagrammable dinner parties, and hosted the cutest children's parties. But so far all of that has happened in my head. So for this book project it was clear I had to outsource the creative part.

I might not possess the perfect decoration skills, but good taste - yes, I have that in abundance. And that's exactly what I relied on when I selected the twenty-two amazing talents in this book. As proponents of their style, and as creatives in their profession, they are the absolute best. From Belgium, Croatia, Denmark, Germany, and Italy to Australia, France, the UK, and the US they are all gifted with the talent of creating magic. Some excel at arranging flowers, others think in colors or have a great eye for framing the perfect image. Some are designers, other are stylists, florists, or event planners. Some like talking for hours and hours whilst others prefer to respond

to me in two-sentence emails. But they all share the same conviction. *That the table is an extension of one's personality.* Which gives this book a whole new dimension. We are not talking about ways to fold napkins; we're talking about you. Who are you and what message do you want to give to your guests? Luckily, we have twenty-two inspiring creatives to guide you on that journey.

The art of setting the table has become more and more popular over the last few years. No surprise there. The whole culinary scene has transformed beyond recognition. *Chefs have become rock stars, restaurants are practically art galleries, and tables have become their business cards, mainly on social media.* And as recreational chefs are more skilled than ever at reaching the same level as their gastronomic idols, so are the DIY stylists. Scrolling down Pinterest and Instagram in search for inspiration, tons of women and men around the globe have gradually discovered their own ability to create a magical setting at the dinner table. But then something scary happened. All these enthusiastic decorators saw themselves trapped in what is called the 'creative bubble' without even knowing it. They became slaves to the algorithm. *The downside of Pinterest and Instagram is that those social media have the tendency of showing the expected.* Of offering you more of the same. So whoever has done a search on boho beige table settings gets inundated with pampas pictures for the rest of their life.

If this book is anything, it is your gateway to breaking out of that creative bubble. A way of discovering styles and creations you would never have looked for on Pinterest. A subtle nudge to explore some out-of-the-ordinary combinations, to try evoking that wow-effect with your guests. Because guess what? Your entire table is on Instagram. They have all seen the same décors scrolling by again and again. Attaining that wow-effect won't get any easier in the future. The bar is set really high and that is our own fault. Visual social media have made beautiful tables seem so easy. The art of wowing your guest lies in stepping away from picture-perfect expectations. Create something your friends and family wouldn't expect. *Give room to serendipity, one of the greatest luxuries of our future.* This book aims to be the ideal inspiration for doing just this. In this book I know you'll discover your personal style, but you'll also discover tables outside the bubble you have created thanks to the algorithms in your social media. Follow your heart when selecting color schemes and materials. *Don't aim for perfection, aim for personality.*

CONTENTS

FALL

WINTER

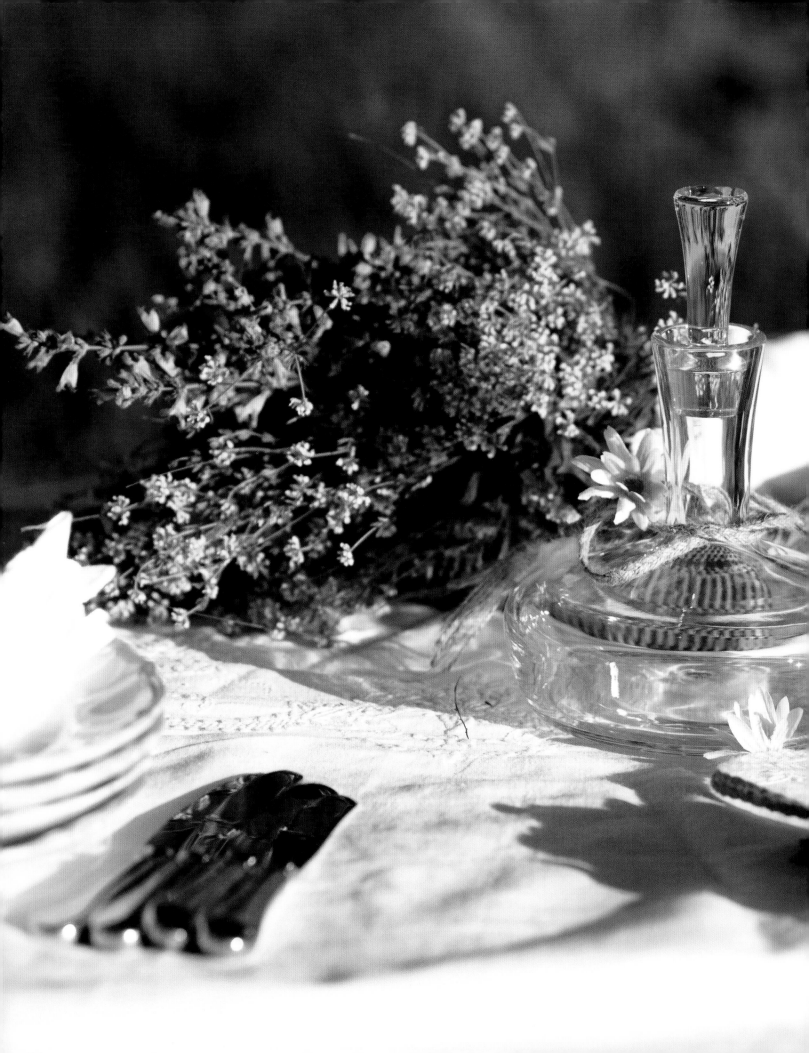

SPRING

The good news: during springtime setting an inviting table is pretty easy. All your guests are excited to see fresh flowers again when temperatures start rising. Just pick some nice vases, put some colorful flowers in there, and you're done. The downside though: an overabundance of options. Self-control is key. Don't lose yourself buying every attractive bloom you see at the florist's. Pick a color scheme and stick with it. Pastels are a safe option in spring and are easier to combine than bright hues. A rewarding choice for Easter parties, for weddings, baby showers, and children's celebrations. *Spring evokes this feeling of a fresh start, of new beginnings.* This is a fantastic sentiment to focus on when you create your table. Go wild with tulips in soft pink, add some crocus or – a personal favorite – an overload of soft purple hyacinths.

Saluting
the Imperfect

with MARIE MICHIELSSEN

Belgium
@MICHIELSSENMARIE

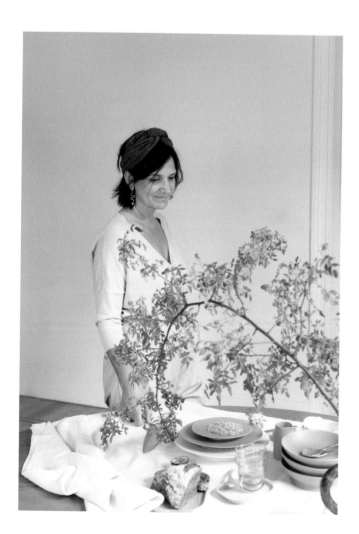

Ratio molds the soul of every object. For Belgian designer Marie Michielssen creating furniture and accessories with a soul is an important goal, if not the most important. "I am not sure where this preoccupation with ratio comes from. I was trained as a graphic designer and am passionate about architecture; both disciplines have definitely shaped me as a designer." For most of her career, Marie has worked for interior design label Serax. A brand she has a very special relationship with, not only because she is married to its CEO Axel Van den Bossche. "I used to design small accessories like candleholders and the ubiquitous cactus vase. In recent years, my work underwent a transformation. My designs answer an internal urge to create my own world. A world that balances on the fine line between art and design. My objects are becoming more sculptural, more authentic." The same evolution continues in Marie's passion for entertaining friends and family in their beautiful historic loft in Antwerp. "I cherish the people around me; it gives me great joy to set a beautiful table and cook a delicious meal." Since Serax is a brand that specializes in tableware – some of the world's best restaurants serve their food on Serax plates – Marie is spoiled for choice in that department. "I am fascinated by contrasts. I love mixing the old with the new, the colorful with the natural, the rough with the smooth. Contrasts add an exciting tension to a table. That makes a table interesting to look at, and to eat at.
"I draw a lot of inspiration from still lifes, the work of the Flemish Primitives for instance. The harmony they create in their paintings is amazing, the balance rouses a sense of tranquility.

Tranquility is something
we all look for these days.

In my designs and in my tables I try to combine different shapes and different materials but unite them in a particular formal language. They must evoke a sense of unity.
"I have been creating for the past thirty years. At this stage of my life I have the freedom to do whatever I please. That may well be the greatest luxury of all. I also allow myself the freedom to fail. It is crucial to be able to recognize when things are not that good, or processes that don't run smoothly.

\rightarrow

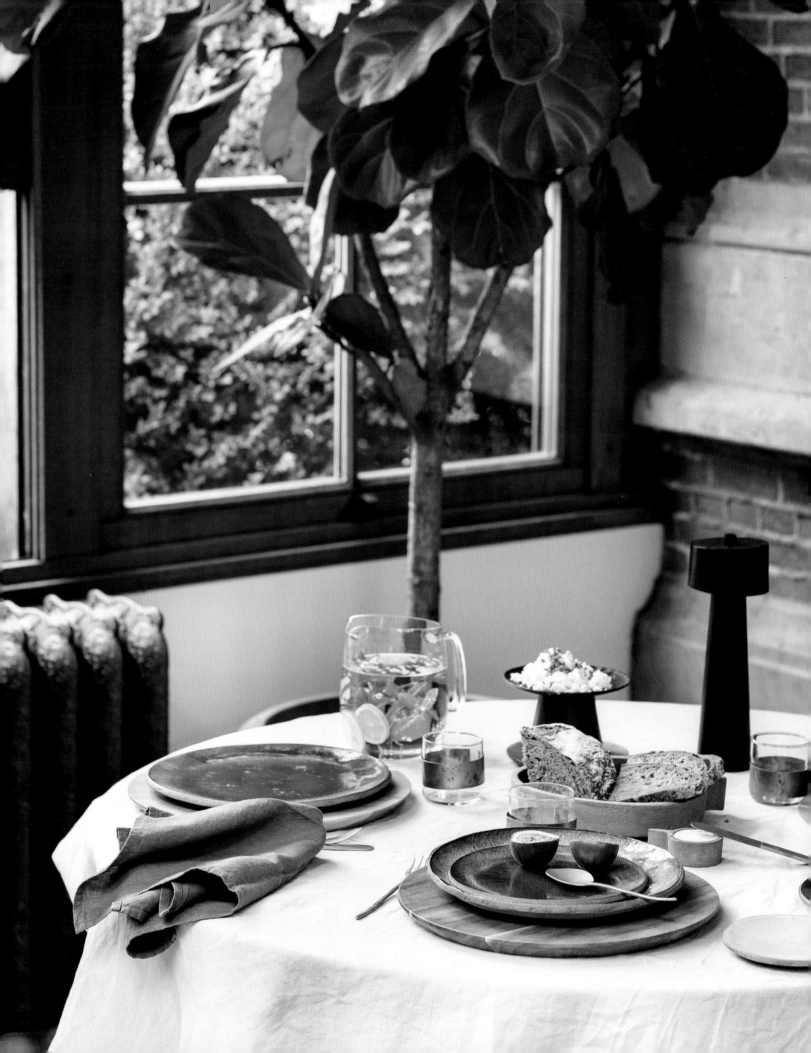

I am fascinated by contrasts.
I love mixing the old
with the new, the colorful
with the natural, the rough
with the smooth.

MARIE MICHIELSSEN

That's why I love the actual creating. Feeling an object with my own two hands and seeing it grow between my fingers as I sculpt. Always driven by a gut feeling. The same gut feeling I use when dressing a table. I don't follow any fixed procedure when creating an inviting décor.

I recently designed my very first dining
table in wood, I love experimenting on it.

"My feeling for beauty and decoration definitely runs in the family. My mother and grandmother both loved to fill their houses with fascinating objects they found at flea markets. They inspire me so much, and I try to recreate that same authenticity by combining different tableware collections. I salute the imperfection of tableware and decoration that aren't an obvious match. Last year I fell in love with the tableware of Ann Demeulemeester, the renowned Belgian fashion designer. The bright green may be an unusual choice for a dinner table but, to me, that's what makes it so interesting to work with." Working with her creative friends is another aspect Marie finds interesting. Stylists, photographers, and designers that help her create the unique universe she exhibits both at Serax and through Instagram. "I love to surround myself with the amazing people I have had the honor to meet over the past decades. I value their opinions, I savor their companionship."

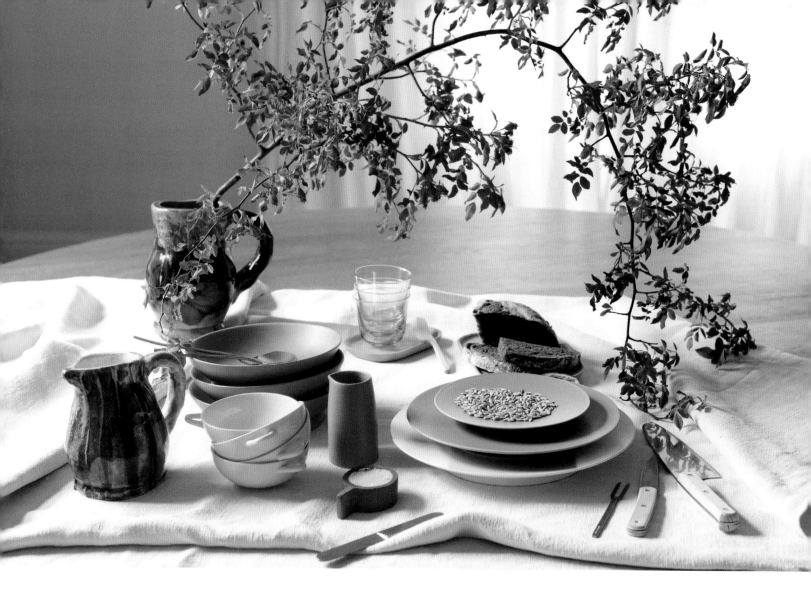

I salute the imperfection of
tableware and decoration that
aren't an obvious match.

MARIE MICHIELSSEN

The bright green may be an unusual choice for a dinner table but, to me, that's what makes it so interesting to work with.

MARIE MICHIELSSEN

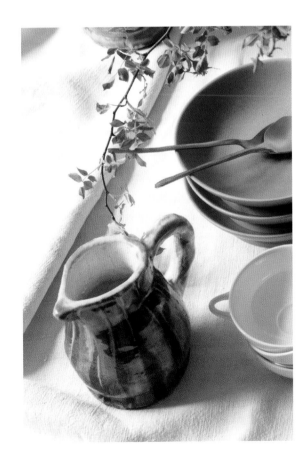

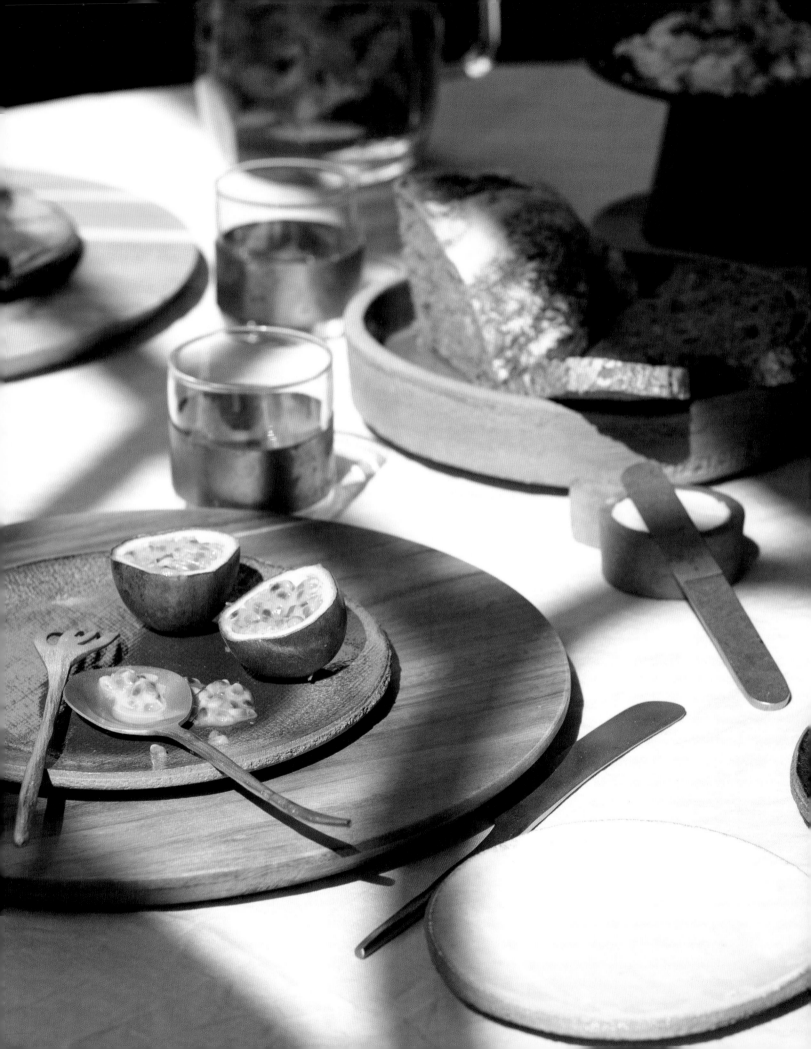

HOW TO
TELL *Marie Michielssen's* STORY ON YOUR TABLE

Don't be afraid of contrasts: *mix the old with the new, the colorful
with the natural, the rough with the smooth*. This will create
an exciting tension on your table.

Think about balance and ratio: whilst creating your tablescape,
step back now and then, and see if your décor is balanced.
That *balance will evoke a sense of harmony*.

Perfection is dull. To avoid things looking too perfectly matched,
combine different sets of tableware.

A tranquil tablescape doesn't mean you have to shy away from color.
Even a calm, balanced table can have *a splash of color*. A dash of green often
beautifully complements the blooms and twigs you have chosen.

You can't go wrong with *natural materials* like glass, wood,
paper, and linen. These natural touches reinforce the unity and sense
of balance of your tablescape.

An understated table *doesn't need elaborate flower decorations*.
Find a pretty branch in your garden.

Remember this: Whatever you *put your heart and soul into*
will be cherished by your friends and family.

The Feel-good Factor

with FOOD & MOOD

Mateja Zvirotić Andrijanic
Croatia
@FOODANDMOODBLOG

Give yourself some time to breathe now and then, and inspiration will come. Good advice from Croatian food blogger Mateja Zvirotić Andrijanic, who started Food & Mood a few years ago. As the name of the blog suggests, Food & Mood is all about recipes and feel-good décor. "It is my happy online corner of the world, a small creative project to put all my creative energy into. My main goal is to connect with people who enjoy the same things I do – preparing delicious meals for family and friends, growing fruits, vegetables, and herbs to develop amazing seasonal recipes with. At the end of the day, food brings us closer together." And her inspiration? "I find it in literally everything around me. It can be a book I read, going to my favorite farmers' market, spending time in my family's garden, watching a good movie, or even going to the museum."

> With every new recipe comes a new table setting.

"Whenever I can, I try to pick tableware that suits the recipes I'm preparing," Mateja says. "It all depends on the story I'm trying to tell. For example, when I prepare a themed dinner for my friends with Portuguese food, I will serve it on plates or even tiles I bought during my trip to Lisbon last year. By weaving together the food and styling to tell a harmonious story I try to recreate the emotions and setting of the typical Portuguese mood we experienced there." Food and tablescaping have the magical gift of transporting you to another place and time and inspiring a different state of mind. "When you are far from home, for instance, you'd probably give anything to taste your mom's amazing chicken soup or your grandma's dinner rolls filled with homemade plum jam. Even the smell of this comfort food can remind you of carefree childhood days and conjure up happy feelings."

A big advantage of growing your own fruit and vegetables is regaining and re-appreciating dependence on seasonal produce. "For as long as I can remember, I've felt the need to live in harmony with the seasons. As a little girl I would cut out the most inspiring pictures from magazines and tape them up on my bedroom walls according to the changing seasons. I realize that I'm still doing the same thing, only now I am using my blog and social media as a bedroom wall."

→

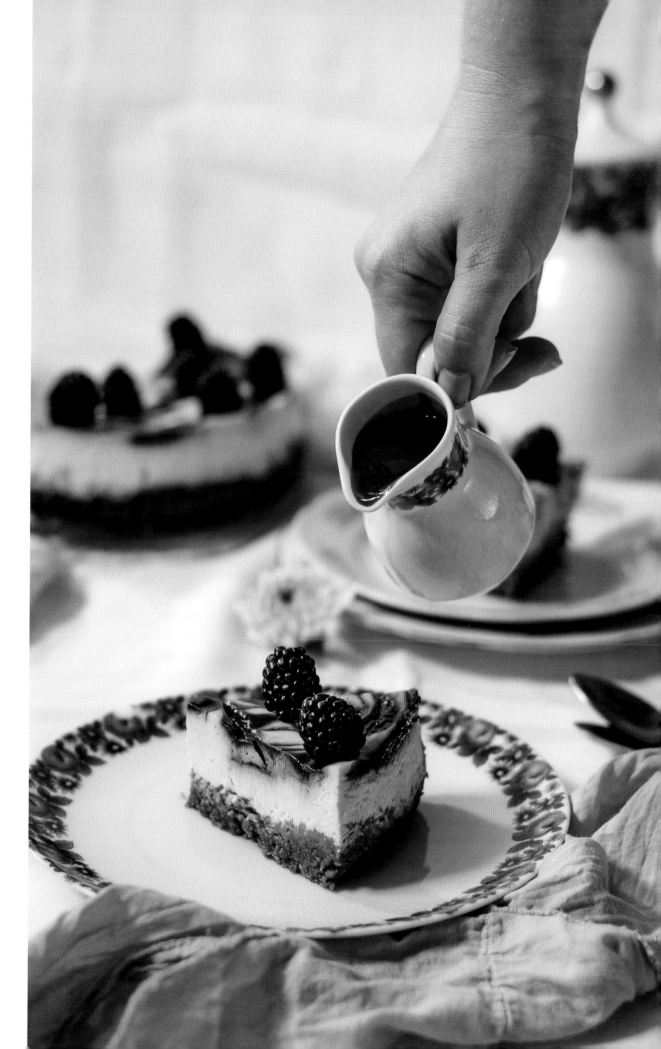

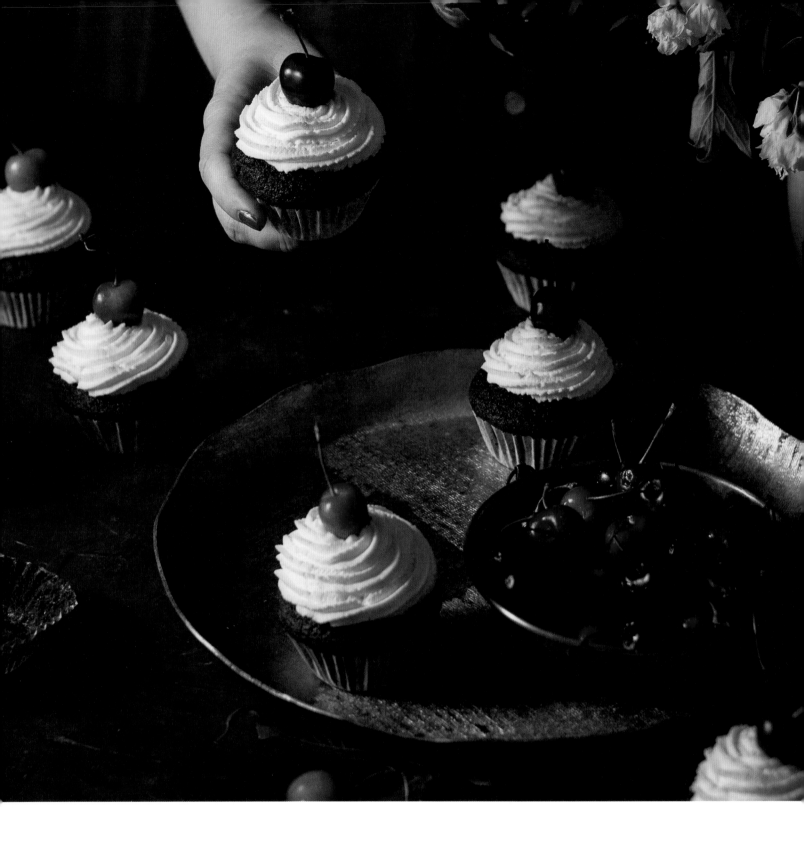

Rustic stoneware and quality pieces bought from local ceramicists and potters are definitely having their moment right now.

MATEJA ZVIROTIĆ ANDRIJANIC

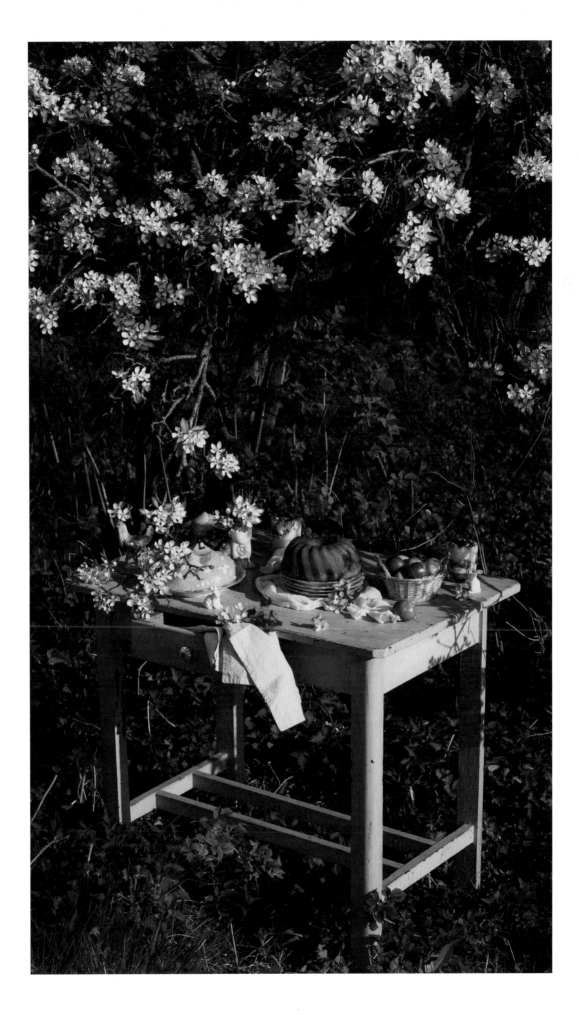

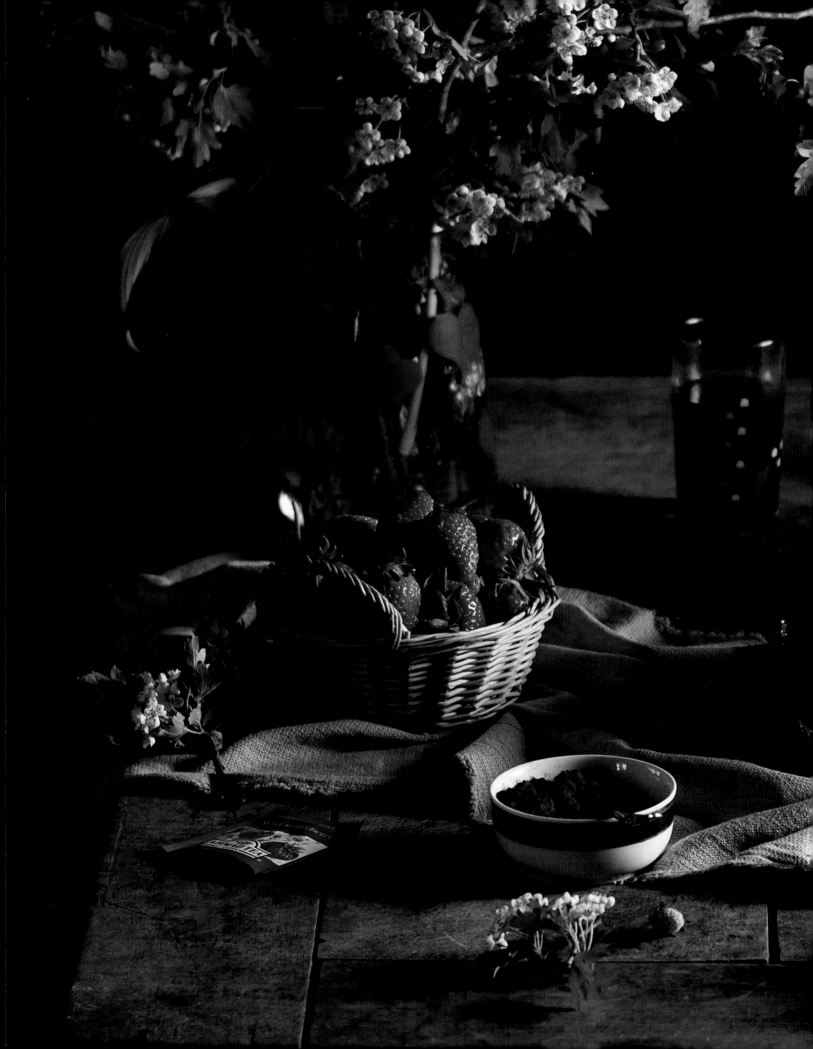

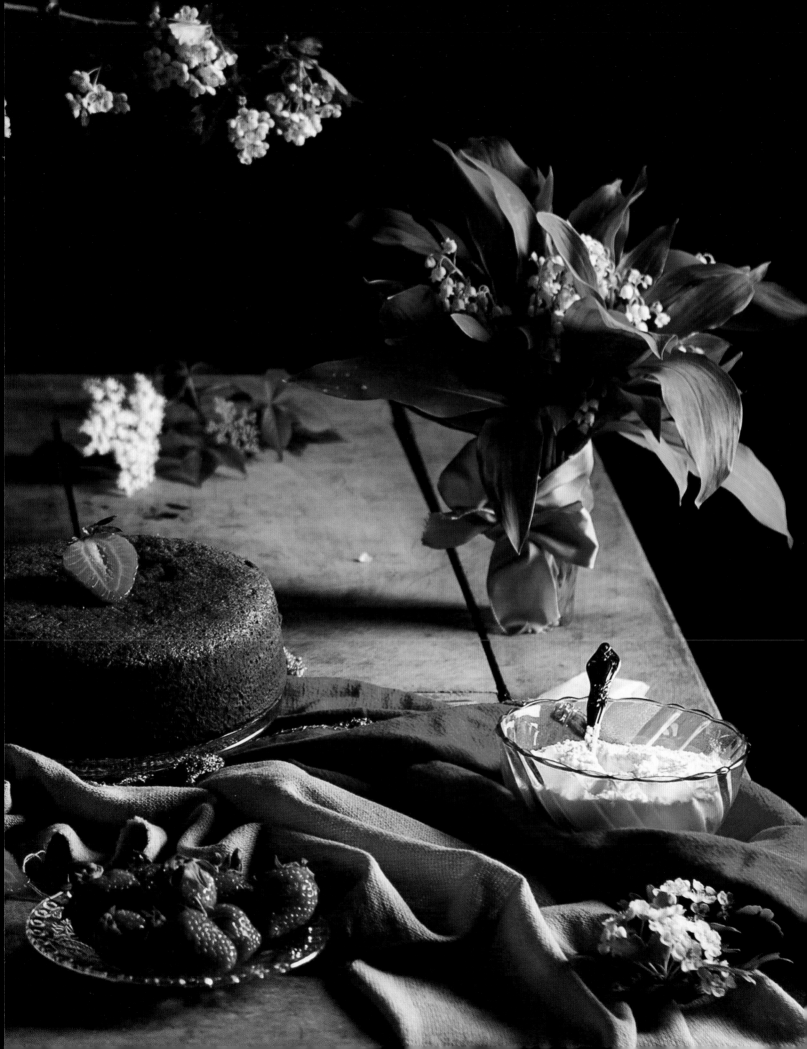

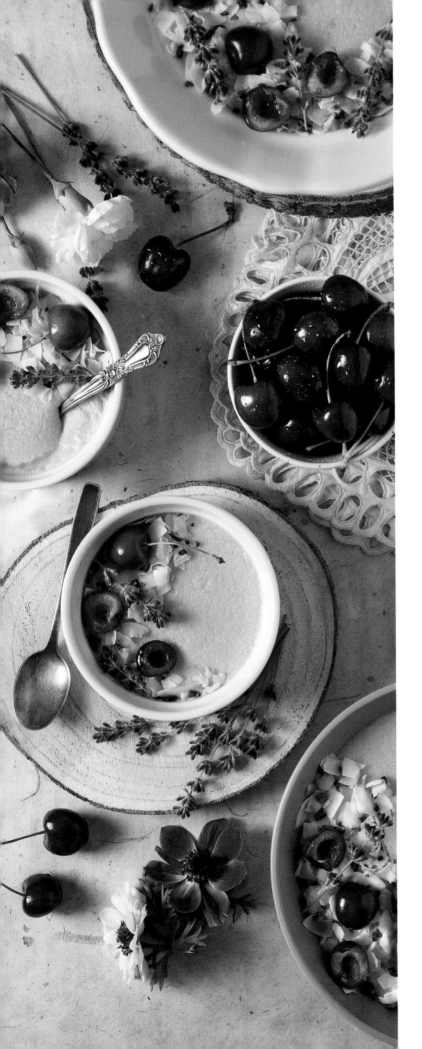

Together with seasons and recipes, tables tend to change throughout the year. "My styling and photography are inclined to be dark and moody, with occasional experiments with strong, bold colors. Sometimes I even like to play with bright and airy images and table settings. Trends in table styling are always changing, but there are some elements that have remained constant over the last few years. Rustic stoneware and quality pieces bought from local ceramicists and potters are definitely having their moment right now. And I also love to use vintage pieces thrifted from flea markets or from my grandmother because they add a special charm and warmth to the table." According to Mateja, there are a couple of basics required to set your own stunning table. Freshly cut blooms or greenery always do the trick as a centerpiece. Besides that,

It's good to have some neutral colored placemats that can go with almost any type of plate you have in your home.

For an added rustic vibe, instead of fancy napkin rings, I like to use simple twines in different colors and add spices like cinnamon or star anise. It looks great and smells amazing." Focusing on the 'mood' a table represents, Mateja likes to keep things casual. "Fancy setups belong in restaurants. When I entertain guests I like them to feel comfortable and relaxed. I don't like an overcluttered table, it needs breathing space, just like we do."

HOW TO
TELL *Food & Mood's* STORY ON YOUR TABLE

Try telling a harmonious story on your table: let the decorations match the type of
food you are serving. Don't create a blue-sea-themed table when you'll be serving a
huge side of roast beef. When your story is coherent, it will evoke emotion.

As your recipes will *evolve with the seasons*, so will your tablescapes.
Adapting to the state of nature that is surrounding us will become
more and more important.

Important basics: neutral colored placemats will fit any type of ceramics.

Adding warmth and charm to the table can be achieved by using
rustic stoneware or vintage pieces. Try not to clutter your table. Like us,
a table needs space to breathe.

Eating is not only about stimulating the visual senses and taste buds.
Smell is an important part of creating an ambiance. Instead of fancy napkin rings, use
simple twines in different colors and add spices like cinnamon or star anise.
They look great and smell amazing.

Finding that Happy Place

with HILDE

Anne Ladegast-Chiu
United Kingdom
@HILDE.STORIES

"It's been said many times before, but for me, inspiration is quite literally everywhere. I'm a real observer and feel especially drawn towards the details and how they can change your perspective on something. Recently, I designed and styled a supper club on the theme of 'Hope' with all proceeds going to London rough sleepers. We created a table runner using a specific flower, which was placed between shards of concrete tiles, as a visual reference to perseverance and hope. We also created an illustration of the flower for the menu cards. The inspiration for this was a buttercup, a tiny yellow flower that I saw breaking through a small crack of concrete whilst on my way into town."

Just two years ago, Anne Ladegast-Chiu traded a corporate career in the creative industries to explore creativity within herself. "I have always had a love of styling or 'making things look nice' - it's part of who I am, and a huge part of my life. As a little girl, I remember I was always rearranging, changing, and tidying things, sometimes for hours. Just trying all the different ways of changing my shelves, my room, the living room. This urge to create environments and to be creative hasn't changed over the years, instead it has evolved into what is now HILDE." HILDE refers to Anne's grandmother, of whom she has fond childhood memories. The name also recalls Anne's roots in the German countryside, where celebrations and gatherings were organized with great attention for detail.

For over seven years now, Anne has been based in London, and still draws inspiration from her surroundings. "I love to immerse myself in raw nature and London's diversity and really embrace the best of both worlds. I'm hugely inspired by my husband, country walks, interiors, and our travels." Converting that inspiration into a beautiful wedding décor is what Anne loves to do. "For weddings, I usually begin with the couple and draw all the inspiration for their day from their stories, passions, and the things that make them 'them'. Once I can feel the creative direction and tonality of the wedding, I start mood boarding and define colors and accent colors for the entire event.

> Although a wedding is more than just a dinner, the table is certainly the focal point.

and again can be inspired by so many different things - sometimes simply a phrase, texture →

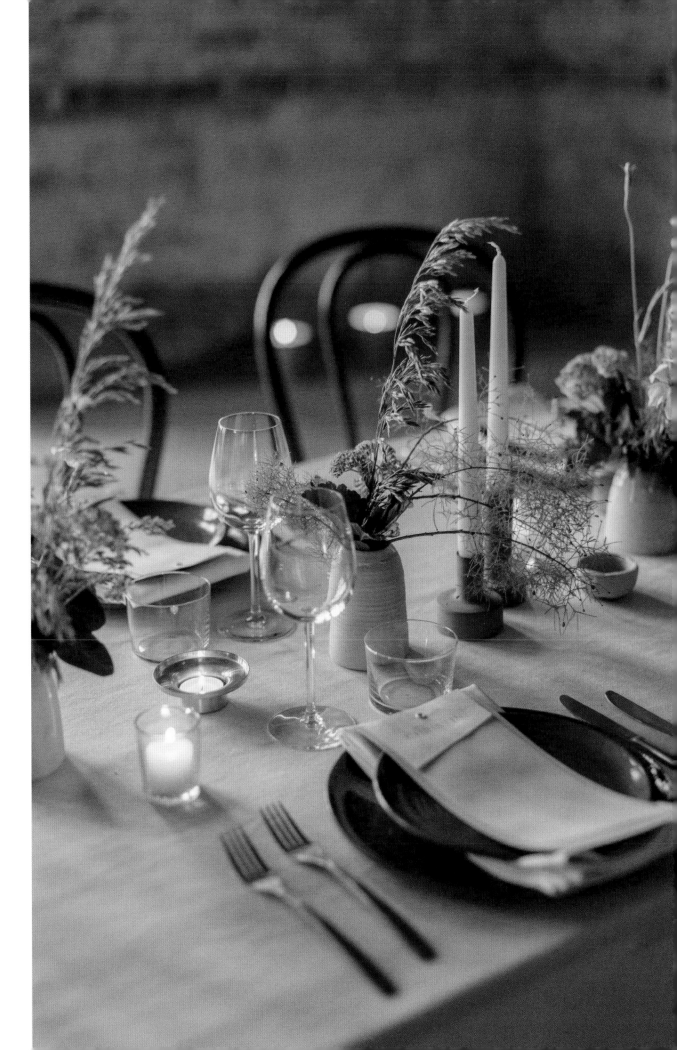

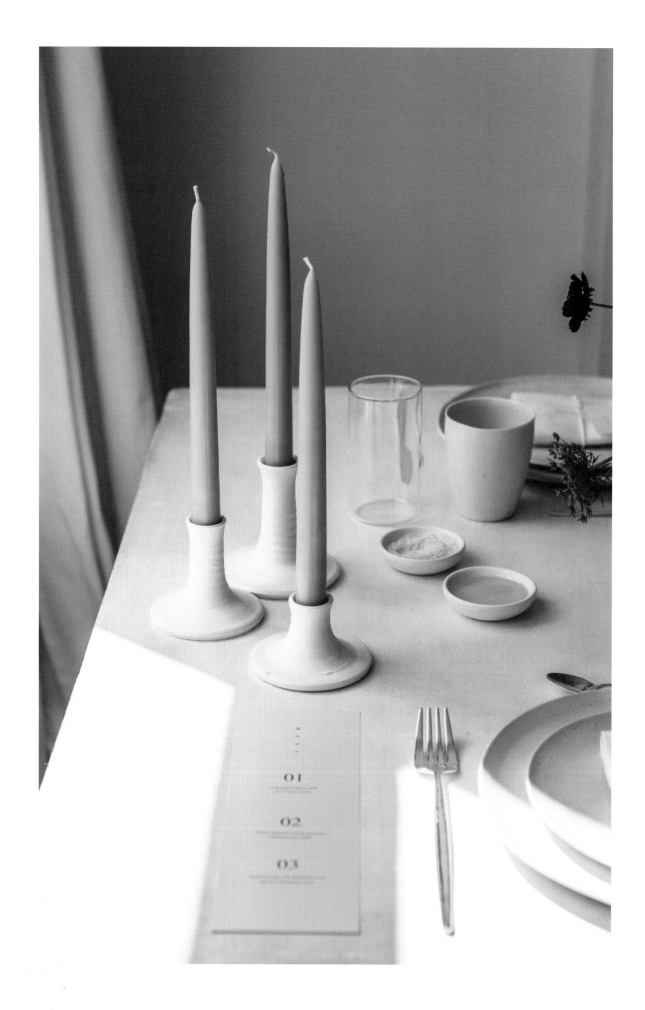

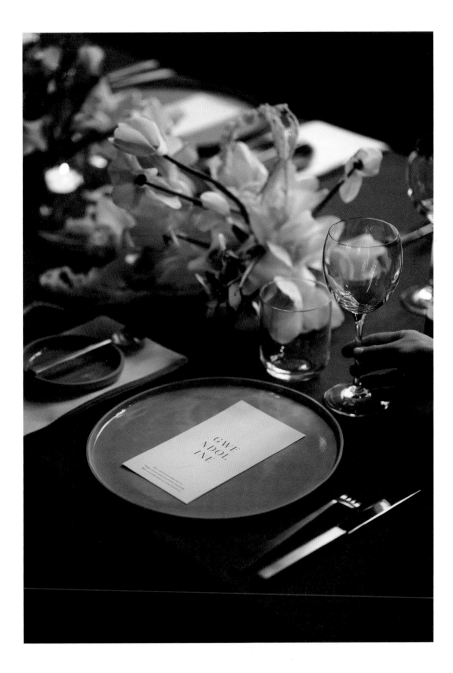

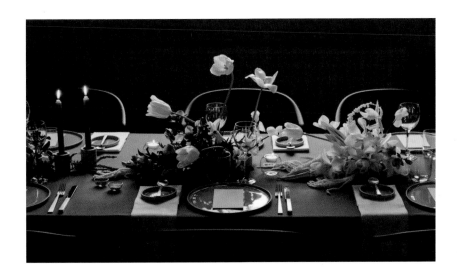

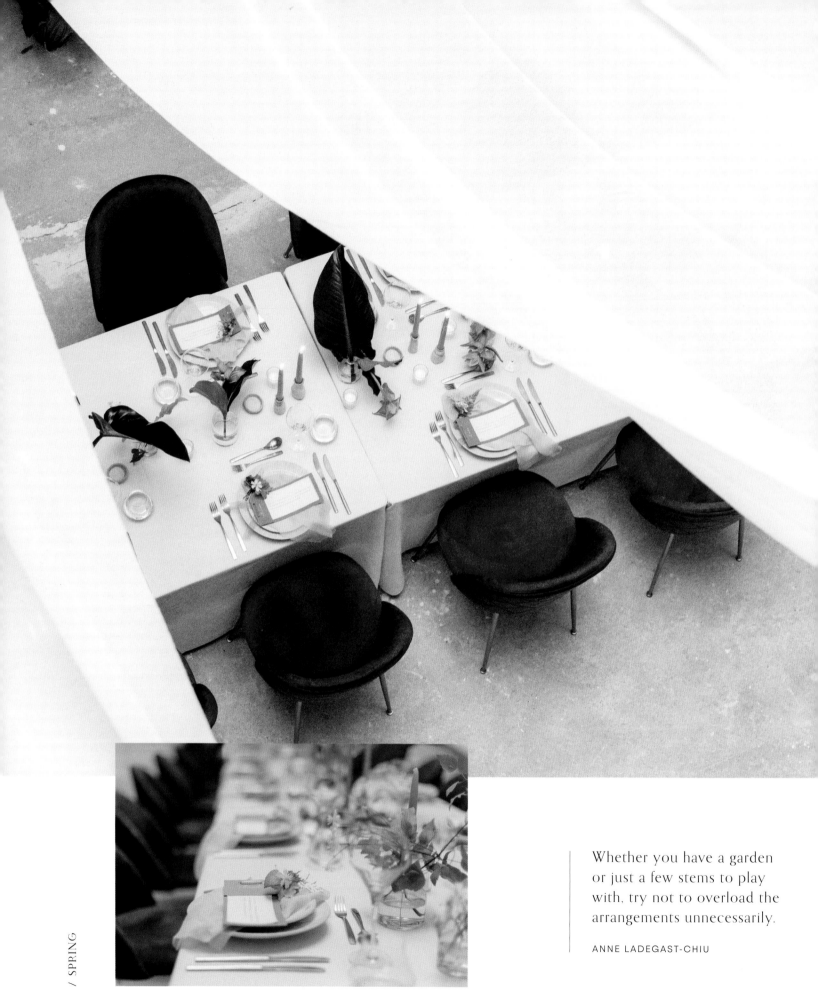

Whether you have a garden or just a few stems to play with, try not to overload the arrangements unnecessarily.

ANNE LADEGAST-CHIU

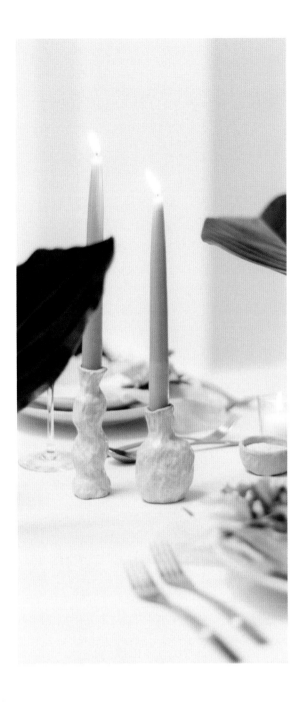

or flower that the couple like; other times it's a coming together of people with vastly different backgrounds, a union formed between two or sometimes more cultures. Every couple and every brief is so different, I love that! "Over the years I have built up a small collection of things that I love and so these days setting a nice table at home is definitely my happy place," Anne admits. But she has some tricks for anyone who is not a professional stylist. "Before you get to the styling, the first and most important thing that will transform any dinner setting is the lighting. If you want to create an instantly inviting dinner atmosphere, turn any cold lighting and ceiling lights off. Instead, if you can, bring in ambient lighting by placing smaller lamps with warmer bulbs in corners and closer to the table. Using candles is another way to add warm light. I like to dot them around the table and the room and always keep them in clusters of uneven numbers. If they are of different heights, even better. This adds movement and a little 'drama' to the table. As an admirer of details, I almost always add elements like small vessels, pinch bowls with coarse salt and pepper, and a variety of small and larger bowls for serving to our tablescapes. There are also a hundred and one ways to fold and place napkins - something that instantly enhances any dinner setting. Pinterest and Instagram are full of inspiration for this. Lastly, if you have access to flowers, they will also transform a table and vibe, something I would normally spend most of the time on for my event designs. Whether you have a garden or just a few stems to play with, try not to overload the arrangements unnecessarily. I like to use no more than four to five different elements and three different colors when working with flowers. This way each flower can speak for itself and the contrast is so much better with less going on." Because less can definitely be more when it comes to dressing a table, the art of styling is knowing when to stop adding extra accessories. "I will only stop making adjustments to a design when it feels balanced and 'right' to me. It's more a feeling than a formula, sometimes it's instant, other times it needs a few more rounds of trying out different ways."

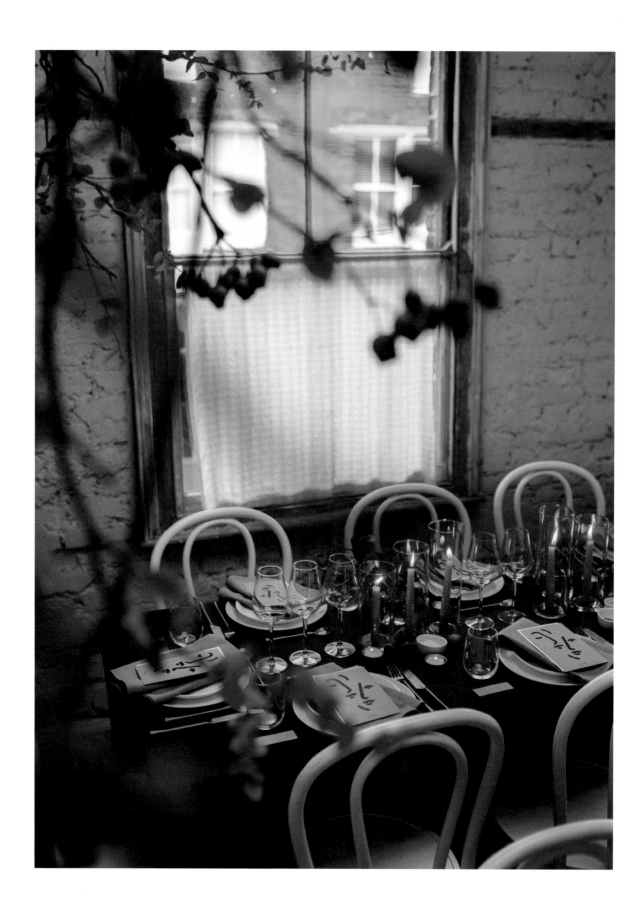

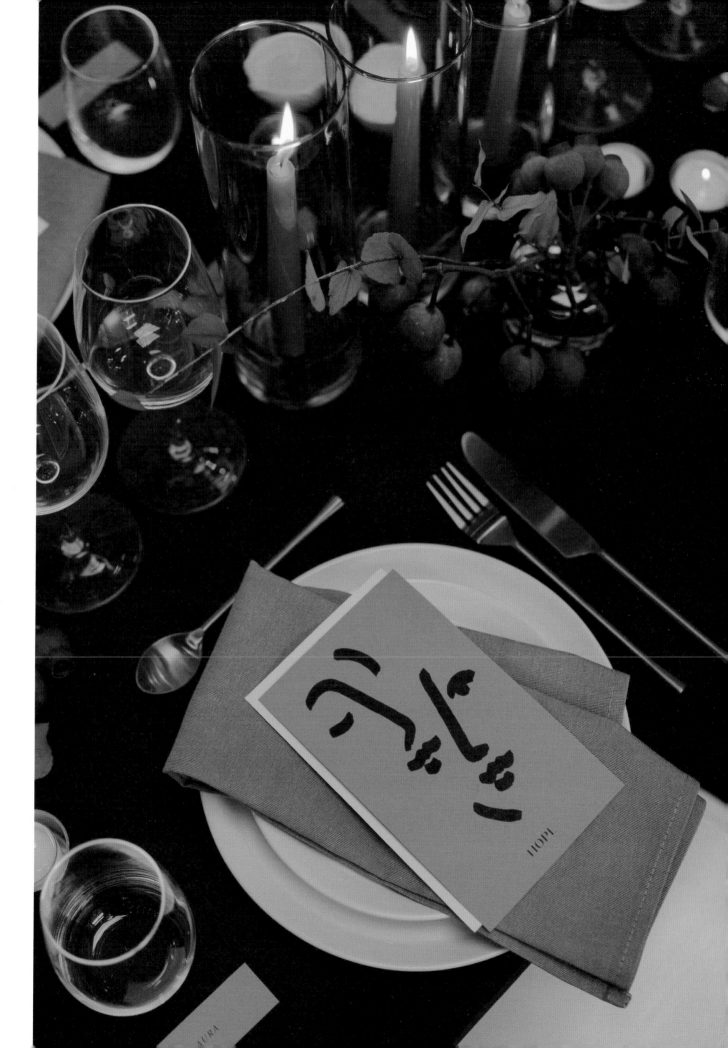

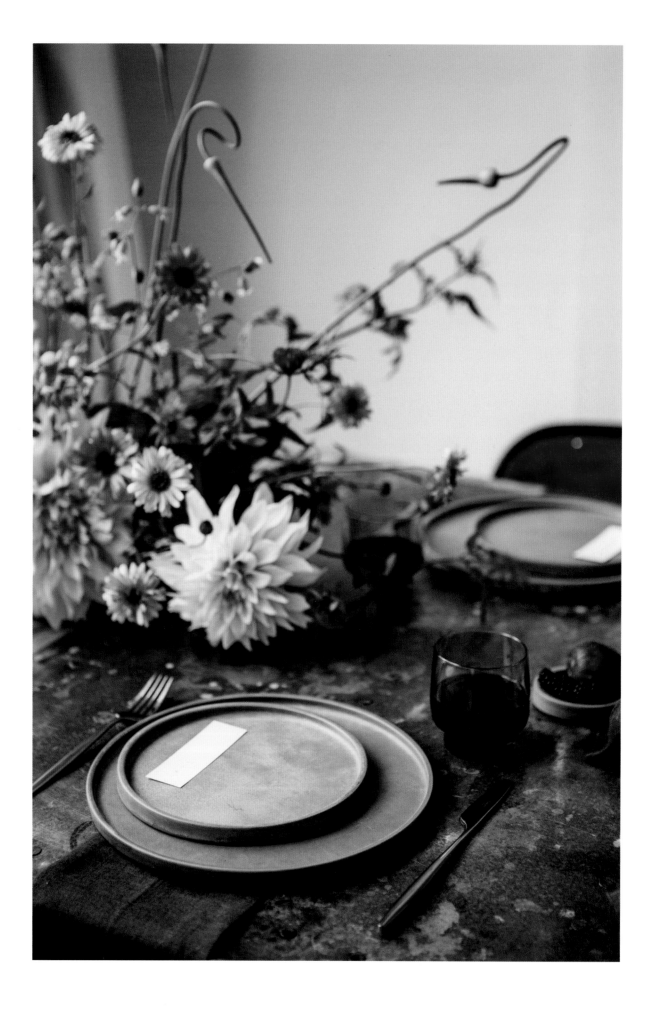

HOW TO
TELL *HILDE's* STORY ON YOUR TABLE

When creating a wedding décor, get to know the couple. Ask about their stories, passions, and the things that make them 'them'. Perhaps there was something special, funny, or touching about how they first met. You never know what might spark great ideas for styling the table.

Create a mood board. That way you have a clear idea of what you like and dislike. It's also handy in helping you to stay true to your initial idea – it's easy to get carried away when composing a tablescape.

First concern: lighting. *Turn off any cold lighting and ceiling lights.* Instead, if you can, introduce ambient lighting by placing smaller lamps with warmer bulbs in corners and closer to the table.

Using candles is another way to create an inviting ambience. *Place candles in clusters of uneven numbers, and different heights.*

Browse YouTube for inspiring napkin-folding tutorials.

When working with flowers: *Do not use more than four to five different elements and three different colors.*

Less can definitely be more: instead of flower arrangements you can easily *use some stems from your own garden* to play with in your tablescape.

No-bling Elegance

with ANATABLESCAPES

Ana Laborda
Claudia Muñoz
Spain
@ANATABLESCAPES

"Every event has its own magic. It is our job to capture that magic," says Ana Laborda. She is the Creative Designer at the Madrid-based agency AnaTablescapes. A few years ago, Ana created a stunning décor for the *Telva Novias magazine* in the Madrid Railway Museum. When Claudia Muñoz visited she instantly fell in love with Ana's creative work. The two ladies connected and soon after Claudia joined the AnaTablescapes team. Now Claudia is an expert in planning and organizing whilst Ana continues in the role of creative leader of AnaTablescapes. "For me, it all started with my passion for creating beautifully styled tables where people could share memorable experiences," explains Ana. "But as time went on, we started working on larger projects and events, creating unique, unforgettable occasions. Now, we create gorgeously styled, evocative events from start to finish."

> In recent years, people have become more appreciative of the art of table design,"

Ana continues. "Our work is all about creating a design tailored to the needs and story of every occasion, whether it is a wedding, an anniversary, a children's party, or a private event. We are able to work within a wide range of budgets, adjusting our concept accordingly. What makes AnaTablescapes special is our talent for creating something magical with the minimum." When it comes to table styling, Ana has an eye for the latest trends. "Right now, the big trend is for designs that breathe simplicity. Less is definitely more." But less doesn't always mean super-minimalist. "If you use unusual blooms or artistic tableware, you don't need much bling to create an elegant table."
Social media have had a huge impact on the success of AnaTablescapes. "It's a fantastic way to share every detail of our events, decorations, and lots of gorgeous content inspiration," says Claudia. "All the images are of our own events. Social media are ideal for showcasing our art and style. That's why we put so much time and care into our online presence." Instagram is perfect for connecting with and inspiring people who want to host their own small-scale event. The photos of the children's party they organized for little Pablo give parents who aren't sure where to start some fantastic ideas.

→

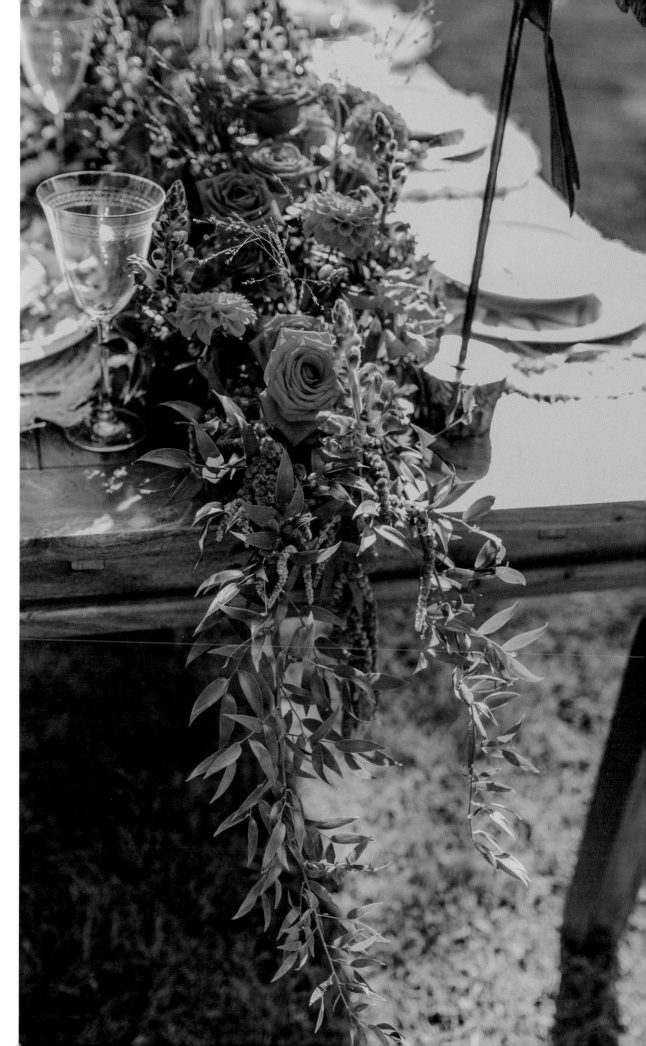

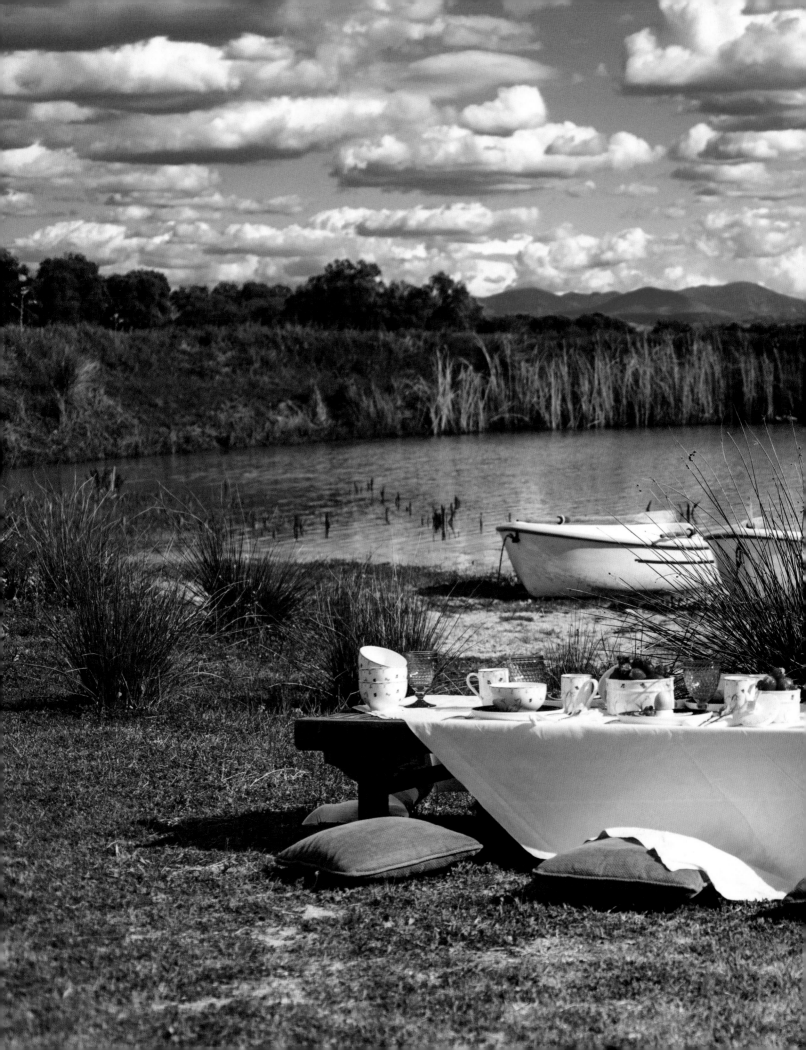

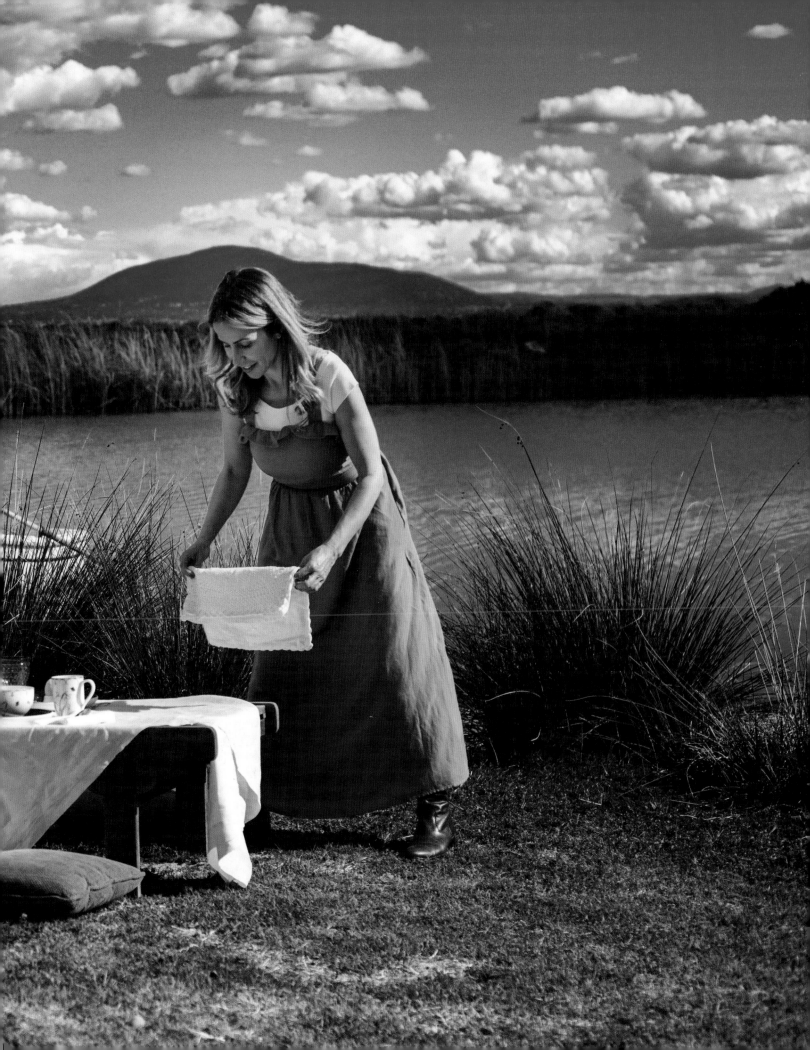

Right now, the big
trend is for designs
that breathe simplicity.
Less is definitely more.

ANA LABORDA

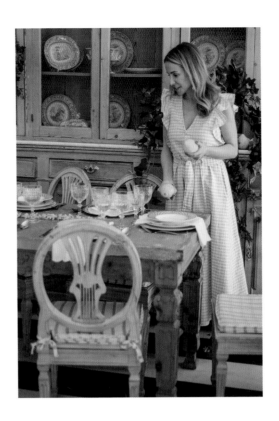

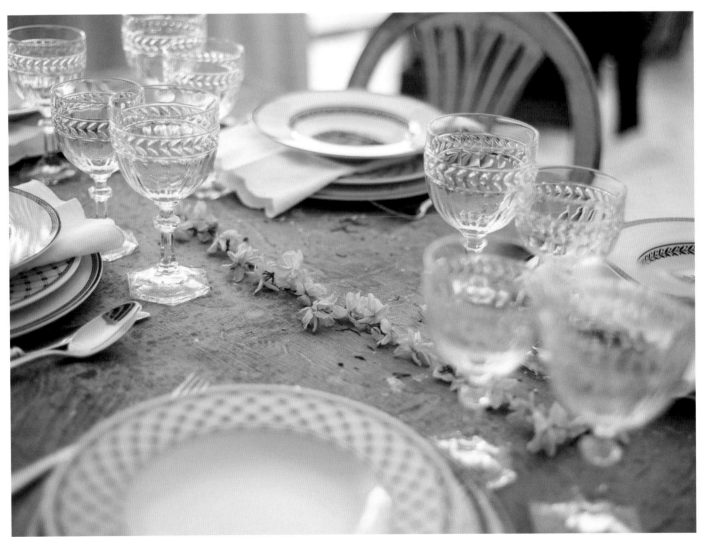

The candy doesn't have to be
spectacular, as long as you make
the presentation special.

ANA LABORDA

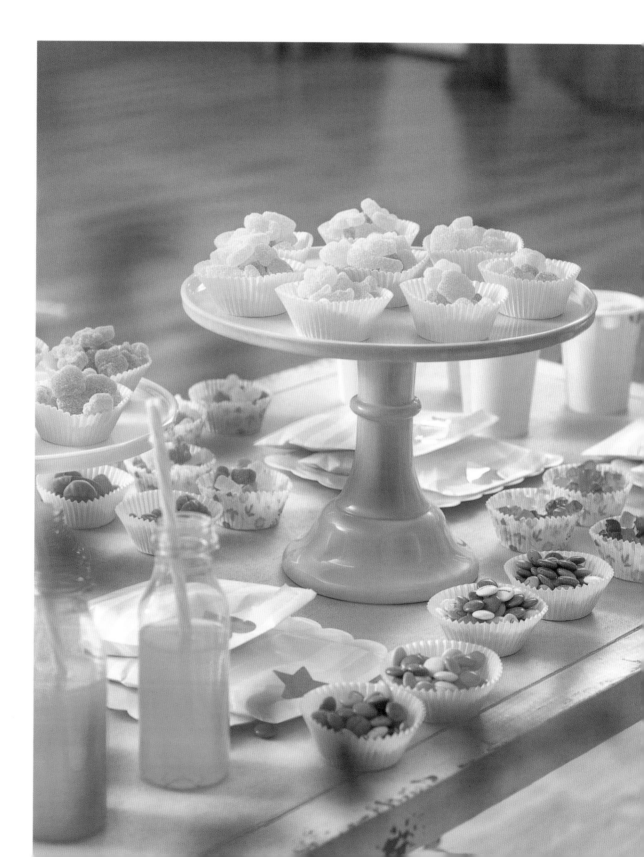

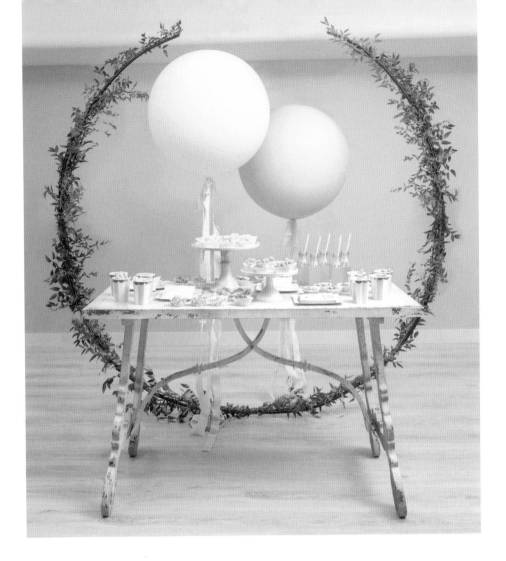

"Children love a grazing table full of candy. The candy doesn't have to be spectacular, as long as you make the presentation special." Ana created a table in shades of bright yellow and pale mint, where different cupcake cups were filled with Gummi Bears and Smarties. For extra impact, Ana added some balloons and a metal circlet wrapped with bright leaves. A wonderful grazing table that appeals to younger and slightly older kids.

"We are Mediterranean, and celebrations are the lifeblood of our culture and traditions," Claudia explains. "Spain is a warm-hearted country, famous for its hospitality. And in Spain, where we have incredible wines and fantastic cuisine, as well as a climate that's ideal for fabulous blooms, the table is always at the center of Spanish life." As Ana adds

"We are driven by a passion to create wonderful, beautifully decorated spaces to enjoy special moments with our loved ones.

This passion is at the heart of our work, and our personal lives, too. These are the ingredients that inspire our natural flair for creating unforgettable tablescapes."

HOW TO
TELL *AnaTablescapes'* STORY ON YOUR TABLE

Less is more, so the secret is focus. Choose *one item* in your tablescape *as the key feature* - it could be unusual, artistic tableware or a distinctive bloom.

A golden tip for children's parties: install a grazing table.
Children love grazing tables full of candy.

The candy doesn't have to be spectacular as long as you make the presentation special. Everyday M&Ms can be spectacular if you present them in a fun way - in cupcake cups or big glass jars.

Helium balloons are another winner at children's parties.
You don't need hundreds of balloons - two or three large ones and some matching ribbon are enough to make an impact.

Use your decorations to create that focal point.
Don't scatter balloons all over the place. Gather them together.

And if you want to make the other parents a little envious ...
Wrap a metal circlet with leaves and fasten it around your grazing table.
It looks very professional.

Children's parties aren't synonymous with garish colors.
It's much easier to style soft pastels elegantly than bright reds or blues.

The Power of Flowers

with ASHLEY FOX

United States
@ASHLEYFOXDESIGNS

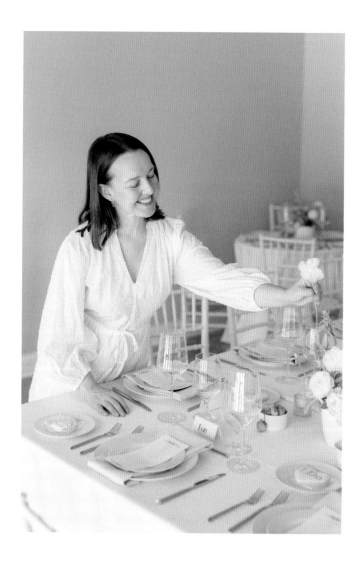

Flowers can express extraordinary dancing qualities. "Especially spring blooms," Ashley Fox explains. "The small delicate nature of those blooms is really intriguing. I love their dancing qualities and soft color shades." Since 2008, Ashley has run the Ashley Fox Designs studio, specializing in weddings and editorial work for magazines. "I love the joy and memories we bring couples during a wedding, but I also love creating on set during an editorial as it continually pushes me to edit the floral work in a way that distills the idea into a clean and elegant format. I love editorial work for the fine detail required to capture an amazing, lasting image." Images that are used in *Vogue, The Knot, Once Wed*, or *Flower magazine* to inspire soon-to-be brides and grooms. "Ideally, my best work comes from clients who give me a color palette, a description of the feeling they would like along with some shapes of designs they love. In the best scenario they allow me the freedom to choose from the weekly market selection of local blooms and select the best expression of those textures, the movement, and the color palette available for the event." That weekly trip to the local wholesale market is a huge inspiration for Ashley's work.

> "At the flower market I'm like a kid in a candy store. I call it my weekly 'bucket of fun.'"

Aside from a bucket full of fun Ashley keeps a small mental bucket list of people she would love to create a table setting for. "Tom Hanks and Martin Short because they've both made me laugh and entertained me as far back as I can remember," she says. "OK, and Grace Coddington. She has inspired me perhaps more than anyone with her innovative drive, spirit, and approach to creating a feeling with an image." Being in the flower business for over twenty years, Ashley has seen floral designs evolve from tidy and rounded in the nineties over light and airy designs in the noughties to clean and sculptural in the past decade. "I love watching the natural progression of each generation of designers whose creations are inspired by their own interpretation of the decade that preceded them and who use flowers in extraordinary ways. We are seeing so many variations of floral design and anything goes these days! It's truly exciting to see," Ashley explains.

→

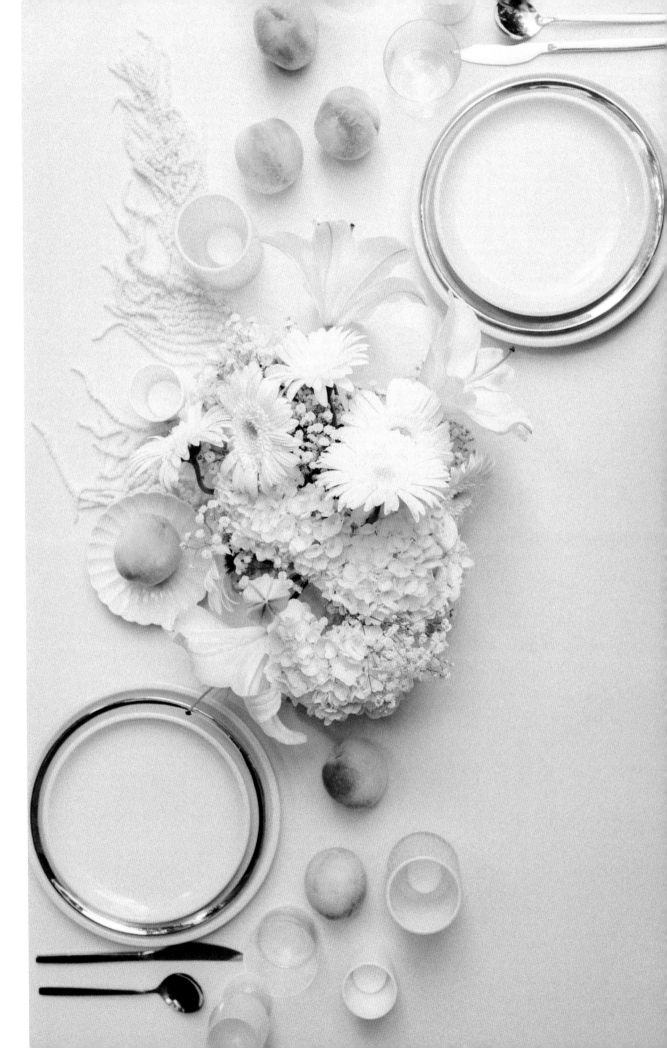

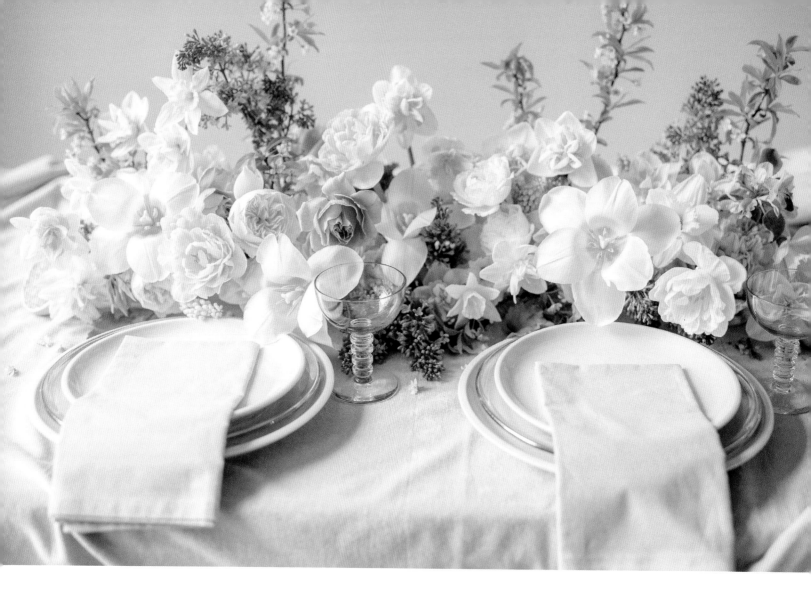

"Speaking for myself, I love creating with tone on tone, using similar colors in a broad spectrum of the same shade, from napkins to flowers and vases. It creates a cohesive look to the entire table. For example: try tying in a dark color foliage in your design if your plate is matte black. They will play off each other beautifully on the table as a whole. "When designing a table for a client I listen to what they love about flowers and other organic elements like foliage or fruit and how they want the event to feel.

Their feelings infuse my choices
for the floral selection.

"If they want a light-hearted, fun feeling to the décor, for example, I may choose a violet-hued Agrostemma - delicate and butterfly-like blooms on a long, thin stem - and have it dance down the center of a long table." Ashley is convinced that with a little practice anyone can create a lovely table setting using fresh flowers. "Using only three or four varieties of flowers at a time, often within the same color palette, really helps to keep the eye from darting →

It is easier and simpler to create a tablescape when you have only a few varieties to place next to one another.

ASHLEY FOX

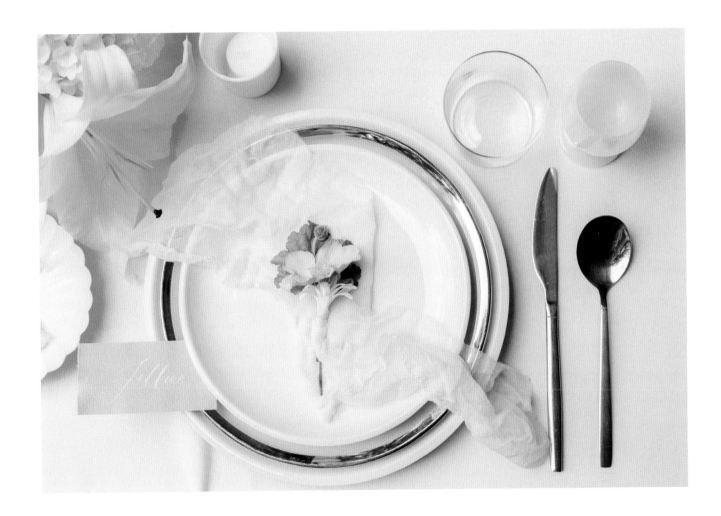

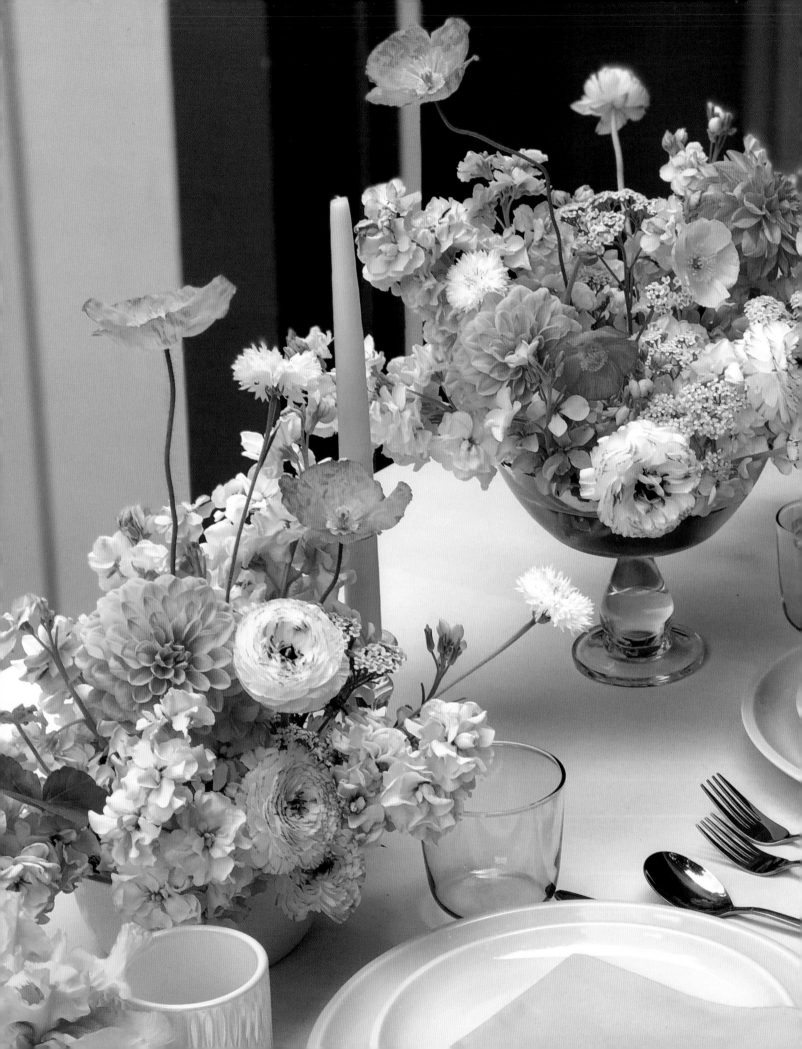

around the table too much. It is easier and simpler to create a tablescape when you have only a few varieties to place next to one another. In late spring those varieties could be pink peony together with white orlaya and lady's mantle. The combination allows for the orlaya stems to be long and create movement. The peonies are low and lush in the container. They create the focal point. The lady's mantle provides a little citron sparkle amongst the blooms and serves as a bridge of texture between the large peony and delicate, dancing orlaya."

For a floral designer spring is an exciting season, but so is the holiday season, of course. "During the holidays I do something spectacular.

> I love creating from the supermarket offerings when I'm purchasing ingredients for the meal.

"I would for example purchase three types of flower and one kind of fresh fruit to pair with the vase designs, to accent the color and texture of the flowers. One holiday I used an antique red hydrangea from the market and gently cut in half some fresh pomegranate fruit to set alongside the vases of hydrangea. The texture and color said 'holiday', not your typical reds and greens."

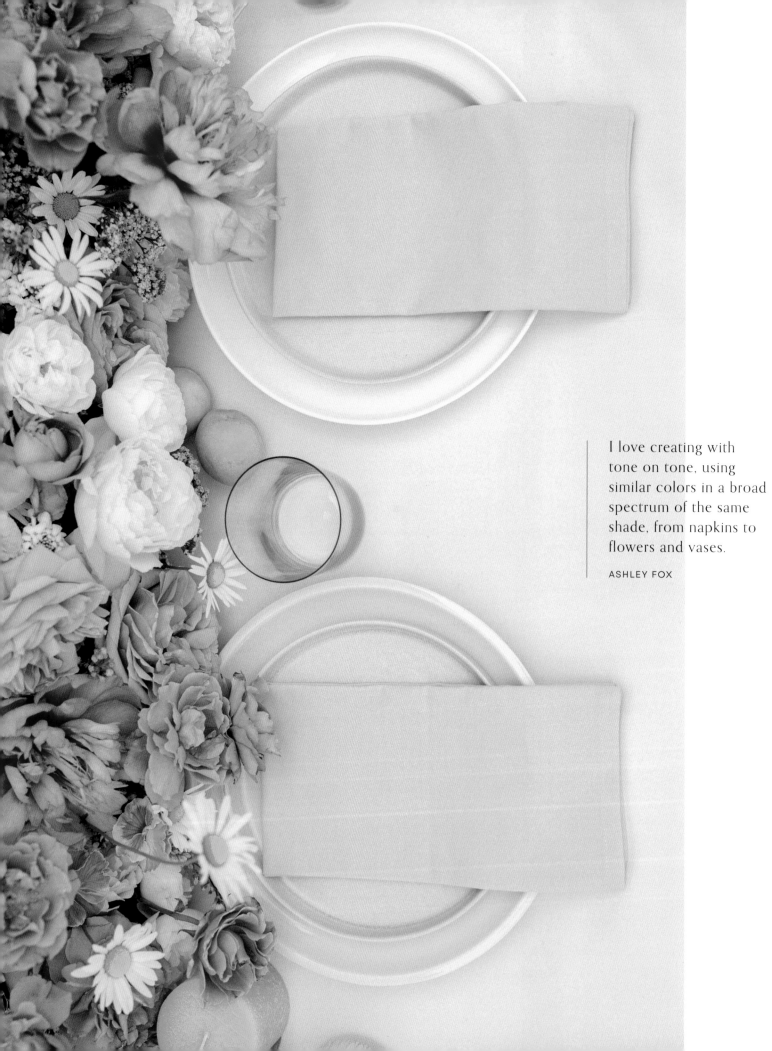

I love creating with tone on tone, using similar colors in a broad spectrum of the same shade, from napkins to flowers and vases.

ASHLEY FOX

HOW TO
TELL *Ashley Fox's* STORY ON YOUR TABLE

A popular look is 'ton sur ton', using similar colors in a broad spectrum
of the same shade, from napkins to flowers and vases.

Include your flower arrangement in the 'ton sur ton' concept. Using
only three or four varieties of flower at a time, often within the same color palette,
really helps to keep the eye from darting around the table too much.

To create *a light-hearted, fun feeling* choose a violet-hued Agrostemma
- delicate and butterfly-like blooms on a long, thin stem - and let it dance
down the center of a long table.

A winning combination in late spring: pink peony together with
white orlaya and lady's mantle.

Don't shy away from using fruits or vegetables in your floral designs.
Some fresh pomegranate fruit cut in half is a feast for the eye.

Guts and Glorious Weddings

with STYLE YOUR SPACES

Katie Brigstock
United Kingdom
@STYLEYOURSPACES

"Candles everywhere! Candles with a scalloped-edge design are a real favorite of mine at the moment. So when I have friends around for dinner, I might add in some of those to the table setting and pick flowers from what I'm currently working on in the studio." That studio is Style Your Spaces, a creative hub where Katie Brigstock showcases a modern approach to floristry and styling, looking at it as more of an art form and incorporating influences of modern fashion, art, and interior design. "Growing up in the countryside and surrounded by wild British blooms, I've always been drawn to nature and flowers. I've attended a few short floristry courses whenever I've had time to do so and sought out opportunities to work and learn from other florists. I worked in the events industry for a number of years, styling big launch parties and dressing different spaces including warehouses or photography studios. I co-founded events and supperclub project We Are Cook & Baker in London, which involved a series of styled dinners, workshops, and brand collaborations, before setting up Style Your Spaces."
As glamorous and fun as the job of a floral stylist may seem, it isn't exactly all valentines and roses. "For so many young people, following their desires to pursue a creative career comes with huge financial burdens and restrictions.

> Floristry is still often regarded by many as an 'other' job, not a 'real' career and I really think this needs to change.

"Without funding to grow your own portfolio, attend courses, and have the luxury of some additional time and resources to commit to often unpaid work-experience placements, it can be a daunting prospect for many. I'm passionate about building a network in Scotland to help to inspire young creatives and florists, to provide them with opportunity, regardless of their background and financial situation. I'm working towards the launch of a new project, CREATEFloral, which will aim to provide funding and opportunities for young florists and creatives. I'm also passionate about advancing sustainable floristry practices. We're a strictly no-floral-foam studio and work every day to limit our use of single-use plastic. We also often work with dried flowers,

→

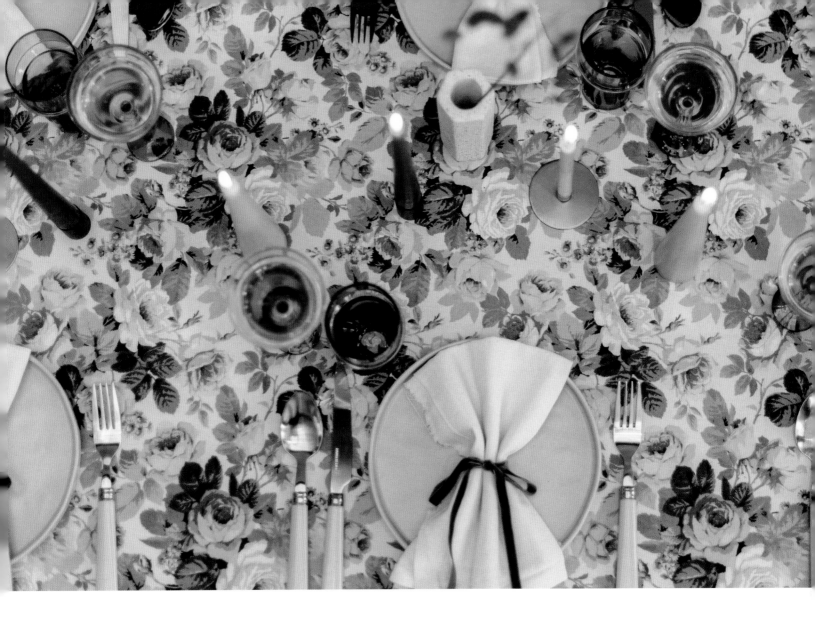

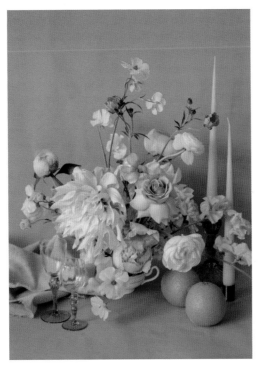

A colorful or patterned
tablecloth acts as the base
for the rest of the table.

KATIE BRIGSTOCK

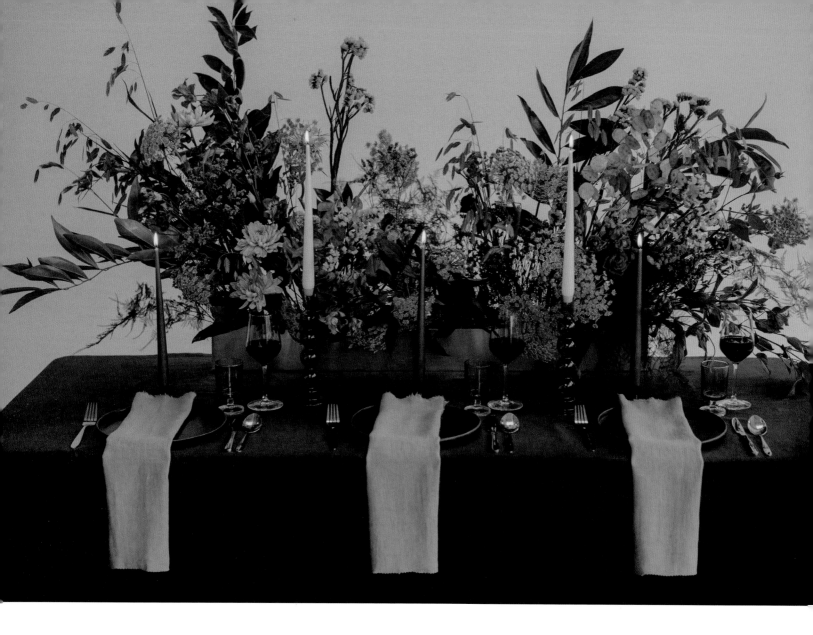

A mass of one particular type of flower along the table with soft neutral linens and earthy tableware can achieve the same showstopping look.

KATIE BRIGSTOCK

repurposing them from a bright and colorful summer season into beautiful, textural hanging installations with rich muted colors for shop windows, rigged from beams above a dining table or as the focal point for a wedding reception." Speaking of wedding receptions, Katie is a big advocate for some more guts when creating your wedding décor. "I notice there is a greater focus on creating a personal, relaxed atmosphere for guests through table design and florals that the guests will really remember. Bold statement tablecloths, colored glassware, and an abundance of blooms in a bold color palette can be real showstoppers for a wedding table design. It doesn't all have to be colorful either: a mass of one particular type of flower along the table with soft neutral linens and earthy tableware can achieve the same showstopping look.

→

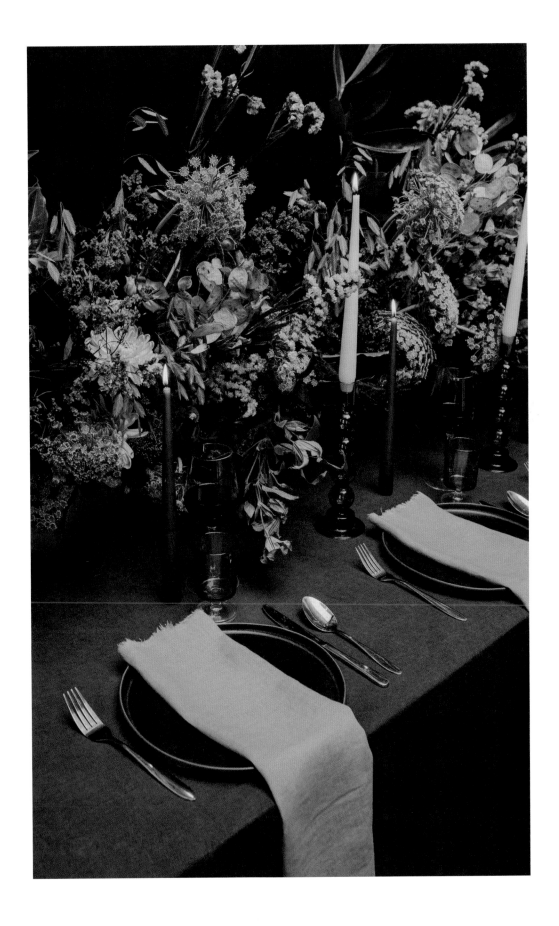

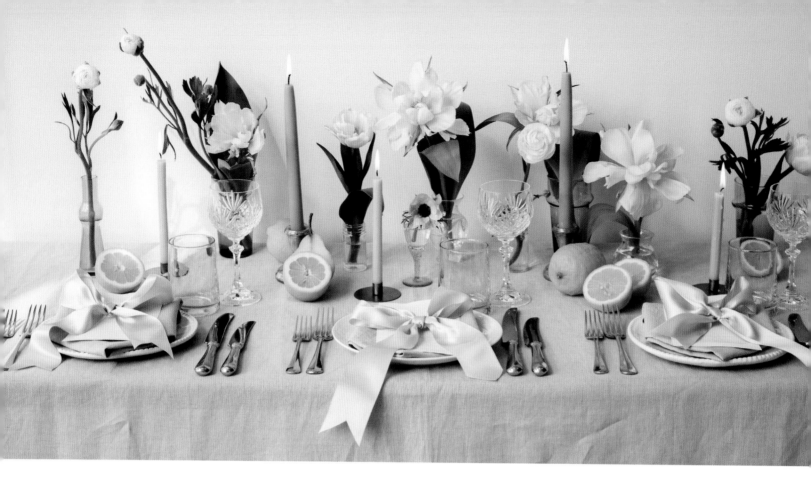

"When creating tablescapes, I like to start with the linens. A colorful or patterned tablecloth acts as the base for the rest of the table. Or perhaps I'm working on a really beautiful wooden or concrete table, in which case this will always impact the sort of style and atmosphere I'm looking to create with the rest of the décor. How the flowers will be arranged on the table then defines the choice of glassware, cutlery, and crockery. For example, I might want to use a variety of smaller vessels and ceramics with single stem flowers and thereby create more of an eclectic, mismatched look. Smaller vessels of flowers allow for greater flexibility in terms of glassware shape, the size of the placemats, and if any the sharing dishes down the middle of the table. If I wanted a bigger floral centerpiece or even a central floral arrangement set into a metal trough down the length of the table, this would impact how much space there was for candles and glassware. It's always important to consider the nature of the event and whether there will be people sat either side of the table. Flowers can bring such a gorgeous pop of color and texture, but you want to make sure the guests can still see each other and interact across the table." But what if Katie herself were to get married? "I think I'd be forever changing my mind about the styling! I would like to get married somewhere abroad in the late summer sun, with lots of beautiful candles, some bold florals and linens designed for the day itself, that guests could take away with them to remember the evening."

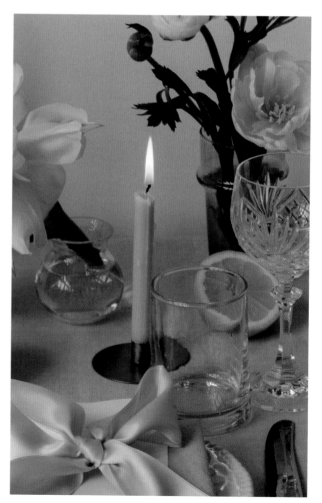

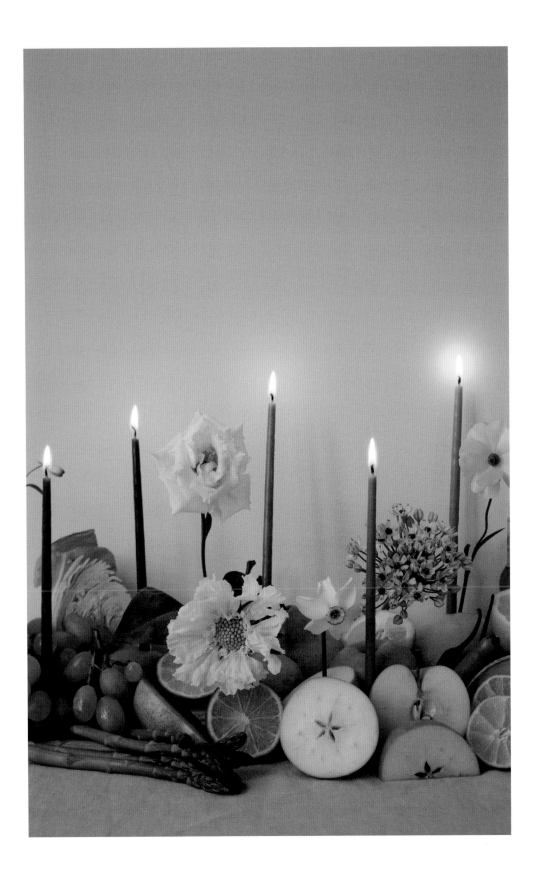

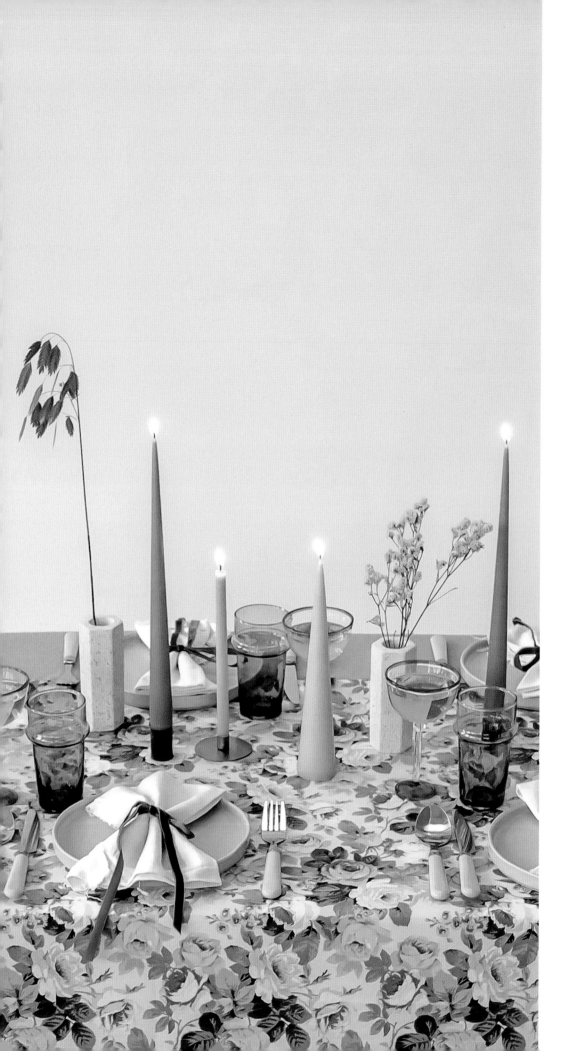

Smaller vessels of flowers allow for greater flexibility in terms of glassware shape, the size of the placemats, and if any the sharing dishes down the middle of the table.

KATIE BRIGSTOCK

HOW TO
TELL *Style Your Spaces'* STORY ON YOUR TABLE

This is a story about sustainability. Avoid using foam in your floral creations
and limit the use of single-use plastics.

Consider the use of dried flowers. Their longevity makes them the
more ecological choice. Dried flowers are the perfect material to
create hanging installations like flower clouds.

There is no rule that wedding tables should have a white theme.
Do something different: choose bold statement tablecloths, colored glassware,
and an abundance of blooms in a bold color palette.

If color isn't really your thing, there are other ways to create some table drama:
go for a mass of one particular type of flower scattered along the table,
paired with soft neutral linens and earthy tableware.

Bend the rules: you don't have to use an off-white tablecloth and
draw attention with a floral centerpiece. Why not use a colorful
or patterned tablecloth as the base of your styling?

For an eclectic look: use a variety of smaller vases and ceramics
with single stem flowers.

Always consider the comfort of your guests: don't let the flower arrangements
get in the way of guests talking to each other across the table. Also here: smaller
vases can be a flexible way to assure interaction.

*It could be a nice gesture to give your guest a small piece of the décor
to take home with them.*

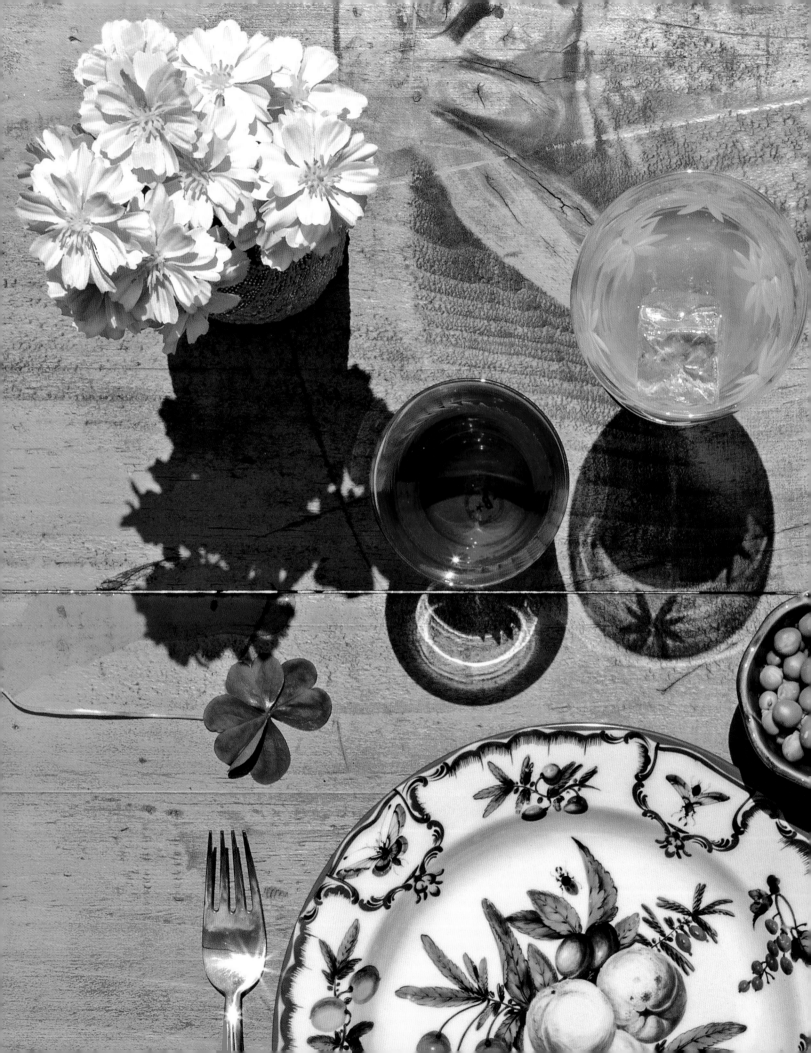

SUMMER

Summertime and the livin' is easy. But setting a table? Not that easy at all. Although summer sees a dramatic increase in weddings, barbecues, and garden parties, there are many pitfalls to bear in mind. We want summer to feel informal, very 'lalala' casual, like a holiday. And for table settings this often translates into not using tablecloths or linen napkins. Big mistake unless, of course, you have a gorgeously rustic wooden table. Another pitfall: using disposable tableware for the friendly barbecue. Not so friendly at all, and a nightmare for the environment. Third hurdle: color schemes. *If there is one season to go totally wild with color, this is it.* If there is one season in which you can lose yourself in a cacophony of colors, it's this one. Let your florist advise you and try not to combine too many different colors and materials. Some good barbecue advice: find a cool spot to style a nice grazing table overflowing with fresh vegetables and fruits. That allows you to go easy on the dinner table. And then the last bit of summer advice: rosé. Works every time.

Image. FUNKY TABLE – *p. 104*

Rule-breaking Weddings

with SASSFLOWER

Sasha Louise Rice
United Kingdom
@SASSFLOWER

"Don't go for the most liked image on Pinterest for your wedding table." Some good advice from Sasha Louise Rice. With her creative studio Sassflower specializing in dazzling wedding décors she attracts what she calls 'rule-breaking' clients. "Couples who think out of the box and look at ways to inject personality into their décor, whether it be through color or texture," Sasha explains. "When people think wedding flowers they think of white, blush greenery, but there really aren't any rules to be broken. It is just a perception of what a wedding should look like. I'm a big fan of mixing fresh, preserved, and dried florals and grasses into my designs - especially for couples who are authentically boho at heart. Equally,

> if you don't have a boho bone in your body then put the pampas down and go for something that feels more you and not just a trend.

"Table florals is the one area my clients are most unsure of. Usually the style of table will determine the design, whether it be round or trestle. Lots of my clients send me pictures of flowing table runners but then realize they won't really work with round tables, so we have to re-think the design and how to format it. Having a lot of tables can eat up a big proportion of the budget, so we suggest lots of little bud or stem vases, supplemented by candles, instead of one main arrangement.. If you are not in a position to hire a florist for your event then I would urge you to go out and see what you can find in the garden. You will be surprised what you can do with natural materials such as twigs, stones, pebbles, and even sand. The great thing about twigs is they have a simple, organic, calming effect and they don't obstruct the view. I would place these in varied height bud vases along the center of the table and add in a few flower stems for a pop of color. If you don't have any flowers to work with you can't go wrong with a foliage runner. Tie small bunches of mixed foliage with twine and place them flat on top of each other, covering each binding to create a hassle-free greenery runner.

Working with creative couples decorating the most important day of their lives, Sasha has great insight into the everchanging do's and don'ts in tablescaping.

→

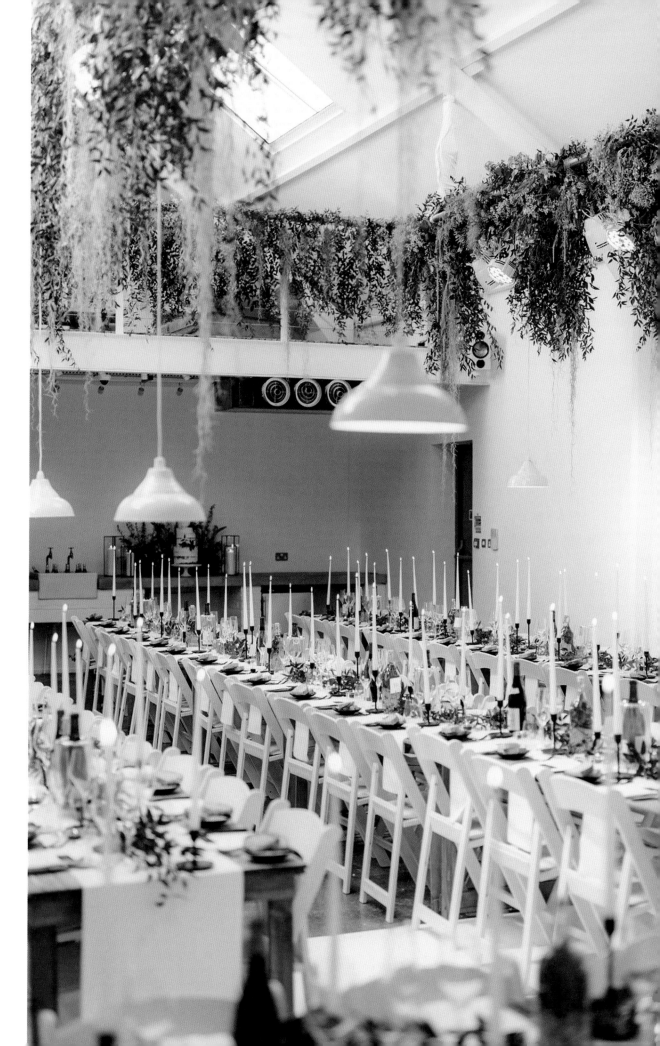

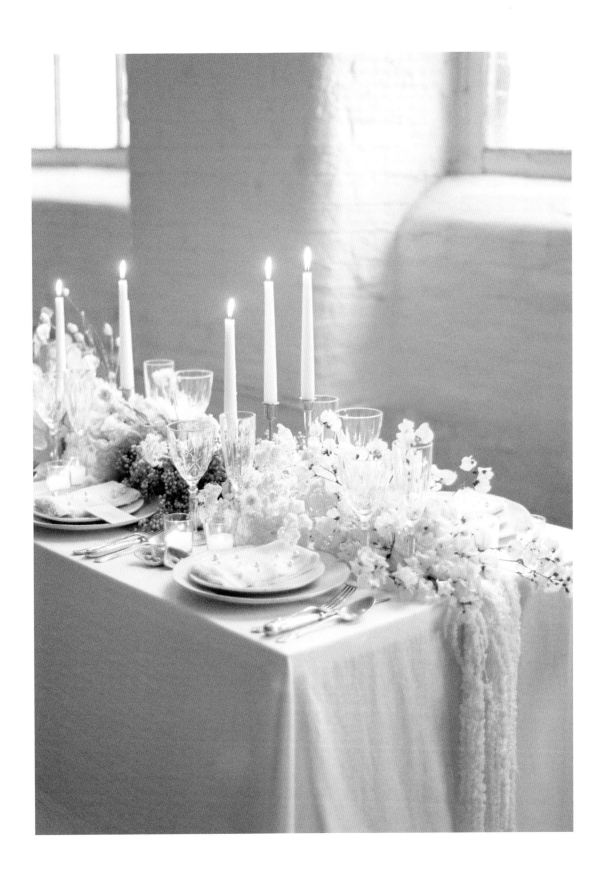

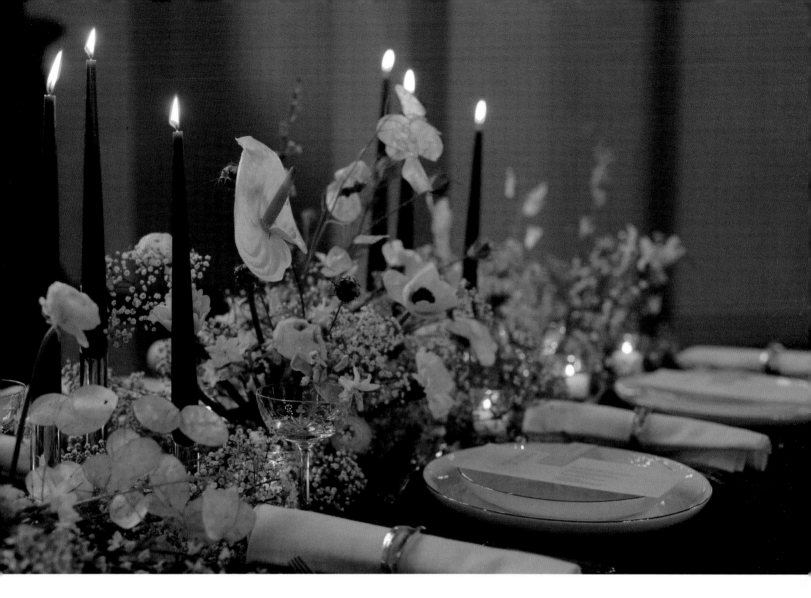

Having a lot of tables can eat up a big proportion of the budget, so we suggest lots of little bud or stem vases, supplemented by candles, instead of one main arrangement.

SASHA LOUISE RICE

"Long trestle tables are definitely the favorite right now, reminiscent of a Mediterranean feast.

Clients are also loving floral runners that drape over the end of the table to the floor, whether it be with flowing greenery or bleached amaranths. Bleached, dyed, and dried materials are huge right now and are also long lasting, with no need for a water source. Personally, I love a mix of fresh and dried, preserved, or bleached flowers. Clusters of a few different products along the table in staggered sizes and heights give a truly minimal, modern luxe style. Hanging features above the table are also extremely popular and will usually inspire a minimal style of table dressing."
When dressing a table, Sasha follows a few elementary steps to achieve extraordinary results. "The first thing I'm looking at is the size, shape, and composition of the table. →

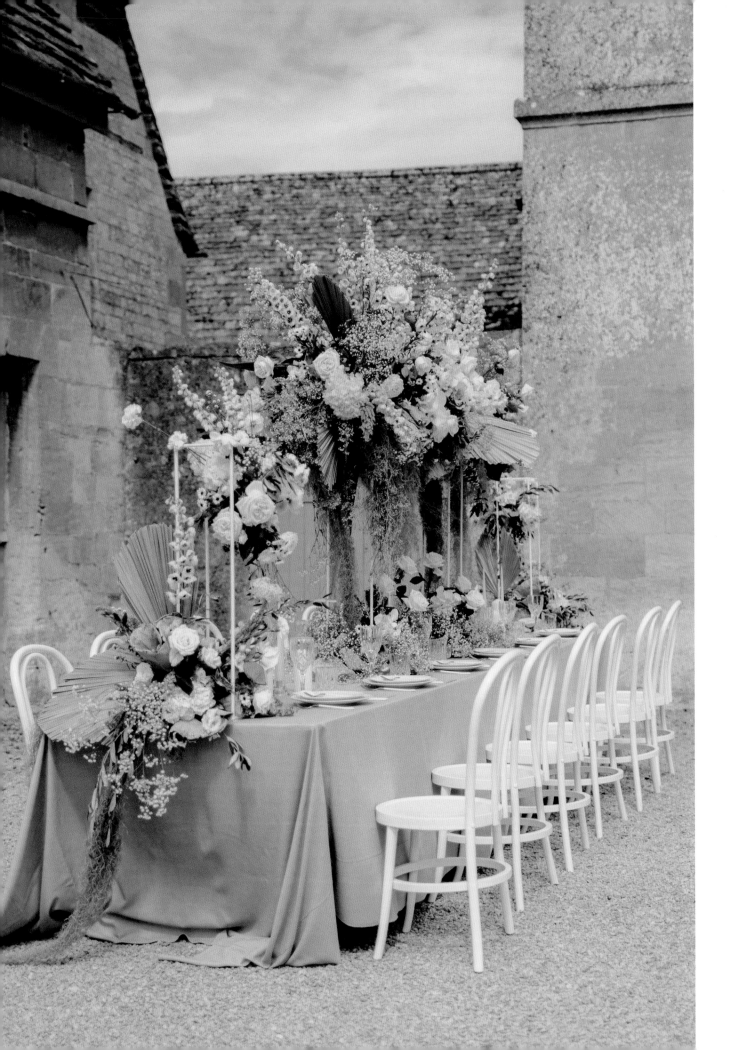

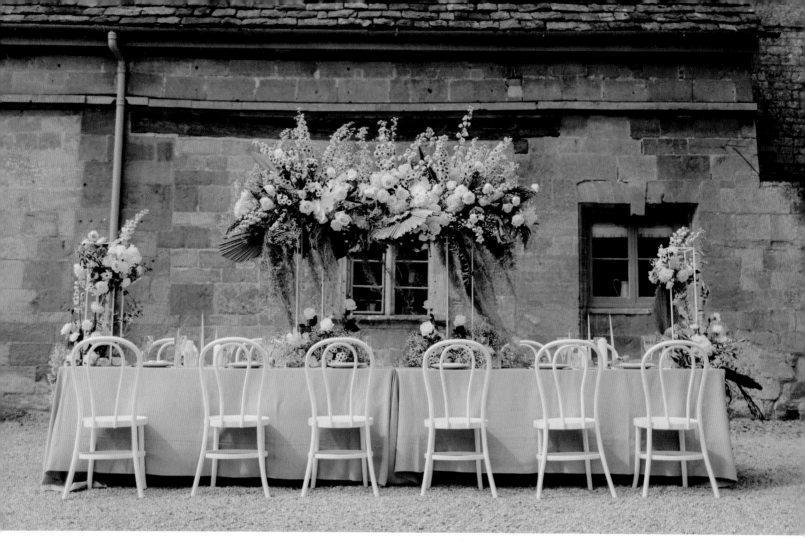

I try to reflect
this eclectic
mix of bold and
muted, of old
and new into
my designs.

SASHA LOUISE RICE

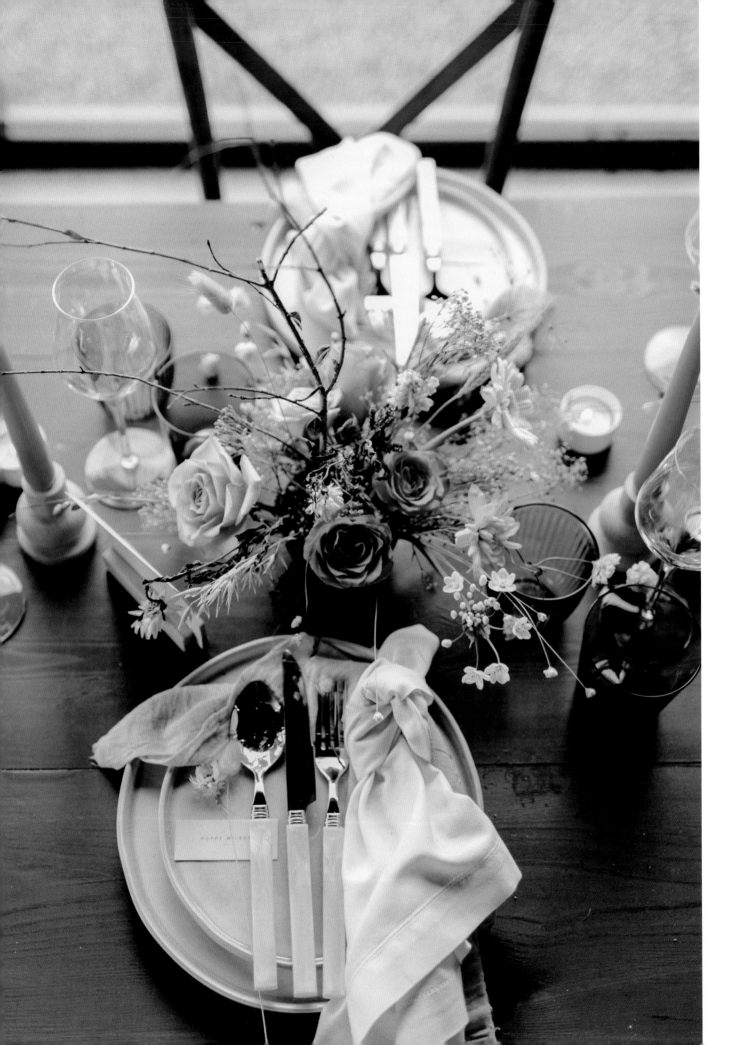

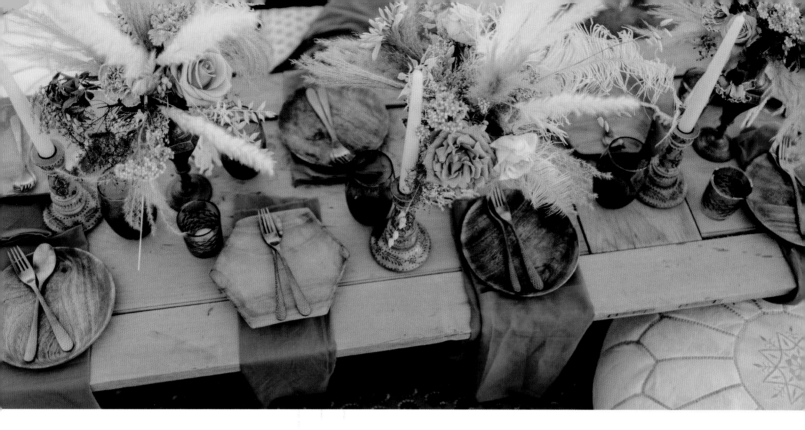

Then it is time to add necessities like crockery. It is important to determine whether there will be a placemat or charger plate and to explore the food-serving situation. I have to properly assess the space and see how florals can function within the table without overpowering or obstructing views. When selecting style and colors, I look at the couple's choice of stationery, and natural elements like the exposed wood of an old table.

Whilst I fully champion seasonal flowers, I find these days there is less snobbery in terms of flowers used.

You can't go wrong with a foliage runner.

SASHA LOUISE RICE

Carnations and chrysanthemums are making a huge comeback; therefore colors, shades, and tints will always lead the design over specific flower varieties."
Hugely inspiring for Sasha to start a career in florals was and still is her nanna. "She was a mythical and creative lady, she believed in fairies and angels. The 'poppy cottage' she lived in consisted of mainly red-poppy-covered items - from wall art to mugs and plates. The poppy has now been incorporated into my branding, I try to reflect this eclectic mix of bold and muted, of old and new, into my designs." Ironically, Sasha is not married (yet). But like many women she has planned her wedding down to the finest detail in her head. "I picture an Italian alfresco wedding full of color and natural beauty. The florals would probably be a mix of lavish and smaller arrangements in shades of blue, red, pink, orange, and white in locally made ceramics. That sounds quite strange, but I would like to give myself the most unusual color combination, make it work, and surprise people."

TABLE STORIES

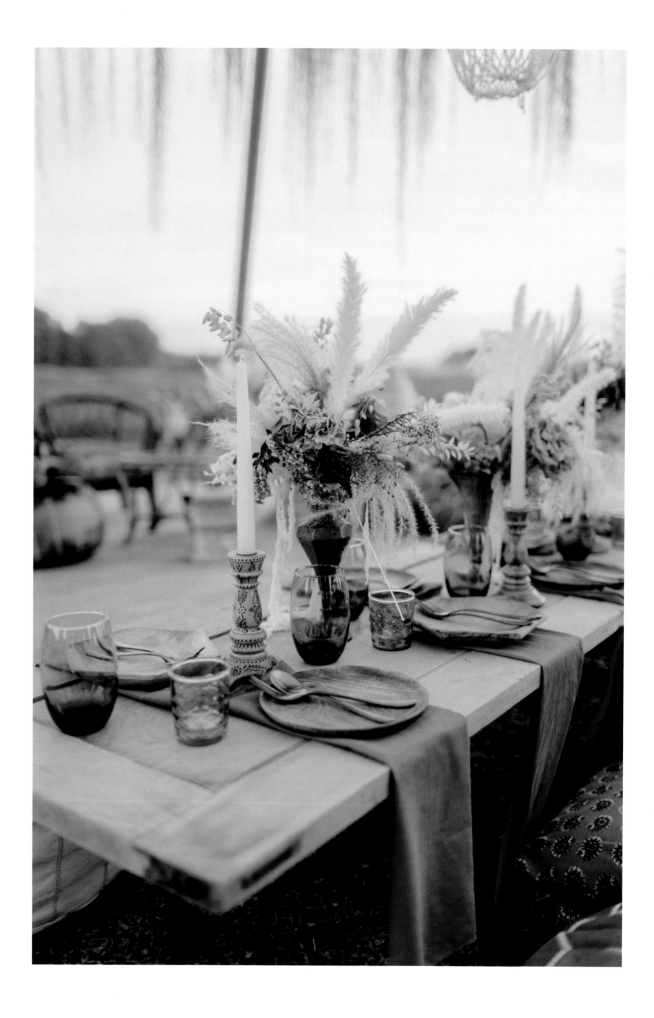

HOW TO
TELL *Sassflower's* STORY ON YOUR TABLE

The most important rule for a *wedding décor is that it should reflect both your personalities.* Stay true to yourself. If you are not a boho person in everyday life, then put the pampas down.

What's best for you? A *round or a long table?* Round tables are ideal for dramatic centerpieces, but don't work with table runners. Long tables usually require a larger number of smaller floral compositions.

The more tables you have, the higher your decoration budget. If your décor includes a lot of tables, you might want to consider a selection of little bud or stem vases.

Make sure the *small vases vary in size and shape,* it adds personality.

Make your own foliage runner: tie small bunches of mixed foliage with twine and place them flat on top of each other, covering the binding.

Let the foliage runner drape over the end of the table and onto the floor.

Mix fresh seasonal flowers with dried flowers.

Choose your color scheme before deciding on flower types. Your color scheme can be inspired by your stationery, your wedding dress, the location, or a specific personal theme. Let your color scheme decide your choice of blooms.

Flowers: roses in unconventional hues like dark brown or deep orange, green twigs of eucalyptus, willow, pine, or olive trees. White pampas. And consider some forgotten flowers: carnations and chrysanthemums are making a huge comeback.

Play with height using tall, elegant candlesticks.

Get that Conversation Started

with STUDIO STORIES

"To be honest: I eat dinner on my couch. That said, there is nothing more pleasing than eating at a meticulously styled table. As a stylist and set dresser I love to push the boundaries of what is considered good taste. There is no better place for experimentation than a dinner table. At our studio we set a catering table every single day. And we never repeat the same tablescape - we want to keep our guests captivated - better still, surprise them. One day I experiment with fresh leaves on the table, the next I play around with modeling clay. There are no limits to what you can and cannot put on a dinner table. As long as it is hygienic of course. Instead of the obligatory flower on the napkin, why not use something witty? It could be anything. A humorous picture, an artichoke or a key, whatever.

> An unexpected feature on your plate can be a great conversation starter.

An De Jonghe
Belgium
@STUDIO.STORIES

"I am on a mission to convince my friends not to blindly rely on the obvious for great table setting ideas but to listen to their own gut feeling.
"A spectacular table doesn't always require a spectacular budget. A simple way to maneuver away from the ordinary is to create different stories on your table. Just put some pots and pans upside down on the table and drape the tablecloth over them. It looks very elegant when you place the bread basket slightly higher, or when you create a spectacular grazing effect on your dining table. Consider your tableware as building blocks. Place your wineglass on top of the upturned water glass. Or choose one eyecatcher for the table - a fabulous artisanal loaf, a colorful vase, or a crazy cake - and style the rest of the decorations around that. It can be clever to choose one main focal point and let all your other props relate to that one.
"I actually studied communication and worked as a television editor for a while. It was around the time that Instagram started to become more and more popular in Belgium, and I just loved the images of Sofie Noyen, also featured in this book. I was so impressed by her work as a food and interior stylist that I contacted her: 'If you ever need a hand, let me know.' I was amazed when she replied: 'Are you free tomorrow?' For the next two years I assisted her on nearly every job and learned to →

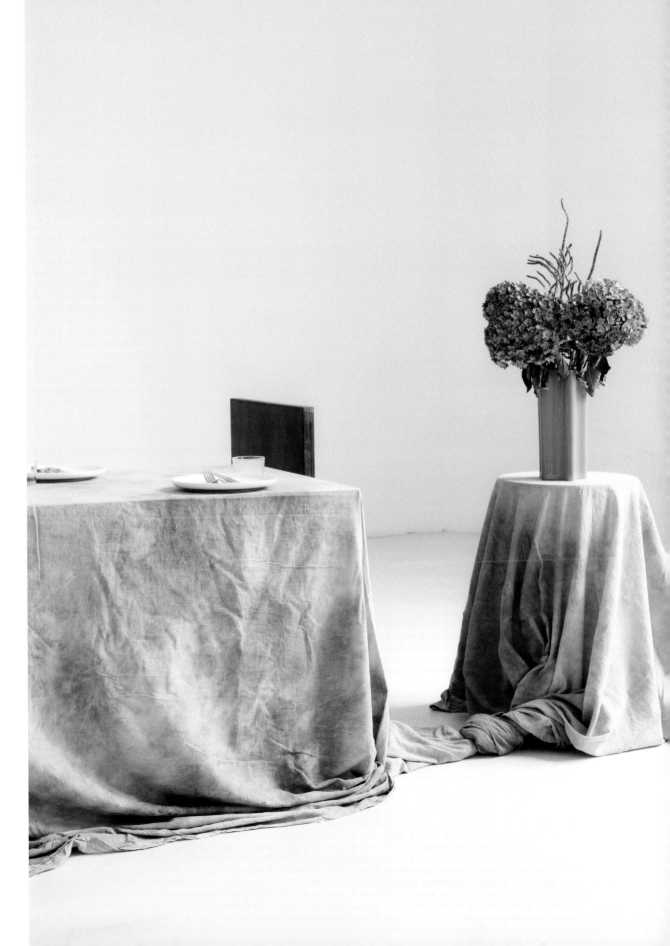

develop an eye for color combinations and the right framing. Since going our separate ways, my style has evolved away from hers. I tend to be more experimental nowadays." Which is quite the understatement when talking about An.

"The more persistent a trend becomes, the less I feel like giving in to it.

"The more I see it appearing, the more I start resenting it. For instance, I have never used black plates. I don't actually think food looks appetizing on a black plate." →

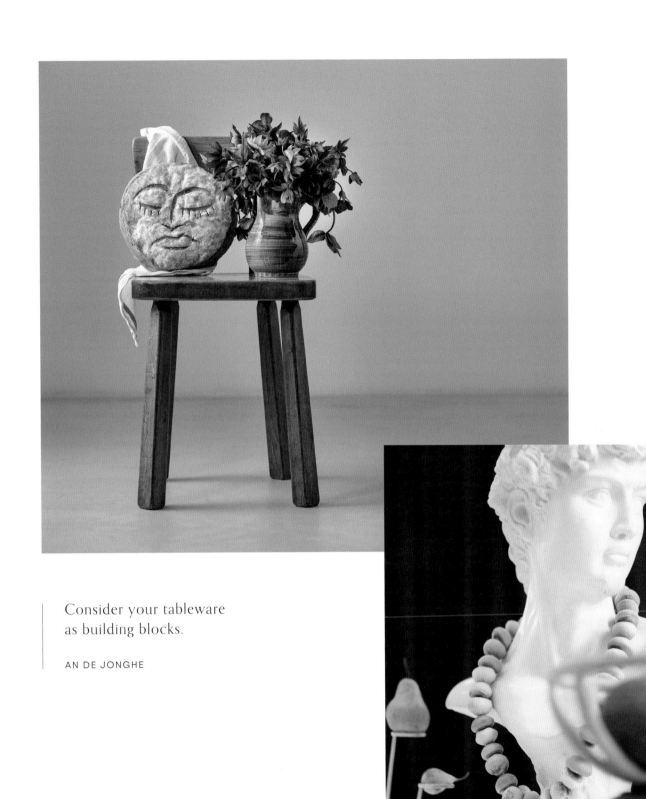

Consider your tableware
as building blocks.

AN DE JONGHE

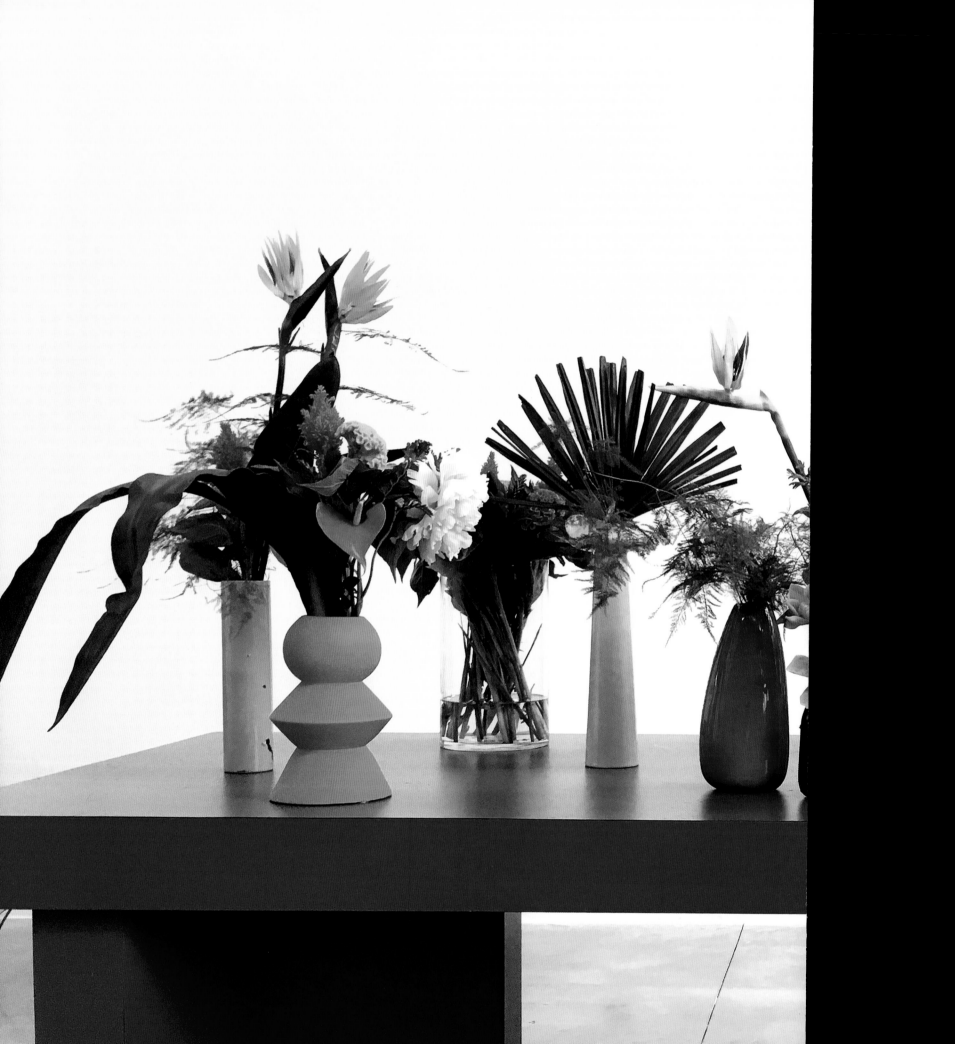

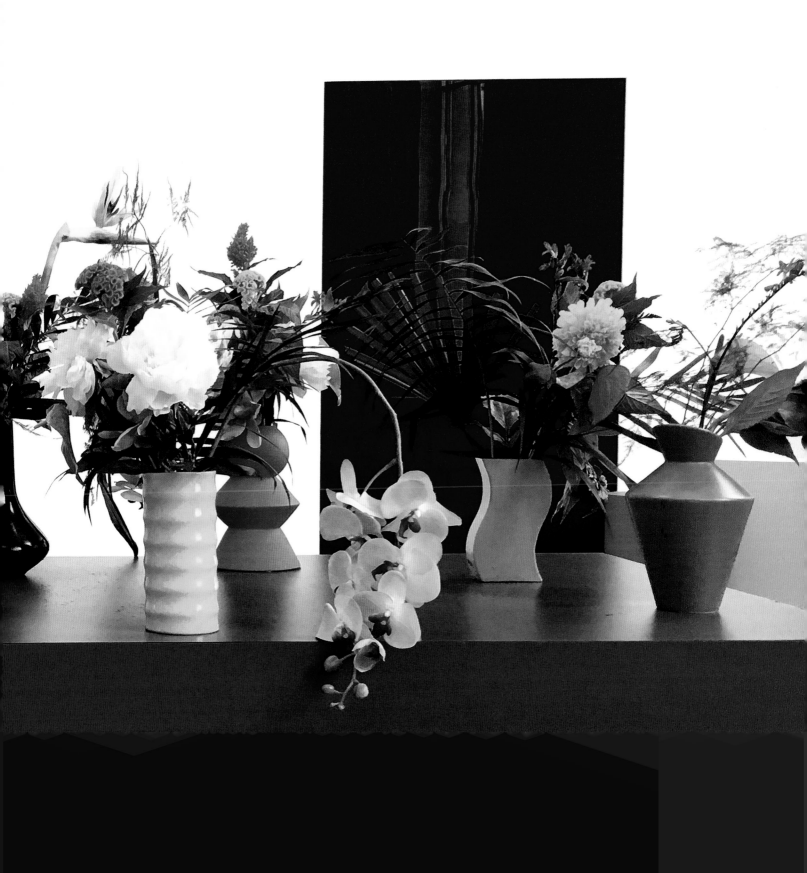

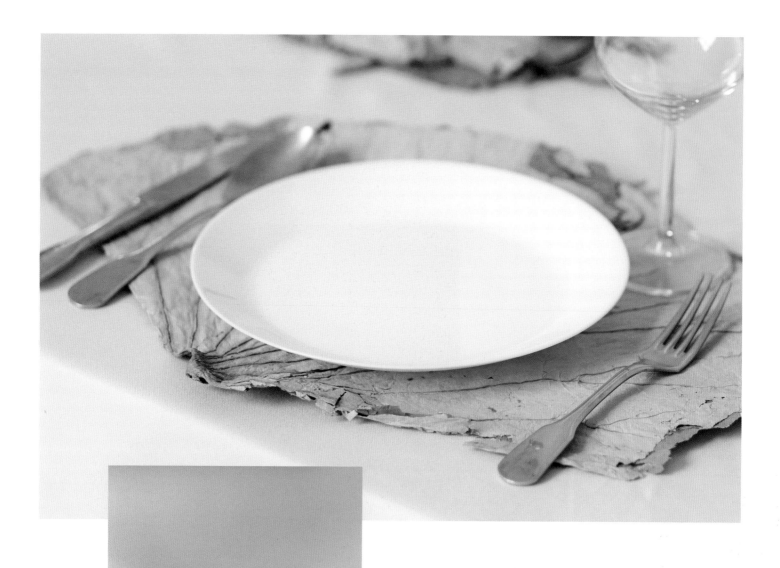

"I'm inspired by literally everything, from reading books, to looking at architecture, and traveling the world. I love it when people make an effort to lift everyday life to the next level, like some market vendors I saw in Nice recently. The way they stack their fruits and vegetables into perfect pyramids, to me that is a work of art. I will definitely experiment with that on one of my next tables. Why not translate that to a Christmas table? I don't think Christmas should be more traditional in any way. As an editorial stylist, I decorate Christmas trees in August. It's so liberating to work on Christmas decorations in summer when you are not surrounded by all things green, red, and gold. →

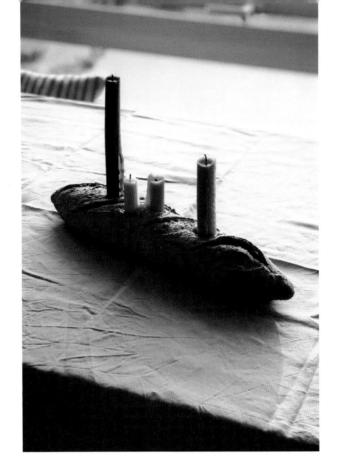

83

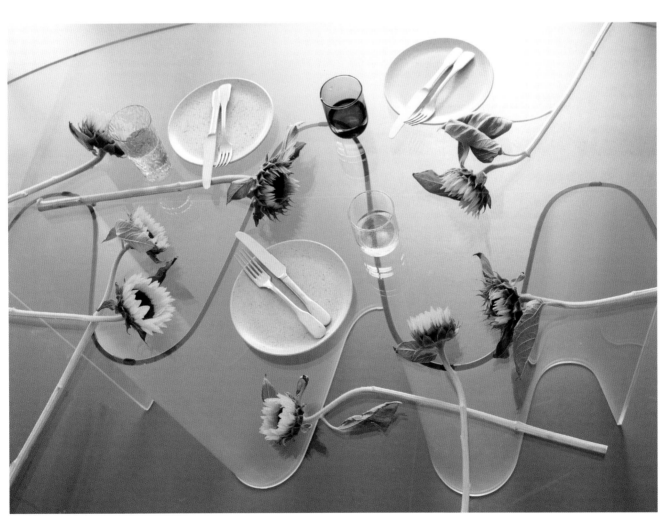

"Social media have definitely
changed the way we dress our tables.

They've taken entertaining to the next level because your
guests take pictures before taking a single bite. But social
media also deliver loads of inspiration. For instance, I love
Laila Gohar's Instagram account, @LAILACOOKS. She does
the most amazing things with food. A cool Salvador Dali
vibe. On one grazing table she shaped butter into a hand.
Although I am not a talented cook those things fire my crea-
tivity. But there's a downside to social media-based inspira-
tion. I feel as though more and more people are doing the
same thing. And that's because they see the same design
ideas all the time. This happens a lot on Pinterest – you get
pulled into a bubble that keeps repeating the same style
over and over again. From time to time, it's really important
to break free of that bubble."

HOW TO
TELL *Studio Stories'* STORY ON YOUR TABLE

Don't just think about your table as merely a décor. *The table can be a playful and interactive asset* to your dinner party or celebration.

Instead of the obligatory flower on the napkin, why not
use a humorous picture, an artichoke, or a key? Could be anything.
It is a great way to get the conversation going.

A simple way to create an unexpected tablescape is to work with different heights:
just put some pots and pans upside down on the table
and drape the tablecloth over them.

Picking a bright color can be enough *to draw attention* to your festive table.

Choose one main focal point and let all your other props relate to it.
That focal point can be anything, it doesn't have to be a floral composition.
It could be an artisanal loaf, a colorful vase, or a crazy cake.

Consider your tableware as building blocks. For instance:
place your wineglass on top of the upturned water glass.

Don't get blinded by the perfect tablescapes on Pinterest or Instagram:
do your own thing. *Break out of your creative bubble.*

Inspiration Comes Naturally

with VERVAIN

India Hurst
United Kingdom
@VERVAINFLOWERS

The flowers, always the flowers. For India Hurst, there is no doubt about the one thing that makes a beautiful table setting. "Their colors, textures, and shapes dictate the mood and style of the table. I build it on from there, selecting tableware and accessories that pick out the shapes and colors of the flowers." In 2014, India founded her own floral design studio in Worcestershire and named it Vervain. "I liked the idea of using a plant name, but nothing too obvious or 'pretty'. I wanted a name that was unusual enough to capture and express a certain wild garden feeling." That wild garden feeling is important because it is actually the very core of Vervain. Everything starts from the private garden India created. "We have our staples, things like towering ammi and delicate poppies that we cannot live without. We love color and we are forever trying out new color palettes, blending vibrant shades with unexpected companions, finding that little touch of mauve and yellow that just ties a color scheme together.

> Adding pops of an overlooked shade of blue or subtle hues of red can add a whole new dimension to our floral work.

Having all these flowers by our studio means we are forever experimenting and offering something new."

An important factor in designing a table setting these days is that it has to look very natural and laidback. "There is definitely a leaning towards the effortless elegance of a perfectly laid table right now," India confirms. "Whether that is created with a pared-back look of just delicate flowers in stem vases, or the more abundant look of styling with a mass of summer flowers and fruits, capturing a picnic vibe. They are both made to look natural and easy yet are tricky to achieve."

For weddings and other events Vervain creates the most amazing floral designs, but when India personally invites friends and family over for dinner, she tends to keep it a bit simpler and more easy going. "If time is restricted I use some bud vases and a few candles. Just a few flowers and the warmth of a little candle light can transform a table. I always have a few go-to vases, these are vintage ceramics and handmade small vases I have collected over the years. →

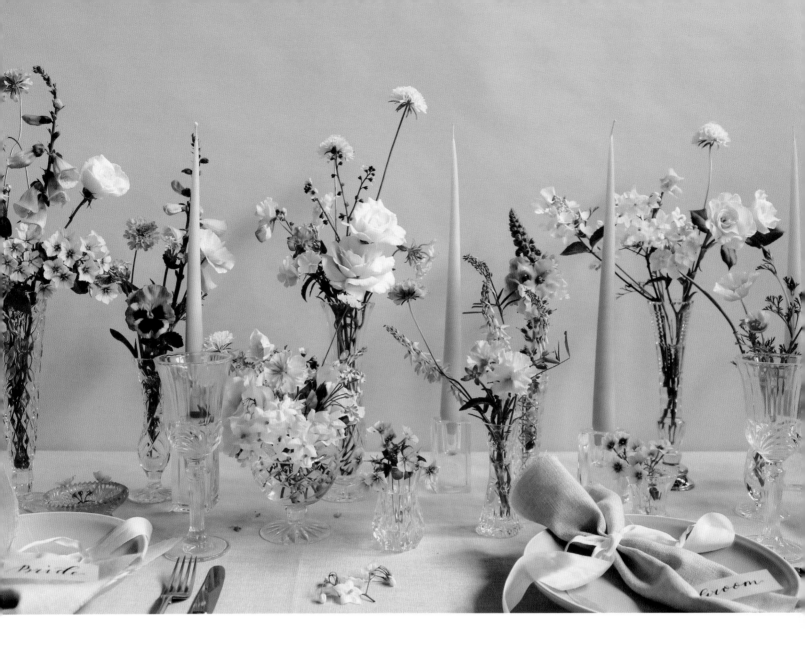

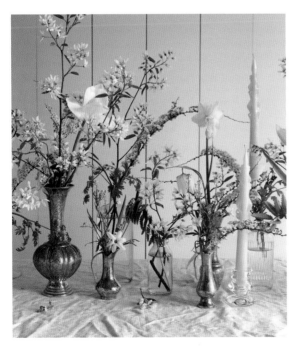

Just a few flowers and the warmth of a little candle light can transform a table.

INDIA HURST

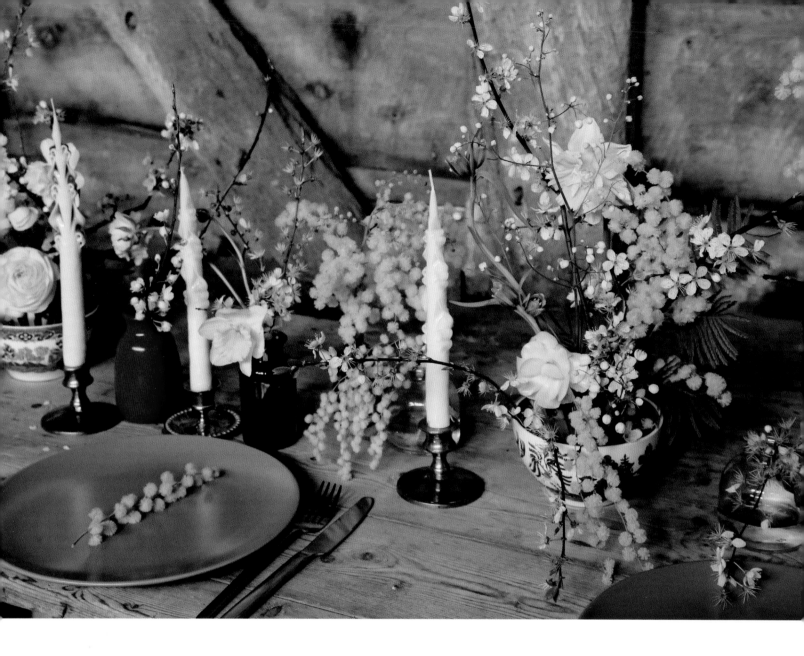

"I add a few unusual flowers or foliage - things like tiny alpine strawberries on the stem, tall delicate toadflax, and pea flowers and their tendrils, dotting them around a few candles, tealights, or tapers - both are perfect, and you have a simple but elevated table."

Nothing inspires me more than the flowers and gardens that surround me.

India explains. "I have grown up surrounded by flowers, so I think that passion and love has always been there, it just took a little time for me to realize." This love for nature is translated in using sustainable techniques. For instance, only renewable materials such as wire and flower frogs are used to arrange flowers. "Our work is about celebrating the natural fleeting beauty of flowers and foliage. We create work that is an expression of the relationship with the natural world."

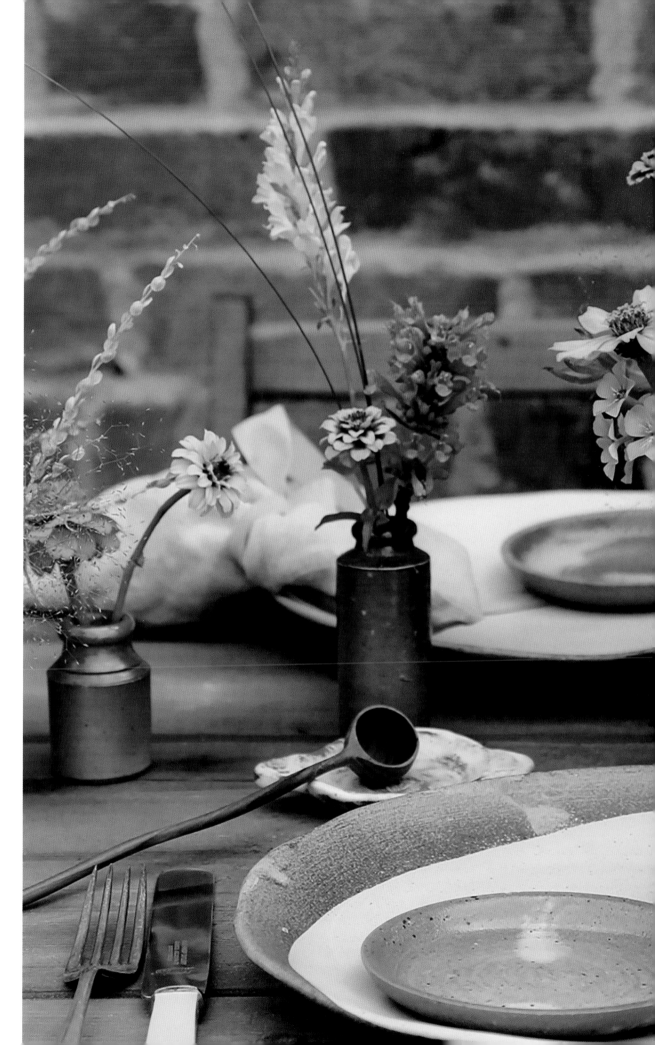

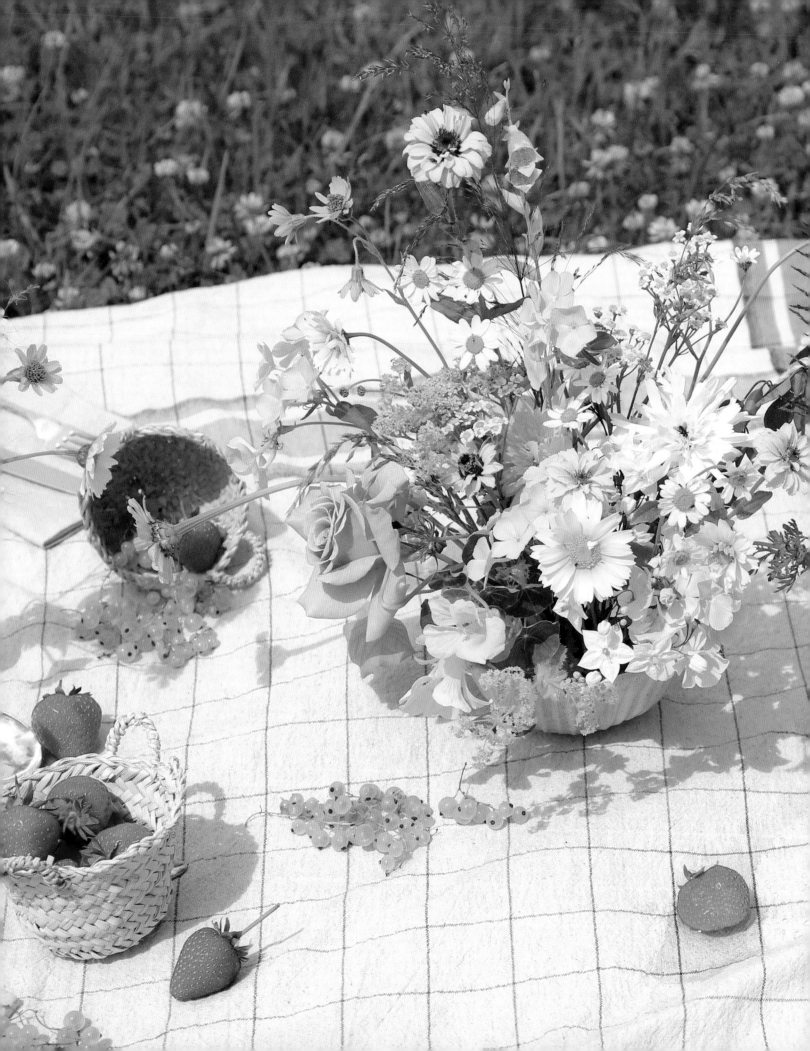

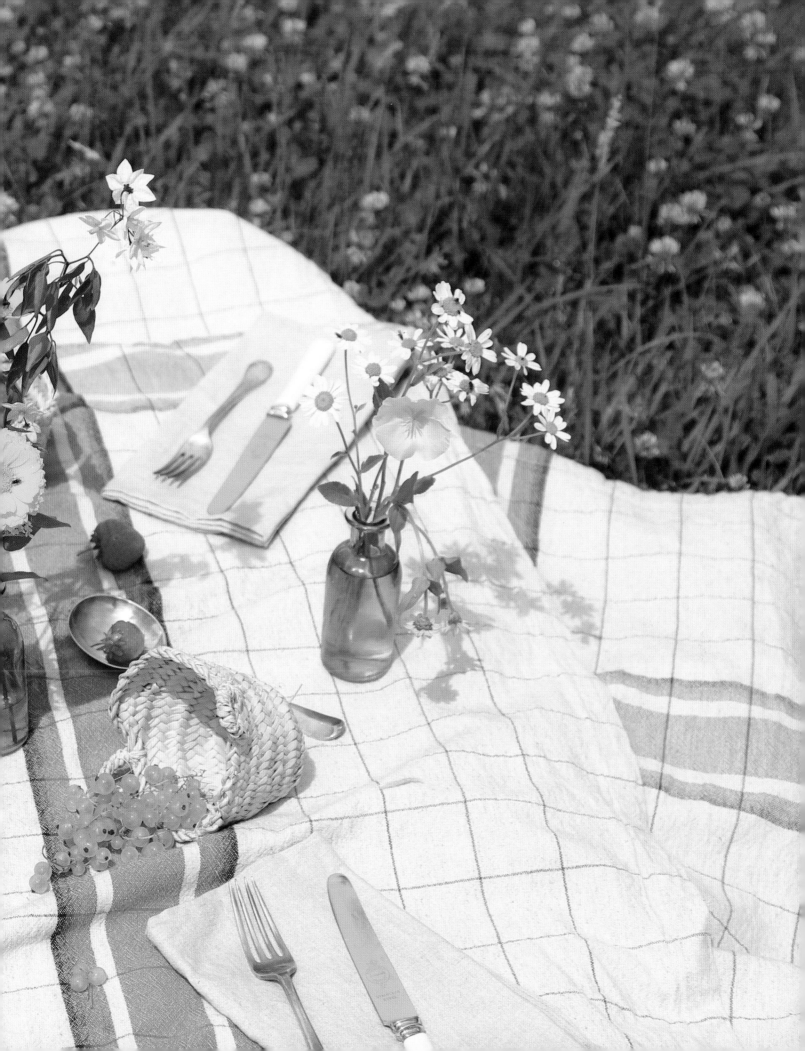

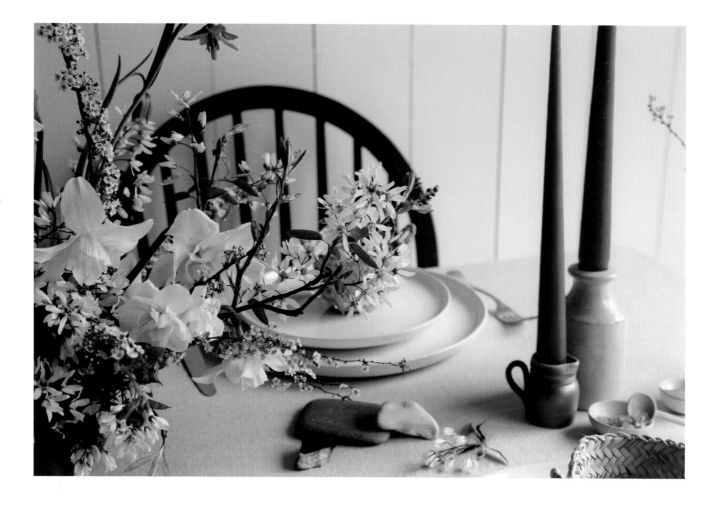

There is definitely a leaning towards the effortless elegance of a perfectly laid table right now.

INDIA HURST

HOW TO
TELL *Vervain's* STORY ON YOUR TABLE

First things first: pick your flowers. And *match all the other items* on the table to
the color, the texture, and the feeling of your flower arrangements.

Focus on your color scheme. When you are at the florist, hold your selection
in your hand and see if the combination works. Sticking to a color scheme
doesn't mean you can't have unexpected accents such as purple or yellow
flowers amongst your blue selection. If it looks good,
it will look good on your table, too.

The style we're going for oozes casual elegance. It's all about creating
a stunning table that seems effortlessly put together.
When in fact it took a lot of work.

A few *flowers scattered* about the table, in combination with a candle,
can transform the entire mood.

Add a few unusual flowers or foliage, things like tiny alpine strawberries
on the stem, tall delicate toadflax, and pea flowers and their tendrils,
dotting them around candles, tealights, or tapers.

When aiming for effortless elegance, it's a good idea to avoid elaborate
flower arrangements. Instead, go for delicate flowers in little stem vases.

Aiming for
the Unforgettable

with RUBY + JAMES

Jessie Chalmers
Beck Salter
Australia
@RUBY_AND_JAMES

"The table setting is one of our favorite features to design," Jess explains. Together with Beck she forms the creative studio Ruby + James, specializing in styling and curating exceptional events in Melbourne. "After all, it is what brings all your guests together; there's something unique about the conversations and connections that are shared over a long lunch or dinner party. Surrounded by loved ones, reconnecting with old friends, or creating a space for new friendships to form. This is where we love weaving the more personalized details into the designs to add another layer of meaning: from custom menus, monogrammed place cards and napkins, and handmade plates to ambient candle light."

Ruby + James was founded about five and a half years ago and named after two very special and influential people in the lives of Beck and Jess. "Persons who are sadly no longer with us. They help push us to our creative limits and ignite that fire in the belly feeling when it comes to our work and our passion for events." Over the past few years, the two creative young women have seen a dramatic shift in the details that are now incorporated into table settings. "Clients want to give their guests an unforgettable experience and we've used many different elements in our styling to elevate the event. From neon LED strips running along the center of the table, large overhanging installations that make the guests feel a part of the centerpiece, to dry ice spilling out from the dessert. There are no boundaries to what you can do with a table setting and the options are endless.

"When starting any design concept, we first get to know our clients and delve into the things they love, what they are drawn to, and of course their story surrounding the event. We then turn to the venue for inspiration, looking at the interior and exterior colors, textures, and shapes as well as the menu and what's in season.

> We tend to find there's
> always a hero piece that
> jumps out to us, that starts
> the creative process.

Whether it is a dining chair design, a bold pattern, or a certain flower. The layers then build up from there," says Jess. And although every event is unique and tells a different story, she can detect some clear trends in tablescaping.

95

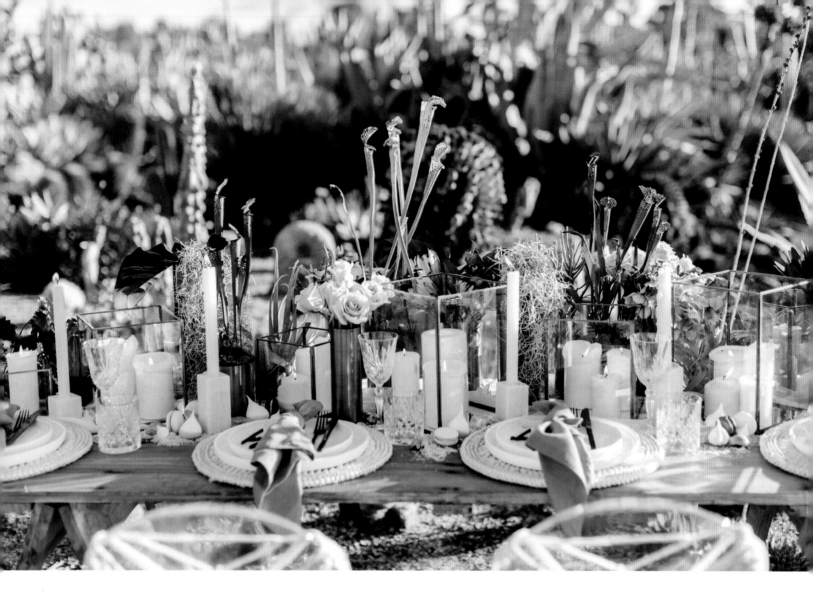

There are no boundaries
to what you can do with
a table setting and the
options are endless.

JESSIE CHALMERS

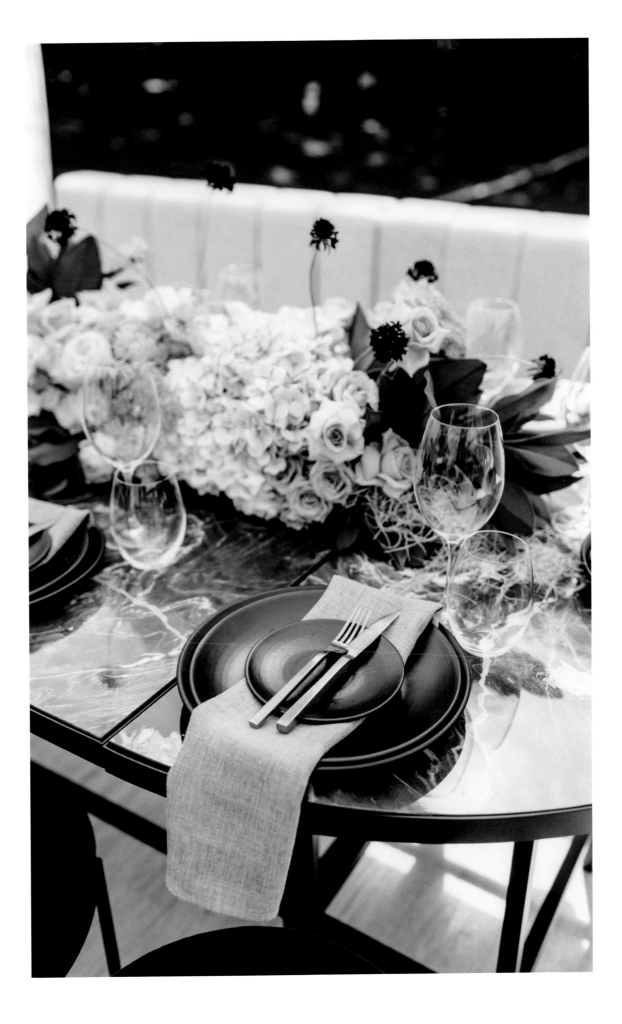

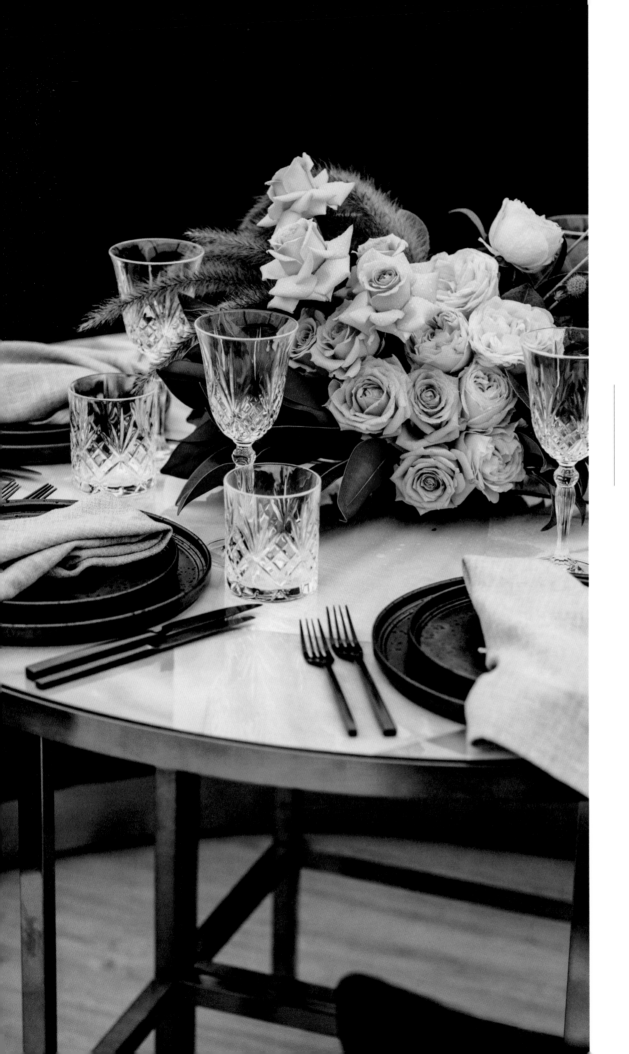

We love all types of occasion, but our favorite would have to be a wedding.

JESSIE CHALMERS

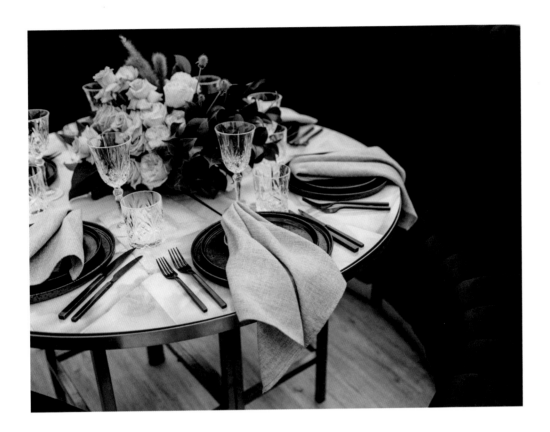

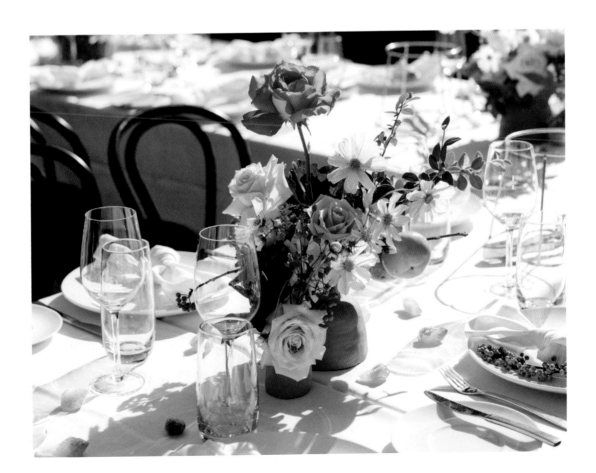

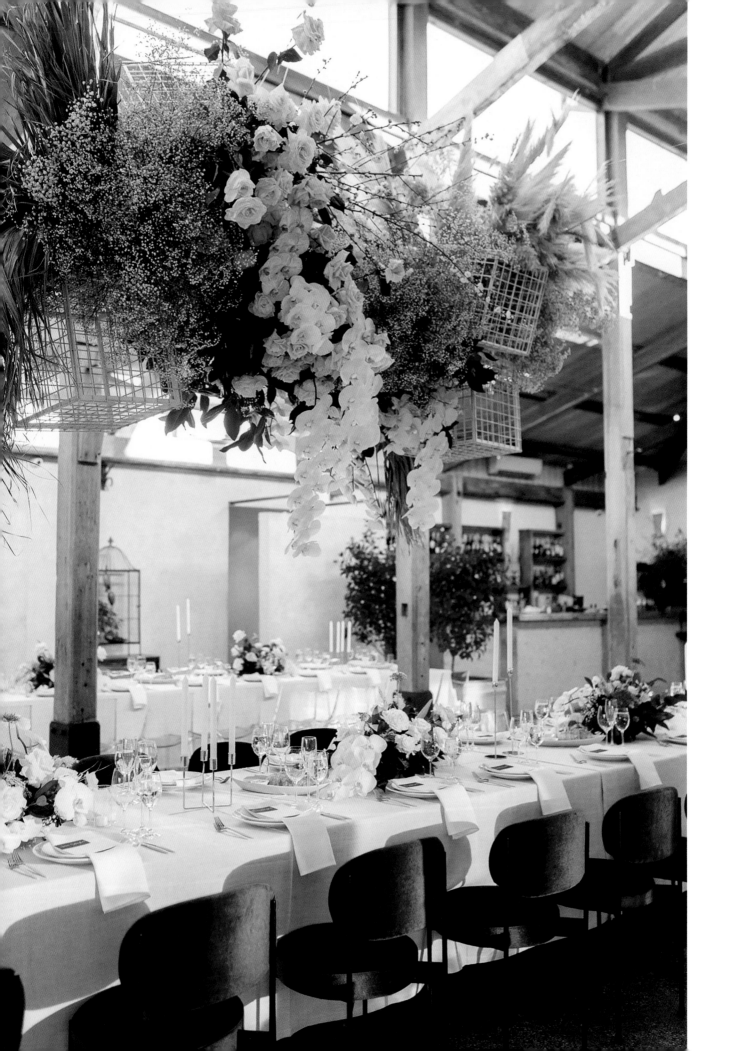

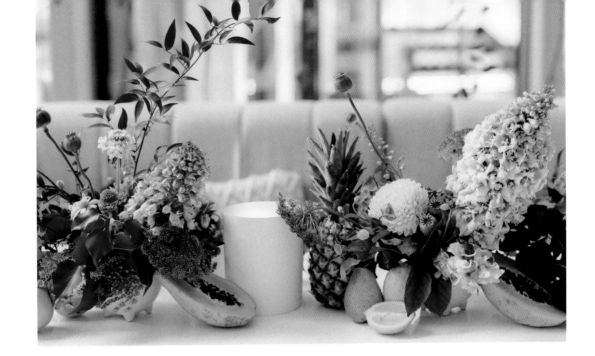

"A main trend at the moment is the use of terracotta hues incorporated into many styling elements. From terracotta linen, flowers, and ceramic vases to custom stationery. It is such a beautiful and earthy color and can work with a vast array of color palettes. We have also started to see fruit and vegetables incorporated into the floristry styling. It brings such a unique element to the table setting and there's so many different ways you can style a table with mushrooms, pumpkins, paw paw, and grapes mixed amongst the blooms." As with so many things, a beautiful table starts with a good base. "Investing in a quality linen tablecloth and napkins will lift the styling of any table," Jess knows. "If hosting a dinner party, candle light plays such a vital role in bringing the right ambience to the table setting. There's something so magical about sitting around a candlelit table. When it comes to flowers,

> We love the look of arranging
> a mass of the same type of flower in
> different-size vases along the table.

Or to keep things simple, lush leaves or foliage branches will create some beautiful shapes and textures. We're lucky to live at the foothills of the mountains and will often go foraging for uniquely shaped branches and foliage." With their creative studio, Jess and Beck style events ranging from an intimate relaxed backyard gathering to a vibrant multicultural wedding for 300 guests. "We love all types of occasion, but our favorite would have to be a wedding. There's just something so special about celebrating a union of two people from two different backgrounds, coming together for one day to celebrate with their loved ones.

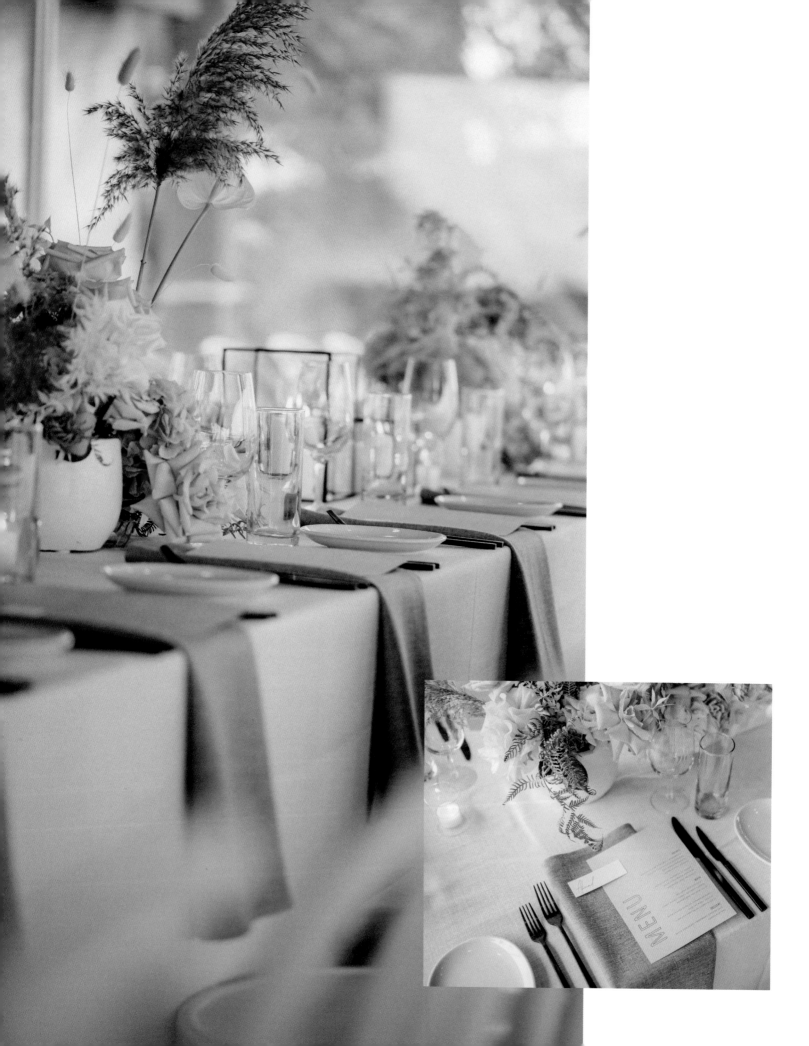

HOW TO
TELL *Ruby + James'* STORY ON YOUR TABLE

This tablescape simply must have *an elegant base:*
a quality linen tablecloth and matching napkins.

Choose one 'hero piece' that will become the center of your tablescape.
It can be a flower arrangement, a candle, a cake, whatever you want.
Try to build your table styling around that.

Terracotta hues look great on a table setting. Use them in the linen,
flowers, ceramic vase, and the stationery.

Don't hold back from incorporating *fruit or vegetables* in the floristry styling.

When you really want to impress your guests: *add some personalization.*
Add place cards, customized menus, or monogrammed napkins
(if you are good with a needle).

No need for an elaborate variation in different flower species:
arrange a mass of one type of flower in different-size vases along the table.

For some extra drama: why not have a neon strip running down the center,
or large installations overhanging the table?

Mix & Match Masters

with FUNKY TABLE

Mariangela Negroni
Titti Negroni
Azzurra Rovida Ortuani
Italy
@FUNKYTABLE_MILANO

Vale tutto. It is one of the most important mottos of Mariangela Negroni and her sister Titti. It means 'Anything goes.' "We love having no rules. We mix and match tableware from all corners of the globe, inspired by what we feel at that particular moment." In 2015, the two sisters from Verona started Funky Table, a store in Milan's historical heart that sells an eclectic mix of amazing tableware and accessories sourced from around the world. Mariangela and Titti also offer personalization and creative consultancy. "We both worked in the fashion industry," explains Mariangela, "but since 2010 I've worked as a design and table stylist for such Italian magazines as *Velvet La Repubblica*, *Vanity Fair*, and *Vogue Italia*. I was used to researching items from different countries, so it was easy to do the same for a store." Now the sisters work on projects with Le Bon Marché in Paris and design their own collection of tableware, carried by the most prestigious department stores including La Rinascente in Milan and Rome as well as London's Liberty.
Lots of colors and expressive prints combining traditional shapes and materials. At Funky Table the art of table dressing is in mixing and matching different styles. "I wouldn't define our style as typically Italian. I love to use and search Italian handicrafts, but

> the mix on our tables
> is more international
> than Italian,"

states Mariangela. The sisters clearly don't abide by the adage 'Less is more.' There is no color they cannot use, no two prints that are 'too much' together. Don't let those two creative all-rounders fool you: they also appreciate amazingly simple table settings. "But even a minimalist table should feature something special, like vintage lace or large flower compositions in the center. Last year we did an all-white table setting with a salt sculpture between candles and it was amazing!
"We get our inspiration everywhere," says Mariangela. "From watching movies about traveling to reading books. But seeing something unexpected on a street corner or in a museum sparks the best ideas." In their shop in one of the prettiest neighborhoods of Milan they welcome an international clientele of travelers on the look-out for something unique.

→

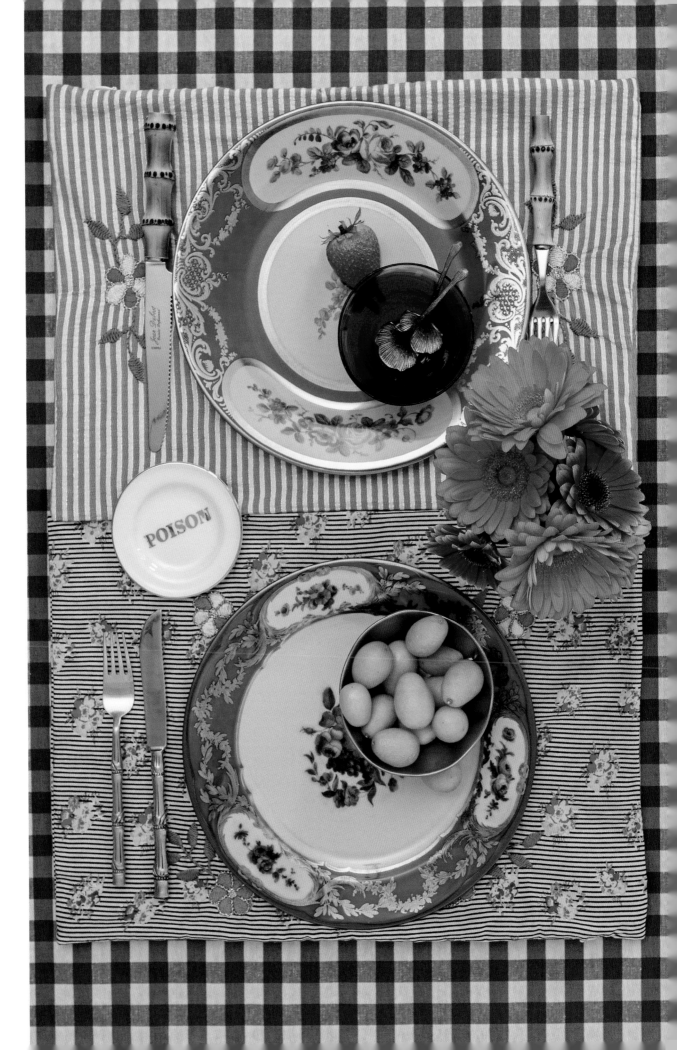

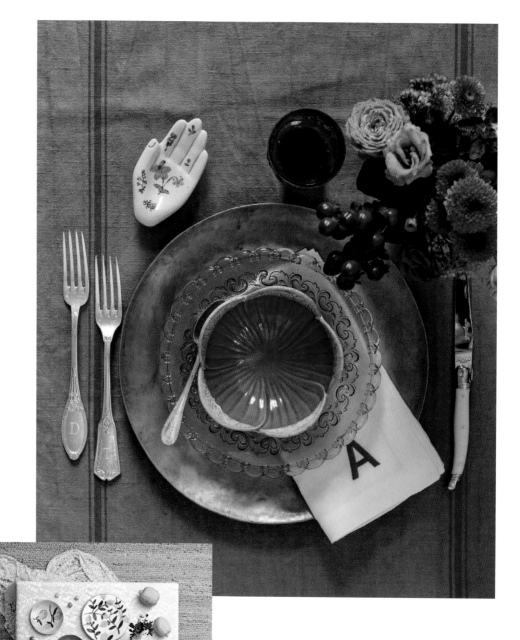

The goal is to find perfection
in the deliberately imperfect,
highlighting the singularity of
every unique object.

MARIANGELA NEGRONI

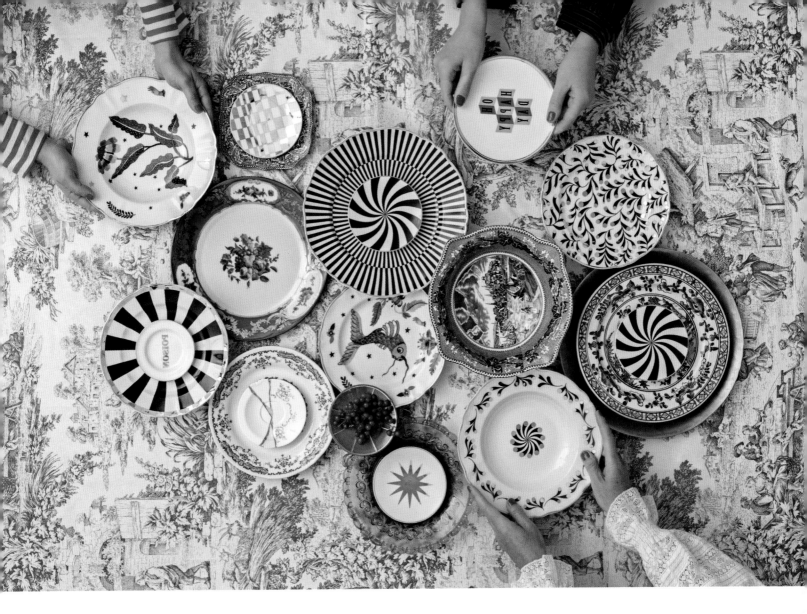

As soon as someone steps into the shop, they can't wait to replicate their ideas on their own dinner table. "There is no magic recipe for a beautiful tablescape. We advise our customers to blend different styles: a few antique objects of your grandmother's paired with brand-new stuff, or a couple of souvenirs from your travels combined with a very classic look. The goal is to find perfection in the deliberately imperfect, highlighting the singularity of every unique object." Mariangela's and Titti's passion for beautiful tableware culminated in the development of their very own collection of vibrant plates, vases, glassware, mugs, cups, and storage jars called La Tavola Scomposta, which loosely translates as 'The Dissolved Table'. "It is a collaboration with the Tuscan brand Bitossi Home. I am the art director of the collection and Bitossi is the producer and distributor," says Mariangela. "We started about four years ago and now have more than one thousand retailers all over the world." Not bad for a plate that says 'poison'.

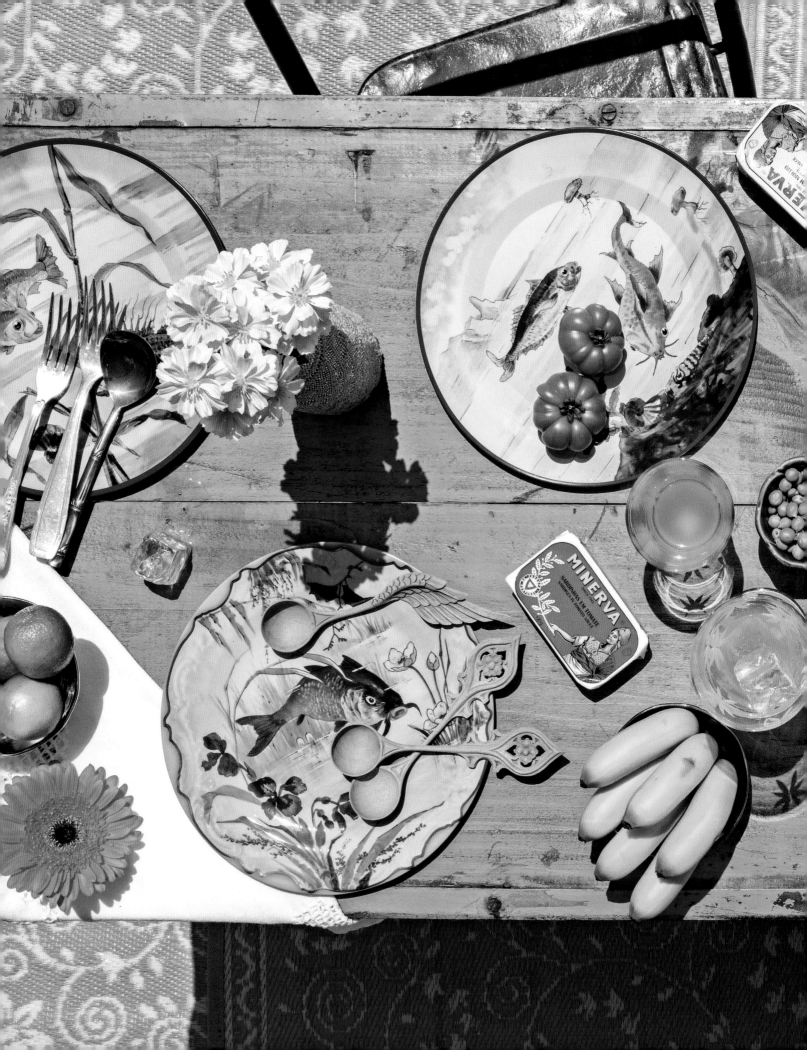

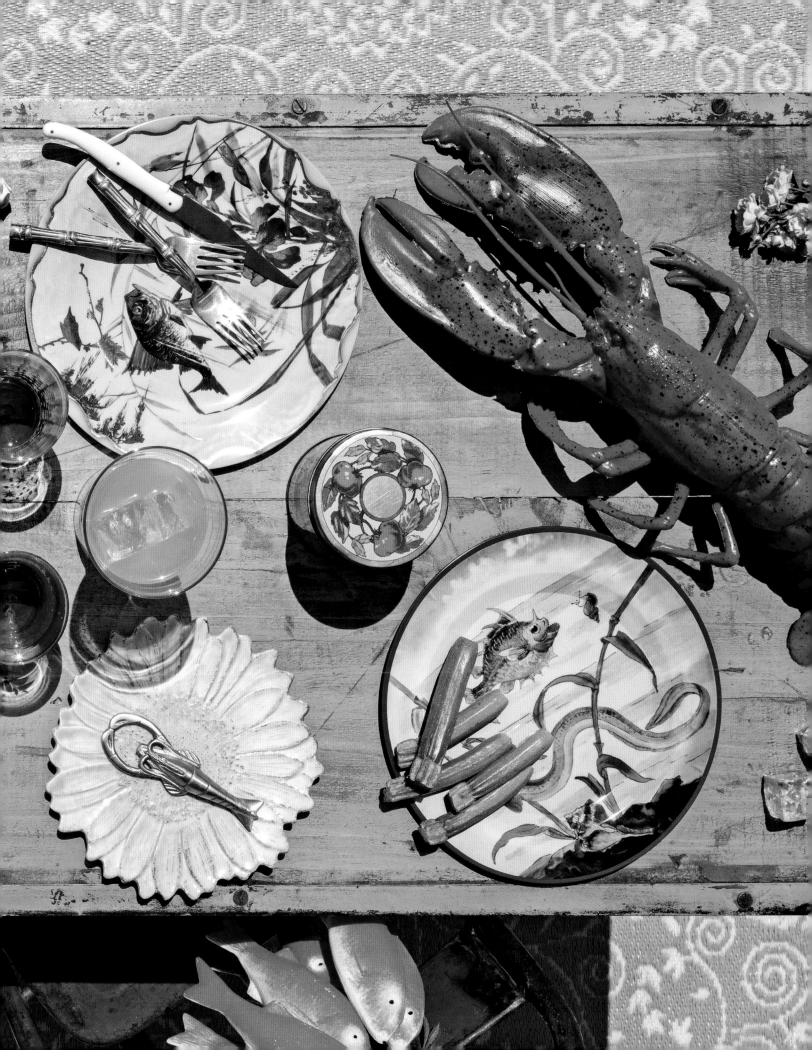

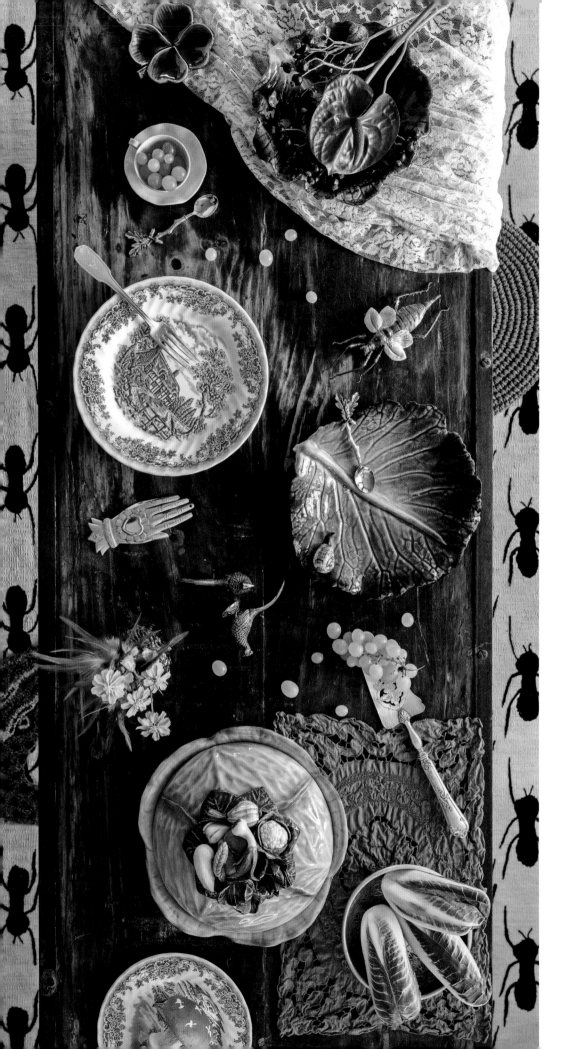

Even a minimalist table should feature something special, like vintage lace or large flower compositions in the center.

MARIANGELA NEGRONI

HOW TO

TELL *Funky Table's* STORY ON YOUR TABLE

There's an easy way to recreate this eclectic style on your dinner table:
treat yourself to a shopping spree in Milan and visit the shop of Titi & Mariangela Negroni.

If that's not an option: *browse flea markets and vintage shops* and buy as many
different prints and colors as you can find.

This look is all about a beautifully textured table or a gorgeous tablecloth. A white
table isn't recommended if you're trying to create this eccentric style.

Don't shy away from using expressive colors and bold patterns. If your tablescape
causes your mom to throw up her hands and cry, "Have you lost your mind!",
you know you've created the perfect funky table.

The key to this style is the tableware. Adding some matching flowers is always
a nice bonus, but *try focusing on the tablecloth, the napkins, placemats, and ceramics.*

Mix and match as if your life depends on it: a few of your grandmother's antique
pieces with brand-new stuff, or a couple of souvenirs from your travels
combined with a very classic look.

Quality over Quantity

with GEOFFREY AND GRACE

Melanie Barnes
United Kingdom
@GEOFFREYANDGRACE

"Slow living isn't about doing everything slowly. It is about purposefully doing things and being present for each part of our day. The art of slow living is not about how much 'free time' you have, but how intentional you are with that time. By choosing quality over quantity, there is more opportunity to savor the simple pleasures and experience those moments wholeheartedly." It is safe to say that Melanie Barnes is an expert on the matter. She even wrote a book on it: *Seeking Slow.* "When beginning to live slowly it is important to spend some time thinking about how we schedule our week and what our purpose and priorities are, as we are then able to understand what is motivating us, cut out anything extraneous, and fill our days accordingly.

Through slowing our homes and simplifying our belongings, we can begin to create space for more rest and play.

By realizing that time spent nurturing and tending to ourselves isn't a luxury, but is, in fact, essential for our wellbeing, of course we make a massive impact on the choices we make. We all need to reconnect and learn to listen to our bodies in order to truly slow down, and we don't need a lot of time: just ten minutes daily can go a long way to support our health and happiness.

"I started my blog and Instagram page when my daughter was little, and I instinctively knew I wanted to use the names of my maternal grandparents. For me, of course, their names encompass so many fond memories of spending time with them and are very much associated with a feeling of home." That feeling of home and the connection with family is what drives Melanie in her day-to-day life. "One of my absolute favorite things to do is to sit down with extended family for a long slow lunch. It's an opportunity to reconnect, chat, and spend time together over good food and drink. It's something I remember doing lots as a child and I have happy memories of family lunches when we all came together, having been dispersed and separate for the rest of the day. Now, for our family, mealtime signifies an opportunity to connect, relax, and all be together. Sitting together around the table creates a calm space to talk through

→

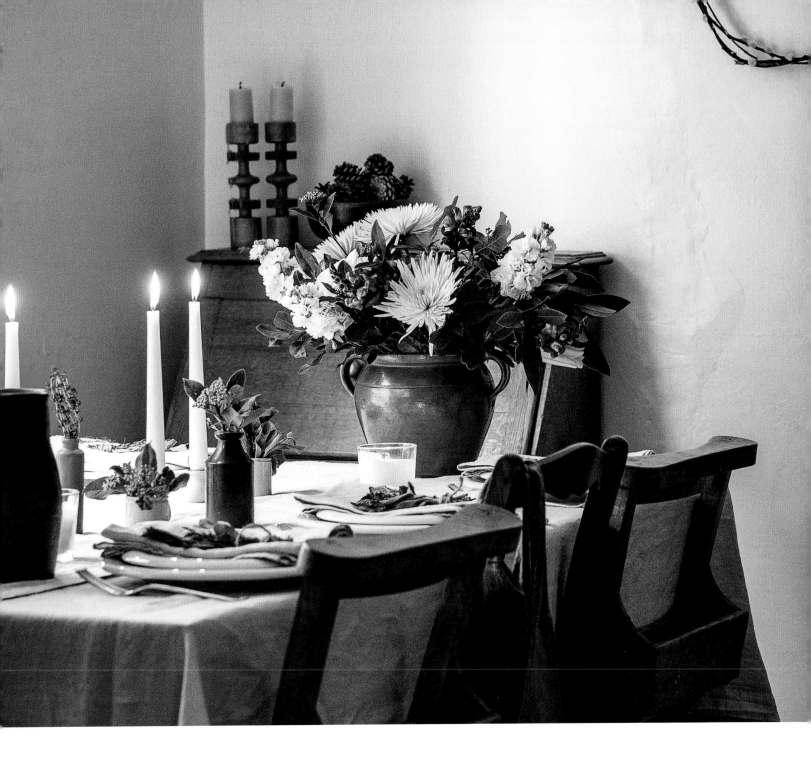

Don't worry about things being perfect
or matching as just a few simple details
can make a table look really inviting.

MELANIE BARNES

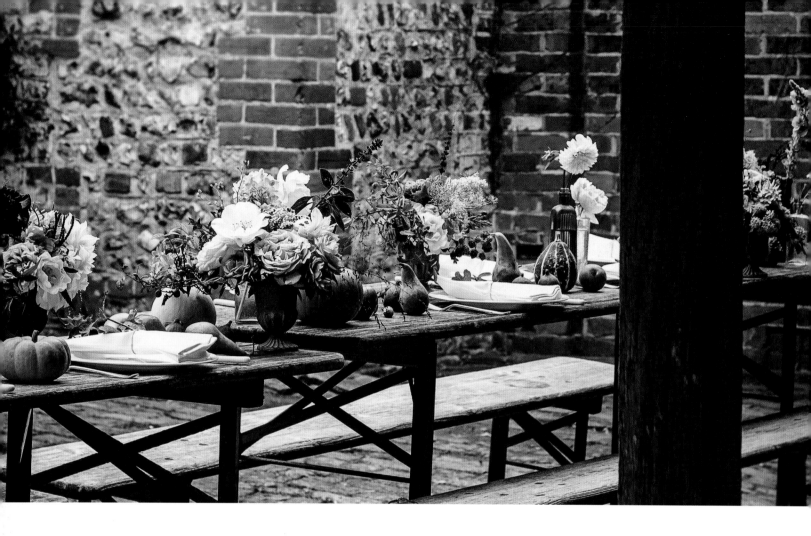

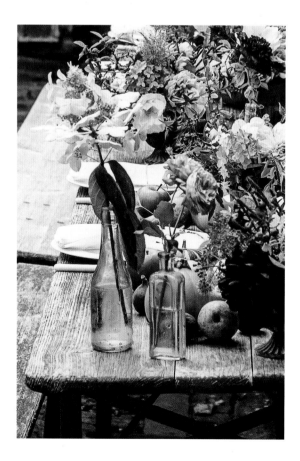

what we have been up to that day, breathe out about any difficult things, and enjoy each other's company.
"Ideally a slow lunch is relaxing and fun, with lots of good conversation and laughter, and the table setting is just one aspect that helps facilitate this. Of course, how the table is dressed can create atmosphere and make the meal special.

> The flower arrangements used in the center of this table were all created by participants of our 'Gather and Tend' day retreat, which I ran with my friend Emma from A Quiet Style.

I always look to the seasons for inspiration when I am setting a table at home. I see what is in our garden or available in the countryside when we're on a walk. Often that becomes the starting point and evokes a specific feeling that I try to carry throughout the table. I will then look throughout the house and gather other items that fit with what I already have. I find that setting the table is such a wonderful opportunity to be creative. →

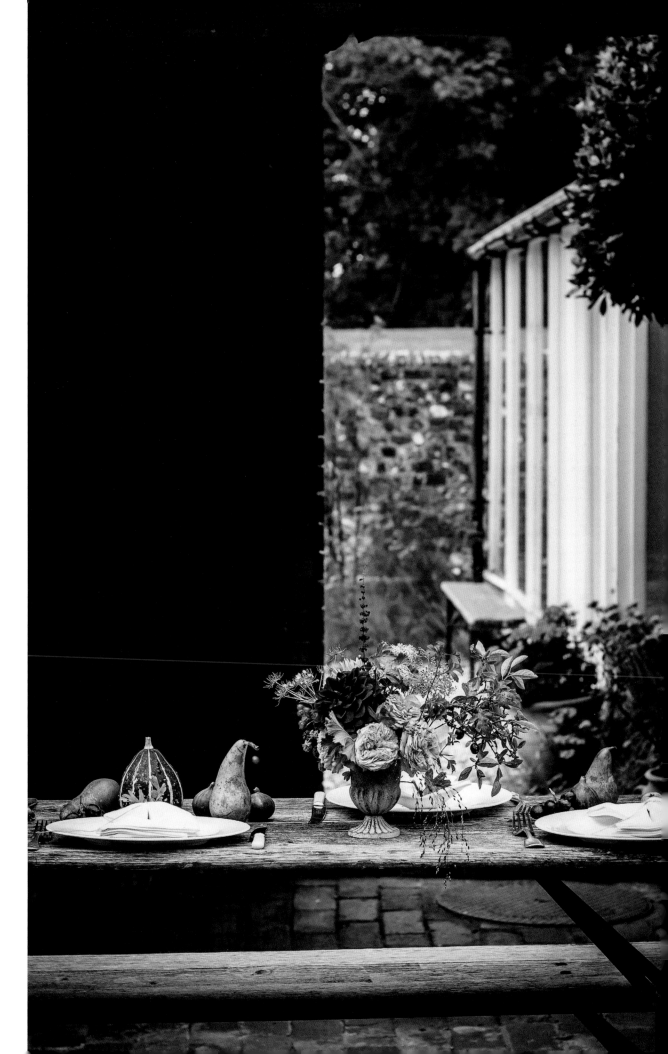

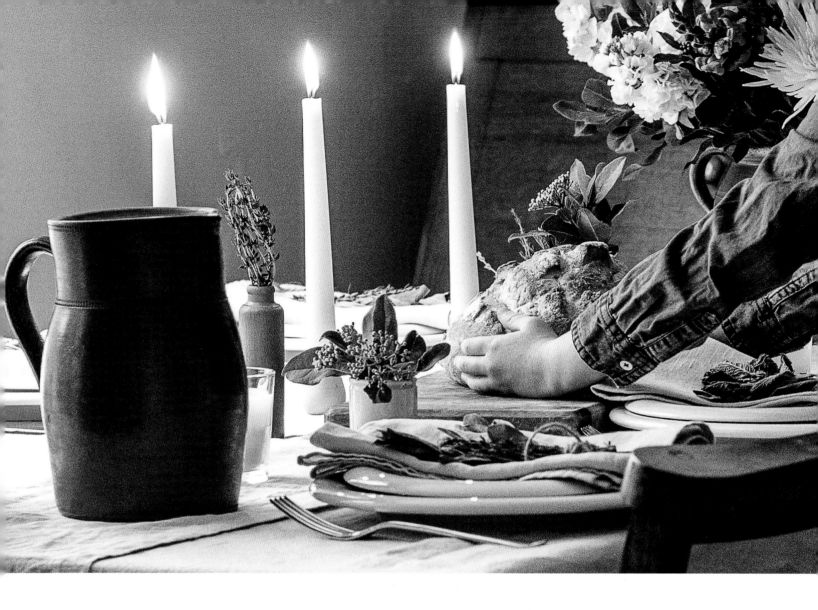

I find that setting the
table is such a wonderful
opportunity to be creative.

MELANIE BARNES

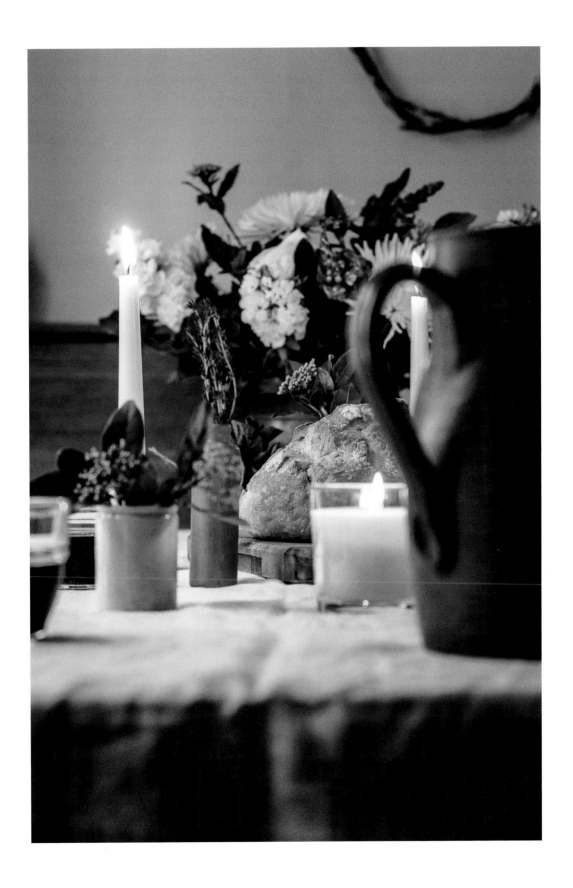

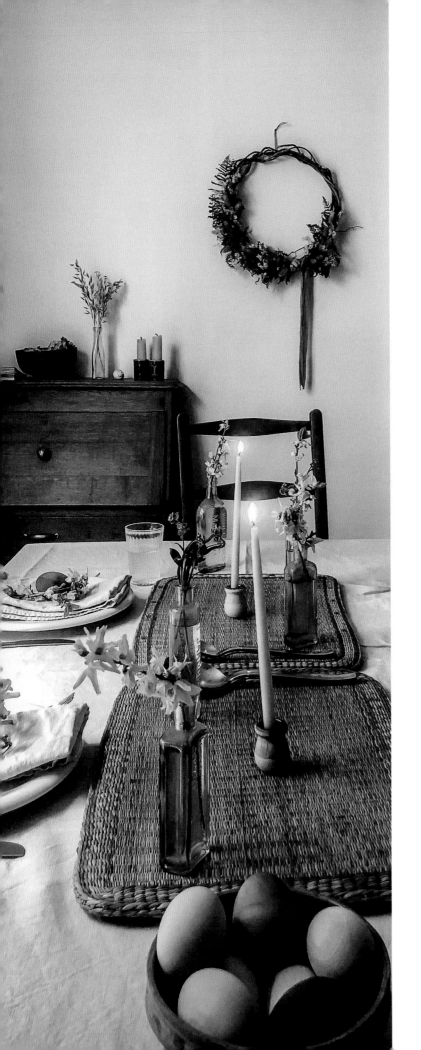

"For special occasions like Easter or Christmas I might take a little more time in making or planning something extra for the table. Last Easter for example my daughter and I had fun making natural dye to dye wooden eggs during the Easter holidays. We then used these to dress the table, with some little yellow wreaths of forsythia." Even for children's parties Melanie possesses the enviable gift to avoid the obvious unicorn of *Frozen* themes. "When my daughter was really little it was easy to plan a party for her; however, as she is getting older I imagine she will want to be more involved in the decision making. For her last birthday I suggested we make paper party hats together, which she got really excited about. We used Liberty-print wrapping paper and added pompoms to the top and then used the hats as a starting point for the rest of the party. This was a great way to involve her in a controlled way. Already having an initial idea and a focus and starting point was an enormous help. Another trick you can easily apply in your own home is to pick one of your favorite vases or pots as a starting point, then gather other things in your home that have a similar style and quality, and create a cohesive mood.
To check whether objects fit together I often put them in a pile on my table. Don't worry about things being perfect or matching as just a few simple details can make a table look really inviting."

HOW TO
TELL *Geoffrey and Grace's* STORY ON YOUR TABLE

As these tables represent a slower way of living, try not to stress too much
whilst designing your tablescape. Try to take pleasure in the process
of selecting all the different components.

Start off with a walk around your garden or in a nearby park. Not only will that create
the right mindset for this ambiance, but you'll also come across key decorative
pieces like autumn leaves, pretty foliage, pinecones, or wild flowers or fruits.

Try to *focus on all things natural*: it will give your tablescape a restful look and feel.

Easter tip: try dying wooden eggs with natural dye and use them on your table
in combination with some little yellow wreaths of forsythia.

Some hopeful news concerning children's parties: yes, you can avoid
a Spiderman or *Frozen* theme. Try to get your children involved in some fun crafting
and they'll soon forget all about Anna and Elsa.

Don't ask your children what they want as their party theme - they're bound to
come up with something you didn't have in mind. Ask them if they'd like to have
fun helping you create a décor.

Craft party projects with your kids could mean making party hats
out of Liberty-print wrapping paper and adding pompoms to the top.

Melanie's tip to check whether your decorations will look good together:
before you begin styling, put the pieces you'd like to use on a pile on your table.
If the pile looks good, so will your table design.

ELBOWS OFF THE TABLE
AN ESSAY ON MILLENNIAL TABLE MANNERS

by AN BOGAERTS

It is one thing to create a stunning table, but quite another to figure out dinner party etiquette. Many argue that today's younger generations, starting with the millennials, don't have a clue about decent table manners. Being one myself - I must be the world's oldest millennial - I am more than happy to defend that generation. Because it's the one setting the creative tone in this book. Millennials may be clueless about the right fork to use for a fish starter, but they do know how to make guests feel welcome. The unwritten message of following the rules of etiquette is the same as it always was: I will do my absolute best to be the most cooperative guest or host possible. Only today that message is being delivered by a host not by drinking tea with your pinky up, but by setting a table that screams 'You are worth putting the effort in.'

covered with a cloth. But that tablecloth served a functional, rather than an aesthetic purpose. Whatever their social status, diners wiped their hands and mouths on the tablecloth. And whilst you might expect Spanish tapas chefs to have invented the whole 'sharing' idea, it was already widespread in the Middle Ages. Guests not only shared the largest bowls of food, but the knives, spoons and cups as well. Back then, the most important rule of dining was the one telling guests in which direction to spit. 'Always behind you, never on the table or on fellow guests.'

> Today's etiquette is not about drinking tea with your pinky up but by setting a table that screams 'You are worth putting the effort in.'

Unsurprisingly, it was a woman who first expressed disgust at all the spitting and double dipping in sauces and soups. Catherine De Medici was born in 1519 into one of the most powerful Italian families in history. Aged 14 she married King Henry II of France, becoming queen consort of France. Depending on who you ask, Catherine de Medici had a significant but slightly different influence on French cuisine and on European table manners. An Italian will say that Catherine exported her good manners to France to re-educate the barbarians at the table. Yet a Frenchman will claim that it was the exquisite French cuisine that inspired Catherine to refine dining etiquette. Although we may never know the truth, countless research papers and historical documents report that, under Catherine's tutelage, tables were elegantly dressed with flowers, table ornaments, and silver forks. Wealthy French families soon embraced the new Italian trend of using forks. Catherine brought delicate crystal glasses, glazed plates, and embroidered tablecloths. She also encouraged napkins as a hygienic alternative to wiping your hands on the tablecloth. Prior to Catherine, women only entered the dining room on special occasions. With her arrival, women became a part of the feast for the first time - dressed in all their finery - to enhance the visual side of the experience.
Hooray for Catherine!

That said, it might be a good idea to freshen up the basic rules of table etiquette. Especially since there have been a few changes since Fra Bonvicino da Riva wrote his 'Fifty Courtesies for the Table' sometime around 1290. It marked the birth of a kind of behavioral code. In human history, etiquette is still a fairly young phenomenon. During the Middle Ages, most dining tables were simply boards set on trestles, hence the expression 'to set the table' - a fun fact to share with your guests whilst sitting at a trestle table, which is once more making a comeback. Back in the day, the table was

In the centuries after Catherine de Medici, strict rules for formal dining were particularly popular in the United Kingdom. The Victorians added a lot of specialty tableware to their dinner parties, as part of the many, and often subtle, social norms that dictated who was part of the group - and who was not. Things like special lettuce and pickle forks, for example, as well as separate plates for every single possible food, specialty glassware, and different spoons for every course. According to Myka Meier - the renowned etiquette coach at New York's Plaza Hotel and founder of the Beaumont Etiquette School - those differences led to three different levels of global etiquette: the American, the Continental, and the British style; American being the least and British the most formal.

> When going
> out for dinner,
> it is important
> to adapt to the
> leading culture
> you are in.

When in doubt as to the formality of the event you are attending, follow the Continental rules for table etiquette, which are considered a happy medium. And this is the style we will address in the following parts of this essay.

In 2012, in *The New York Times*,, journalist Guy Trebay declared that the dinner party was dead. "Plenty of New Yorkers eat on the floor. They do it in their sweat pants whilst juggling an iPad, a remote wand, and the chopsticks that they use to share General Tso's chicken eaten straight from the carton." Hang on a minute, let's not overgeneralize. Some people just don't enjoy a real dinner party, and they have every right not to. As for those trying to do their best to entertain friends and family, I'm serving you a few ground rules laid out by Myka Meier in her book *Modern Etiquette Made Easy*, topped with a sauce of self-relativity and common sense. This is not a bible you should hold in your hand whilst nervously pouring wine into one of the twenty-three glasses on the table. Consider it a gentle guide to the do's and don'ts, and then just do and don't as you please.

> *Every dinner party starts with an invitation.* There was a time, not so very long ago, when you received a formal phone call, or a formal written invitation that arrived by post. Even in this very first guideline the influence of hand-held devices is palpable. Judith Martin, the etiquette arbiter known as Miss Manners, thinks they are disastrous for the social contract. "People don't even respond to dinner invitations anymore," she says. "They consider it too difficult a commitment to say, 'I'll come to dinner a week from Saturday.' Not only do they cancel at the last minute, they do it by text message." Obviously, printing invitations for every dinner with friends is a little over the top, so a quick phone call could be a good alternative to the WhatsApp message. But even when communicating by WhatsApp, etiquette requires you to accept or decline the invitation as soon as possible, and not cancel at short notice.

> *Be clear on dietary requirements and allergies.* A host's worst nightmare is hearing your guest say he or she is lactose intolerant, whilst about to serve an extensive cheese plate. That's why, as a guest, it is your duty to inform the host of any specific dietary requirements a few days prior to the dinner date. This gives your host a chance to create a flexible menu that accommodates your intolerances.

> *Do not arrive empty handed.* There is a difference between a friend inviting you to eat home-delivered sushi on the couch whilst watching the latest season of *Working Moms* and a formal dinner invitation. When invited to a dinner party, show your gratitude by bringing a small gift. Typical choices are flowers or a bottle of wine, but more personal, homey offerings are also perfect. What about bringing flowers from your garden or a jar of homemade jam (or buy jam and tell them you made it yourself - who's to know?), or bake a cake, bring a framed picture of a fond shared memory, or have one of your children make a drawing. Everyone appreciates children's drawings.

> *Leave the napkin.* Whilst dining at a restaurant, it's fine to immediately take the napkin and place it on your lap, but please don't do it when dining at the home of friends or family. Doing so pressurizes the host into serving the food at the table as soon as possible. A napkin on

the lap makes you look hungry, impatient, and greedy. Wait until the first course is served before draping the napkin over your lap.

> Phones should be placed face down close to the left of your fork and set to 'vibrate'. Incoming calls and texts permit you to immediately flip the phone over, gauge the importance of the communication, then glance surreptitiously at your dining companions before either saying, 'Sorry, I have to deal with this' or 'That can wait until I pretend to go to the toilet in about three minutes' time'. *Are you out of your mind?*

No phones at the table, and that is non-negotiable.

When you are expecting an important phone call or have a job that requires access to a landline, inform the party from the start so they don't get the wrong ideas about your phone addiction.

> *Let's get the basics clear*: always hold your fork in the left hand, knife in the right. That easily translates into the table setting: knives to the right, forks to the left. The spoon joins the knife at the right-hand side of the plate.

> The good news: there should only ever be a maximum of eight pieces of silverware per person on the table at once. The exception is the small oyster fork. *The general rule is to start from the outside and work your way in.* But an even better rule is: watch and learn from the host. If anyone at the table knows which cutlery to use, and which utensils to hold onto for the next courses, it is your host.

> *Wait until everyone is served.* However hungry you might be, wait until everybody at the table has been served before digging in. Even better: wait until the host begins to eat. Maybe he or she wants to make a little speech first.

> *After a maximum of four bites, take a break.* Lay the fork and knife on your plate with their tips facing each other. Make some conversation, sip your drink, or just pause. This way, you avoid looking like a gobbler.

> *Ditch the small talk.* Although most of the etiquette guides state that after a few bites you should indicate how good the food tastes, I actually disagree. I have a healthy aversion to small talk. I resent the belief that everybody should tell you how wonderful the soup is when in fact half of your guests think it could use an extra pinch of pepper. Same goes for questions like 'How's work?'. I know one is obliged to say 'Oh, just great', but that isn't in my nature. It's not that I want to gripe. I simply want to answer accurately. So when someone asks me how my work's going, I need an hour or two to explain exactly what is going on and what my future plans are. Mental note to all of my future dinner guests: don't bring up the topic of work. And when you crave pepper, just ask.

> *Avoid controversial topics.* When you are a dinner guest, it is not your place to introduce controversial topics to the conversation. Political convictions can cause friction, especially when guests don't know the ins and outs. It could lead to embarrassing situations for the host. But the dangerous topics go way beyond politics. A few years ago, Martha Stewart published a list of avoidable topics which is pretty accurate. When enjoying a sociable dinner with friends, never talk about your diet, it kills the appetite. Lay low on artistic opinions and never make a suggestion about how to improve the dinner party. Never brag about your job and your salary and avoid topics like religion. Martha Stewart also advises against chatting about celebrities and their lives, but I tend to disagree. Martha just doesn't want us talking about her at the dinner table.

> *Keep the noise down.* Slurping or making other such loud noises whilst eating is completely frowned upon. Yawning, coughing, and chewing food with your mouth open or talking with food in your mouth are also impolite.

> *As far as hands are concerned, etiquette highly depends on your location.* In the UK and US people tend to keep hands under the table, whereas in Continental Europe, as well as in South America, you should always keep your wrists on the table. For elbows there is a much clearer consensus. As in: 'No elbow should ever touch a dining table'.

➤ *If your glass has a stem, use it.* You want to avoid warming the content of your glass with the touch of your hands.

➤ *If you want to use the bathroom, just say 'Please excuse me'.* There's no need to say where you are going and especially not what you are going to do there. And leave your napkin on your chair.

➤ When *leaving the table at the end of the dinner party,* you place the napkin to the left of the plate. Your cutlery is horizontally on the plate, the tips facing the same way. It is a given that you eat what is on your plate. Leaving a large portion of your meal will require a convincing explanation. And as we have said before: there will be no mention of a diet.

➤ *Do not ask whether there will be dessert.* If you are the host, it might be a good idea to tell guests if you'll be serving dessert when they sit down to the main course. Some guests will like to save a little room for a sweet treat.

➤ *Do the dishes, but then don't.* 'Can I help?' It is an obligatory question at the end of a dinner party. As the host, you turn that help down (except maybe when it is your mother asking). Letting your guests do their own dishes can be a big turn-off. *As a guest, don't start clearing the table before the host does.* On a personal note: this is one of my biggest frustrations when I have my family over for dinner. I will have just poured the coffee and my mother and in-laws will start clearing the table and clearing the dishes. Which makes me feel guilty, so I start clearing as well. Whilst I just want to scream: 'Just enjoy some peace and quiet with your coffee, I'll clear up later!'

➤ *Take a hint.* When the dinner host mentions he or she has to get up early the next morning, it is time to go home. When the host initiates some ostentatious clearing: same thing. You leave. A succesful dinner party is defined by guests knowing when it's time to go home.

➤ *Thank you.* Classic etiquette textbooks will advise you to send a written thank-you note after a formal dinner party. That obviously depends on the scale of the event. After a casual dinner with friends, a simple text message will do. From both sides, that is. As a host, you thank the guests for a wonderful evening. As a guest, you do the same thing. If you attended a wedding, a written thank-you note is not considered to be over the top. Again: this goes for both sides, host and guests. And then we are at the honesty part again, one of my favorite topics – as you've figured out by now. My advice would be: if you didn't enjoy the dinner party, don't send a thank-you note. Maybe the host will get the message and stop inviting you. *Life is too short for bad dinner parties.*

124

LITERARY SOURCES

National Geographic
'Modern Etiquette Made Easy'
by Myka Meier
The Independent
Walking Palates
The New York Times
Martha Stewart

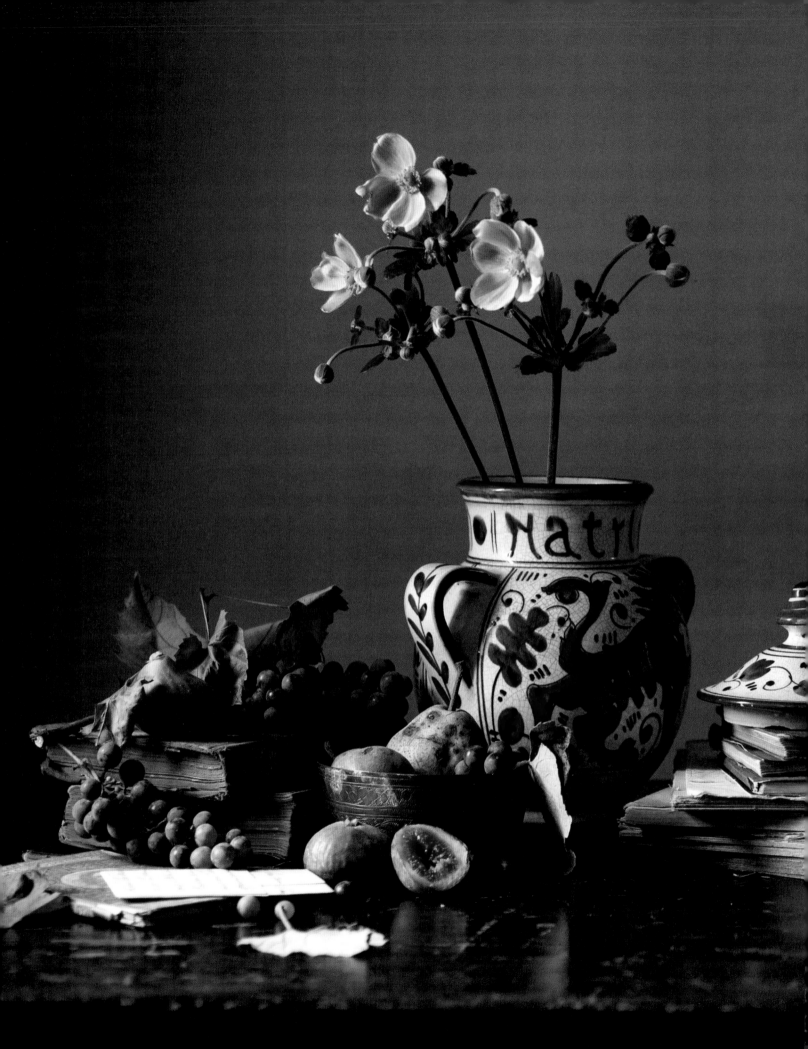

FALL

Find yourself a forest and just wander around. Here you'll find all the decoration you need for a successful fall table. From pinecones to mushrooms, branches, colored leaves, and pumpkins. Or actually no, pumpkins don't tend to grow in forests very often. Anyway, there's an inspirational overload of possible fall decoration. *The main challenge during fall season is to distinguish your table from everyone else's.* Because everybody knows how to scatter pinecones over a brown tablecloth. And that's where this book comes in handy. Steal some ideas you'd never come up with yourself. Add some copper accents, use unexpected colors, and why not paint those pumpkins in a bright white? With Thanksgiving and Halloween on the calendar during this season, it's the perfect moment for some out-of-the-box experimenting.

Image. THE FREAKY TABLE – *p. 160*

Natural Harmony

with OUR FOOD STORIES

Laura Muthesius
Nora Eisermann
Germany
@_FOODSTORIES_

Good things can come from food allergies. Such as a successful blog. It was whilst Laura was struggling to find delicious vegetarian, gluten-free cake recipes that the idea for Our Food Stories was born. Their professional backgrounds – Laura Muthesius's as a photographer and Nora Eisermann's as a fashion designer – proved ideal when it came to creating stunning décors. "We're interested in food and creating recipes, but we've always been passionate about design and interiors, too," say Laura and Nora. "We are convinced that food and design are connected. To create a stylish dinner table, choose dishware that appeals to you, or an unusual tablecloth. When you combine all these elements, you create a stunning, harmonious whole.

"We really like this natural style that is not too overdone. For us it's important that it's not perfect, so you keep a sense of playfulness. Everyone should feel welcome and relaxed at the table. We love to style using ingredients that are part of the food being served. In autumn, for example, pumpkins add a lovely seasonal touch, and during the summer, why not dress your table with seasonal fruits or plants or flowers from the garden? We aim to use natural elements to create a harmonious mood." And according to Laura and Nora there are two important tools necessary to create such a natural and welcoming table. "Beautiful ceramics and some fresh flowers make any table look inviting."

> There is definitely a big trend for flower clouds at the moment,

note the two creatives. "We photographed our first one three years ago with Ruby from Mary Lennox. Mary Lennox is a renowned Berlin-based flower studio founded by Ruby Barber. Nora and Laura have done some amazing settings in collaboration with the florists at Mary Lennox. "Last year we had the honor of working together in Paris to style the tables for a dinner given by Hermès. What an amazing experience!

"We'd describe our style as natural, earthy, and rustic. We are spontaneous and open when it comes to new ideas. We love to photograph table settings in different locations and places where you wouldn't expect a table.

→

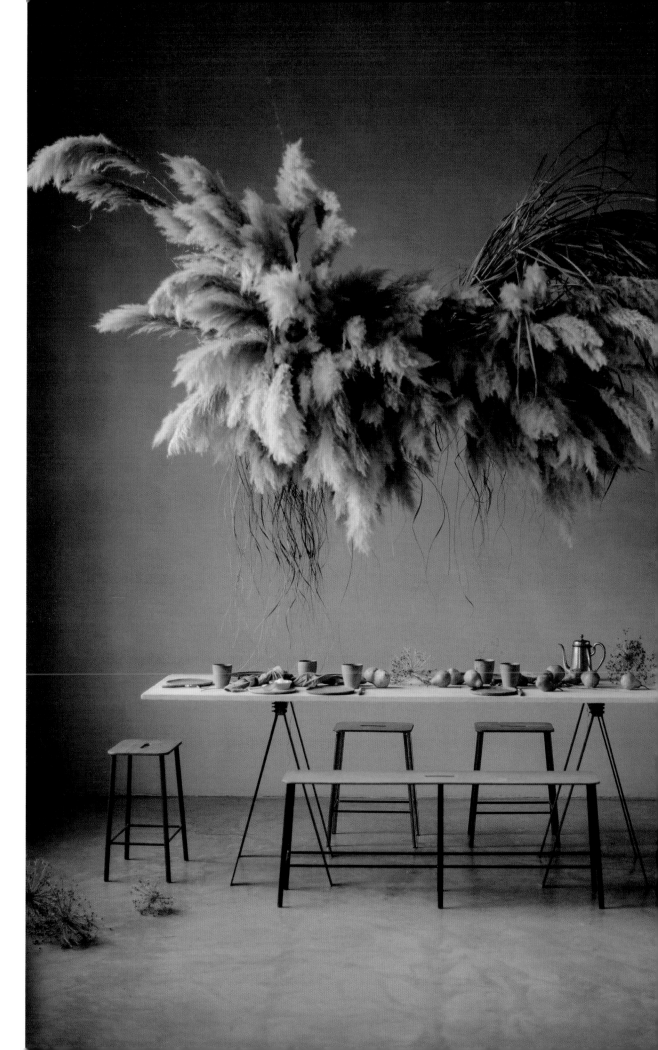

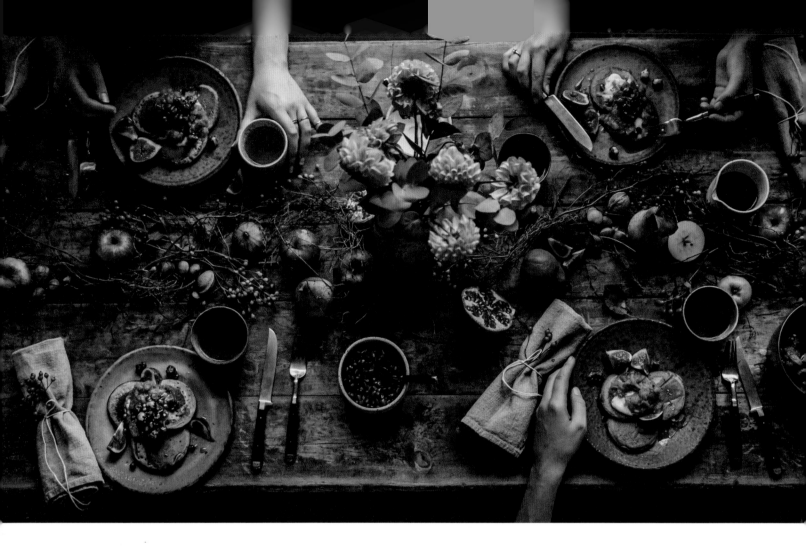

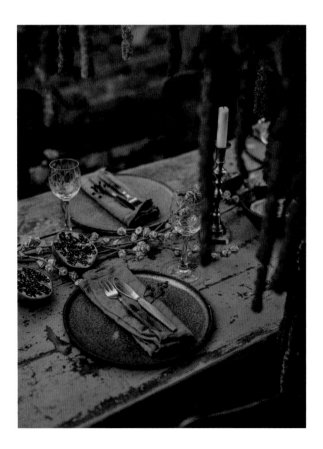

For us it's important
that it's not too perfect,
so you keep a sense of
playfulness.

LAURA AND NORA

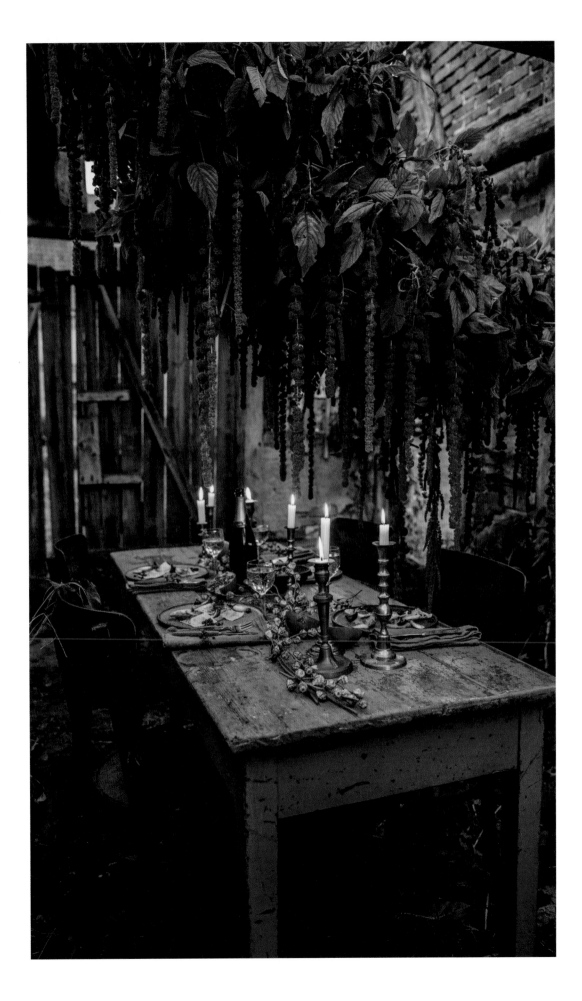

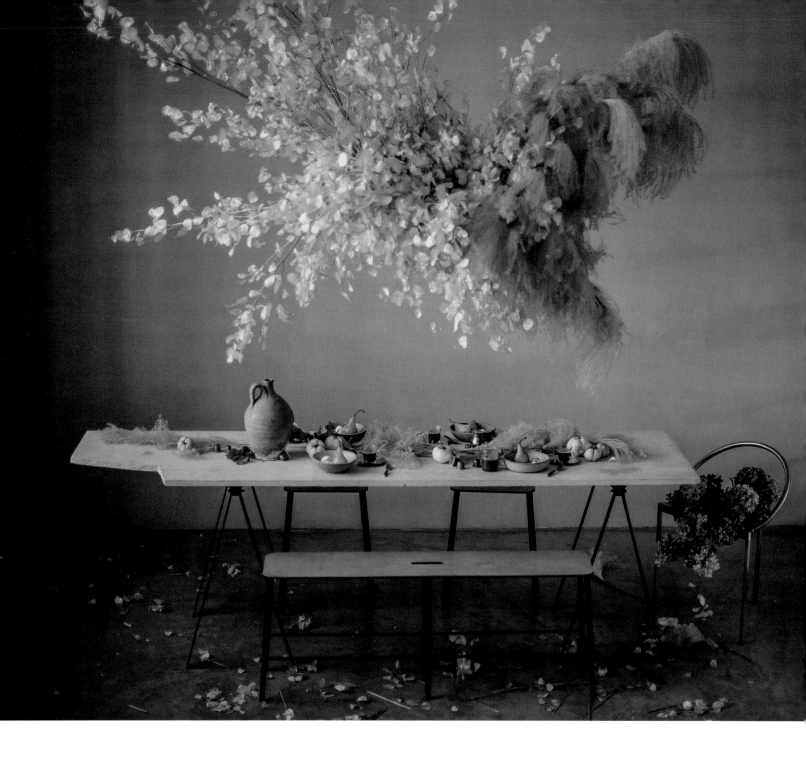

like in a field of poppies, in the ocean, in the woods, or
in a greenhouse." Both women divide their time between
locations in Berlin and the countryside. "We actually spend
much more time in the countryside than in Berlin. In fact,
we're moving our studio to the countryside this year," the
two announce. Being surrounded by nature triggers their
creative process. "We are very inspired by the seasons - the
colors, the textures, the light - there are so many wonderful
and different possibilities each season. But sometimes it's
good to be in the city and be inspired by beautiful design
shops, bookstores, or local markets. We also get a lot of
inspiration from traveling. It's always good to change your
perspective and dive into different universes."

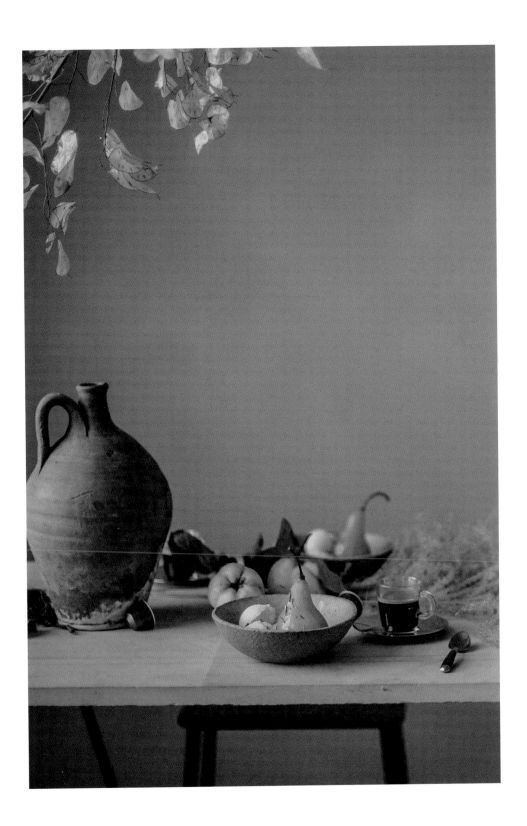

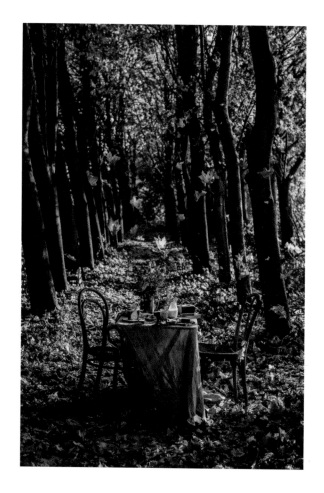

It's always good to change
your perspective and dive
into different universes."

LAURA AND NORA

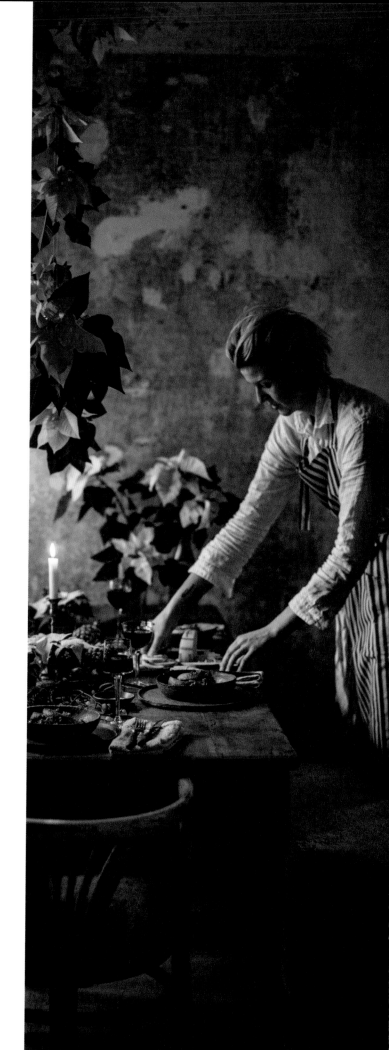

HOW TO
TELL *Our Food Stories'* STORY ON YOUR TABLE

Consider using ingredients as part of the decoration.
Maybe a pumpkin or some seasonal fruits.

Flower clouds are trending at the moment.

Making your own flower cloud is not that difficult. Find some chicken wire and crumple it into a ball. Try to make a small one first, since these flower clouds are quite a lot of work. Then attach the wire ball to the ceiling with fishing line. Make sure the wire ball is attached firmly, then begin inserting flowers into the chicken wire. Baby's breath is easy to use for flower clouds, but you might like to use dried flowers as they last longer.

Your flower cloud shouldn't look too perfectly round.
Complete the design by tucking in some asymmetrical or longer pieces.
And make sure none of the chicken wire is showing.

When you are designing a mood board or a color palette,
make sure the flower cloud matches your selected colors,
and the mood you're trying to create.

And remember, try to keep your table décor fun and playful
- in other words, *don't make it look too perfect or too designed.*

Amazing Graze

with TIFFANY KEAL CREATIVE STUDIO

Tiffany Keal
Australia
@TIFFANYKEAL_CS

Make a Style Statement. Tiffany Keal, from Tiffany Keal Creative Studio sets the bar extremely high: to create personal or professional events that spontaneously wow her guests. A big part of this is achieved by creating a style statement. "Rather than spreading the visual elements throughout your home, choose the area you'd like guests to spend the most time in and use that as a decorative focus. If you're setting the dining table, make this your hero statement. This can be as simple as a consistent color palette that flows throughout the setting and ties everything together beautifully."

A great way to create a style statement at your dinner party or celebration is to opt for a grazing table. "The grazing table will often become the beautiful feature within the space - the talking point that is remembered. A grazing can lend itself to cater to many different styles and settings, as they are not limited to the center of the table. Grazings can also be styled as a series of alluring individual platters positioned over a sequence of high top tables. It's an elegant way to enhance the visual esthetics, as well as a playful way to cater for guests. Adding an exciting grazingscape invites guests to gather and pore over the delicious offerings and the tempting array of produce. A grazing table is often used as the starter for an event and offers guests a fun way to meet and mingle. Guests often love the theater of a grazing table - having this visual feast before their eyes can be exciting, and they will often try something that they may have never bought themselves." As elaborate and breathtaking tablescapes may look, Tiffany senses a significant trend for the minimal approach to table styling. "For us, it's about creating a visual experience through the play of color, tone, texture, height, and shape.

> Creating the visual experience should never outweigh the importance of functionality.

By focusing on a minimal approach, we're able to layer those elements - color, tone, texture, heigh, and shape - in a way that enhances the beauty of the setting whilst maintaining the required function. You can achieve this by picking a simple color palette and playing on tones rather than mixing a profusion of colors - minimal, yet functional, and creating depth and layering."

→

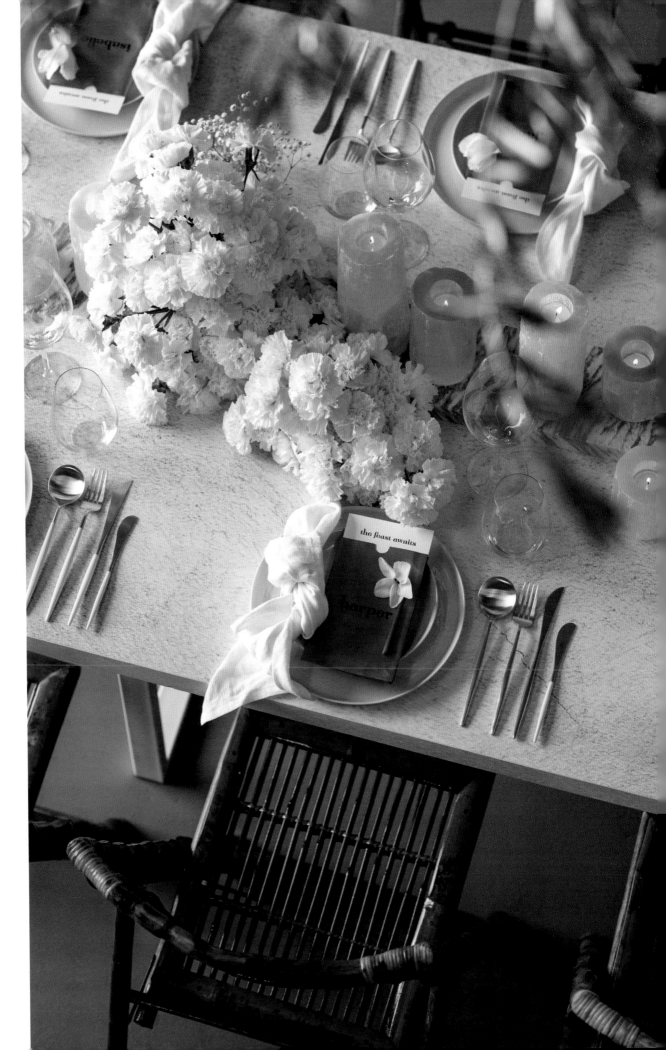

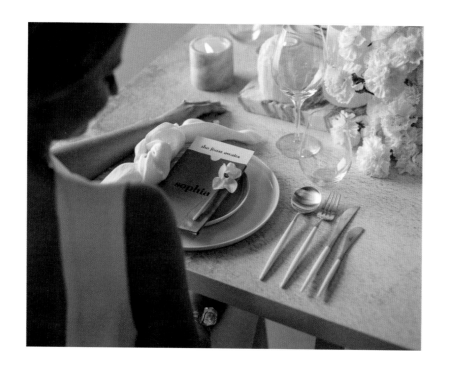

Rather than spreading the visual statements throughout your home, choose the area you'd like guests to spend the most time in and use that as a decorative focus.

TIFFANY KEAL

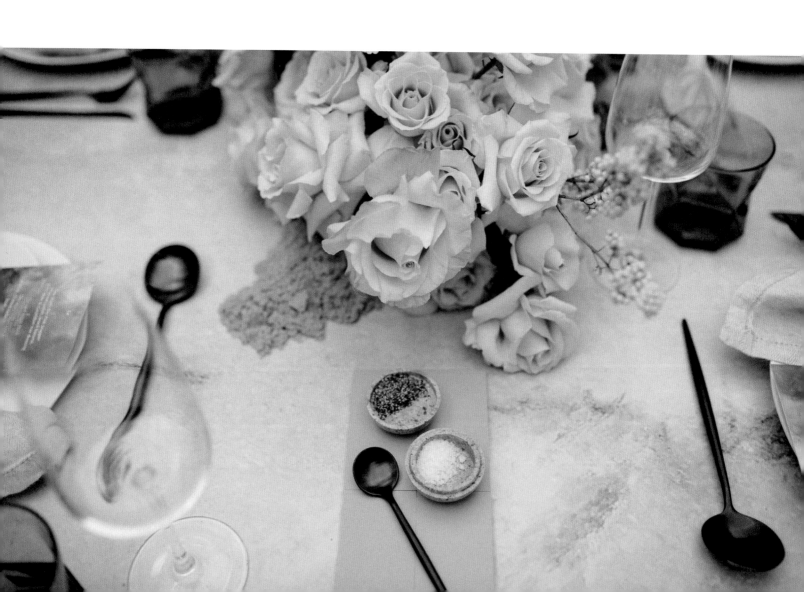

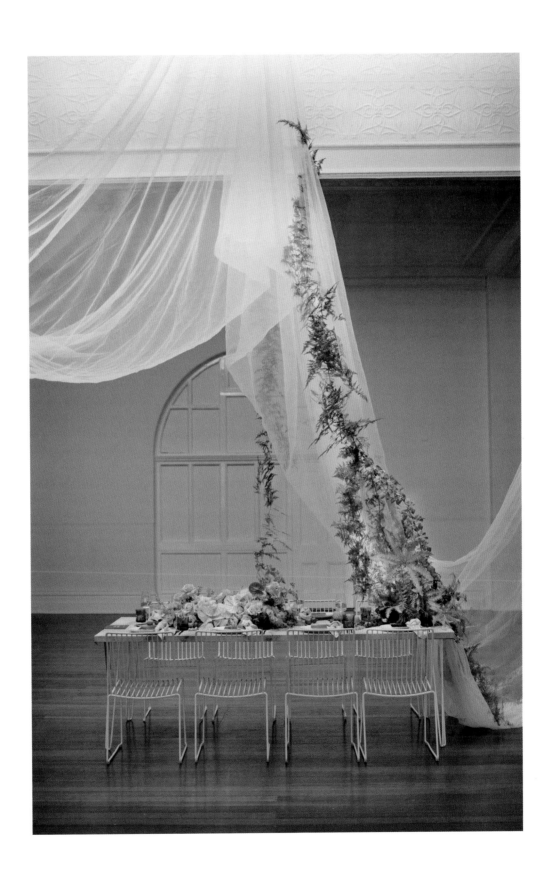

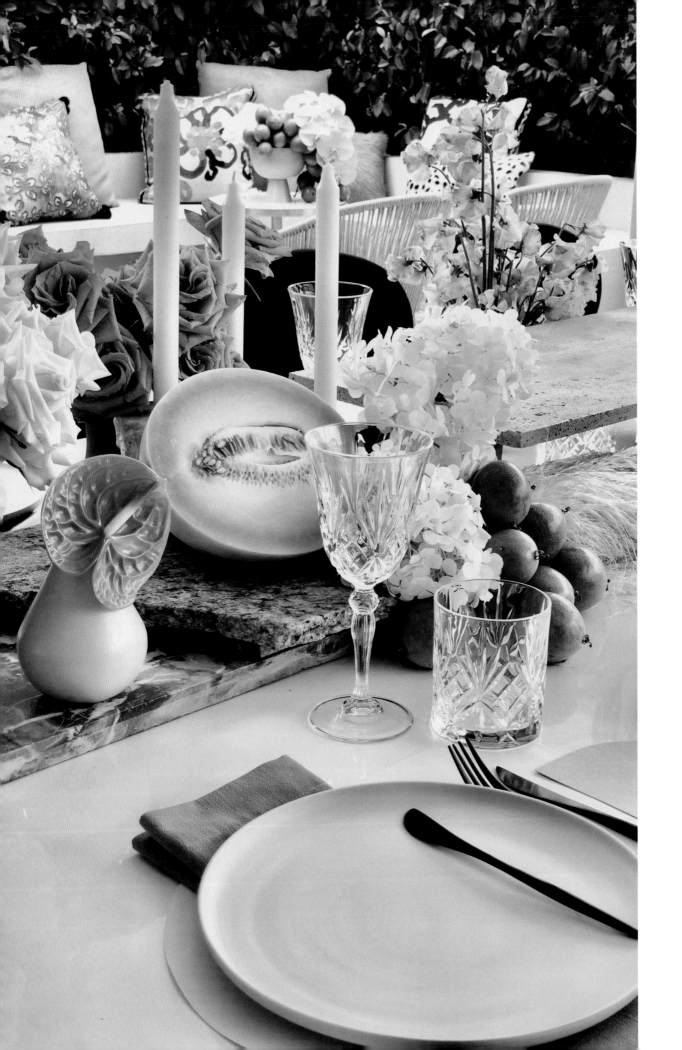

"Growing up, I always had a creative outlook on life and my surroundings, which gave me the grounding I needed to enter the styling world. I studied set and costume design, followed by visual merchandising. This trained me to put my passion into practice, and taught me creative storytelling," says Tiffany. Over the years she's definitely seen a flurry of interest in stylish table dressing. "From dressing a side table to large-scale dining tables adorned with styling or grazing, we've seen more people wanting to create a visual scape that not only creates a social setting for family and friends ...

Through aesthetics and curated details, table settings also create memorable experiences.

We love to encourage the idea of creating a tablescape that is 'one of a kind' - that takes your favorite everyday piece and turns it into a visual feast to reflect the look, style, and tone of the event.

When I entertain friends and family, my approach remains very considered, as it does within our studio. I will often pick out a specific styling collection to suit the occasion but take a much more organic approach. I love to use pieces I already have in our home, and creatively play off their shape. For example, a ceramic dish could be turned upside down and transformed into a beautiful food riser. My children Winston and Clementine also love helping to style the table. Whether by foraging for florals and greenery in the garden or by selecting the feature for the table center, I gain a unique look for every home setting we create - however the food always remains the hero. My husband is a chef, so we love to plan the menu and his incredible dishes become the visual feature along the length of the table for all to share."

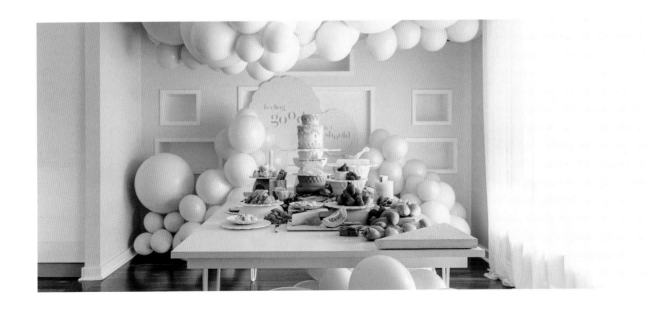

A ceramic dish could
be turned upside down
and transformed into a
beautiful food riser.

TIFFANY KEAL

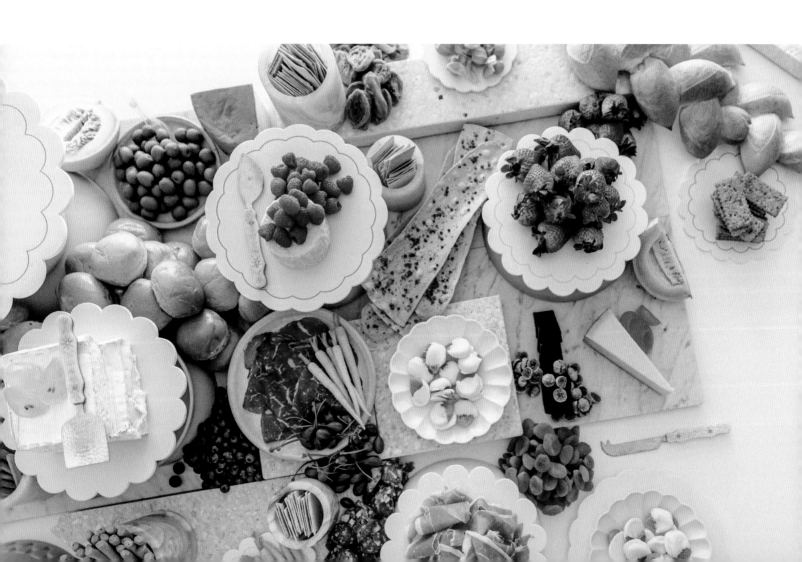

HOW TO
TELL *Tiffany Keal Creative Studio's* STORY ON YOUR TABLE

Instead of trying to pimp a whole room, *try creating a few focal points,*
a few style statements.

A great way to create a style statement at your dinner party or celebration
is to *opt for a grazing table*.

Grazings can also be styled as a series of gorgeous individual platters
ranged over a sequence of high top tables.

Pick a simple color palette and play with tones
rather than mixing a profusion of colors.

A ceramic dish could be turned upside down
and transformed into a beautiful food riser.

Getting your children to help style the table might be unorthodox,
but it's a way to educate the next generation in the importance of a beautiful décor.
And if it sucks, you can always blame them.

The Nordic Feel

with SIGNE BAY

Denmark
@SIGNEBAY

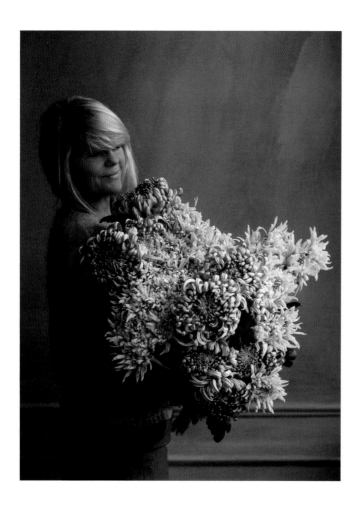

"Using my imagination and telling a story. That's what makes me tick, what's in my blood, and I totally love it." But for Signe Bay, being a professional art director and photographer was kind of a late calling. "Until four to five years ago I worked fulltime teaching undergraduates, but through my 'window' on Instagram started getting more and more photography and styling assignments, so I quit my teaching job and turned my passion into my work, which I'm so grateful for. Now all my time is spent on styling and photography assignments, both commercial and editorial, for lots of different brands and clients.

"Teaching was something I loved but it was so stressful – far too many inefficient meetings and lots of unnecessary paper work. And that's stressful if you want to deliver quality teaching. But I've always been creative and visually oriented. Whether it was setting up a musical with my students or styling a universe for a client, as I do now, it's one and the same. And I'm a free soul, so being my own boss and deciding what I do and when suits me down to the ground."

> I have all these ideas and thoughts and pictures in my head, so being able to make them come alive once in a while is amazingly rewarding.

At Signe Bay's home in Copenhagen there's no need for a special occasion to flaunt the fabulous collection of handmade ceramics, spread a tablecloth, and add some fresh flowers to the décor. "I think that all the time we spend on our phones and social media has given us a greater appreciation of, and need for, spending time with friends and family. After years of being in thrall to the modern, digital world, we can't wait to rediscover our roots and enjoy the slow life – being together, enjoying leisurely meals, at a gorgeously set table. To me, the key to creating a fantastically curated table is adding a personal touch. It's all about combining the right elements and adding natural features. And when it comes to color, I love tone-on-tone palettes – walls, tablecloth, chairs, napkins, almost everything in the same hues. At the moment I'm obsessed with beige and sand tones. Using a tone-on-tone color scheme is an amazing way to let the decoration and the food pop.

→

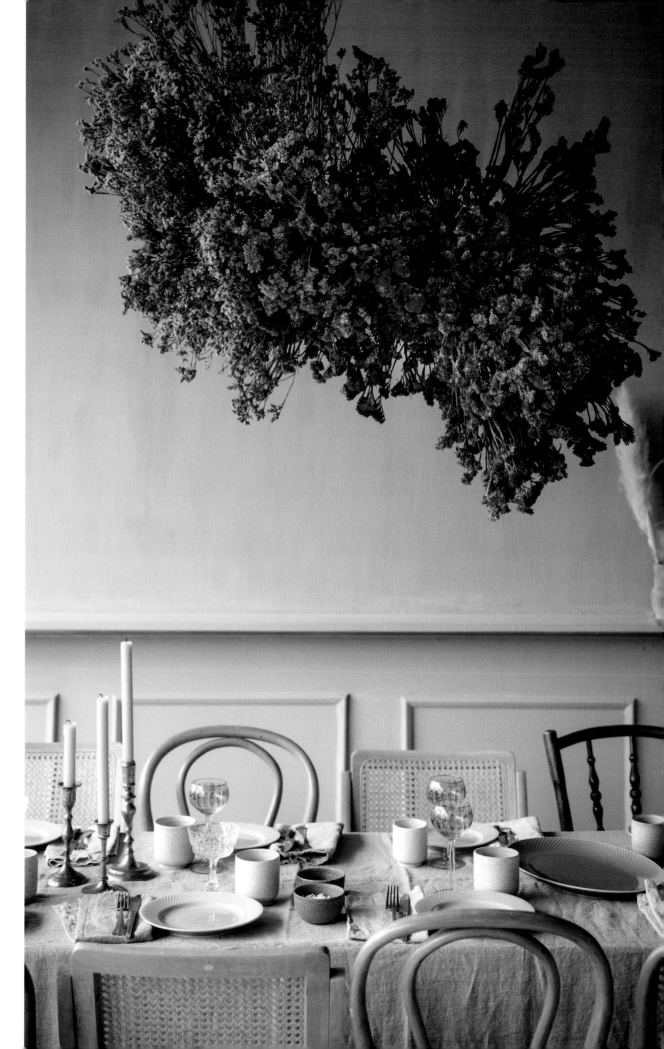

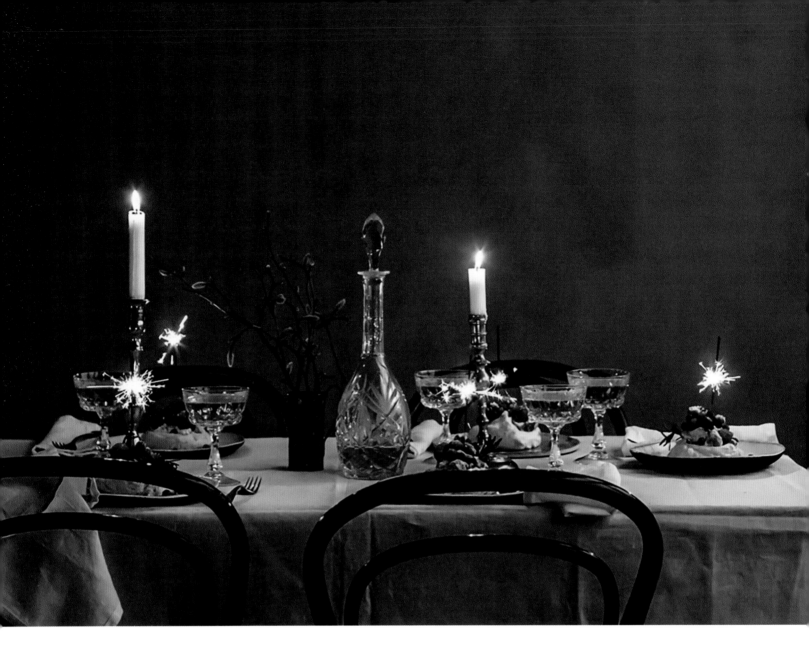

After years of being in thrall to the modern, digital world, we can't wait to rediscover our roots and enjoy the slow life - being together, enjoying leisurely meals, at a gorgeously set table.

SIGNE BAY

For decoration, my tip is to use small natural elements - incredibly simple, and incredibly effective. To add texture I always recommend using linen tablecloths and napkins and matte ceramic plates. For a seasonal touch, gather wild blooms or flowers from your garden, arrange them randomly in a vase, and your table will look fantastic. And in winter, why not use artichokes, nuts, and chestnuts to decorate your table? They create a cozy, relaxed, yet elegant vibe."
Photographing a beautifully set table is often a challenge. Many photographers struggle to capture the right atmosphere. "To be honest, I find them quite easy to photograph. I guess it's because I'm so fond of table settings! I love the 'flat lay' situation where you can clearly see what's on the table. And especially when people are eating, I love to direct and photograph how they interact with each other and with the food. But it's true that if you photograph a table from the end, the viewer has a better impression of the overall atmosphere."

→

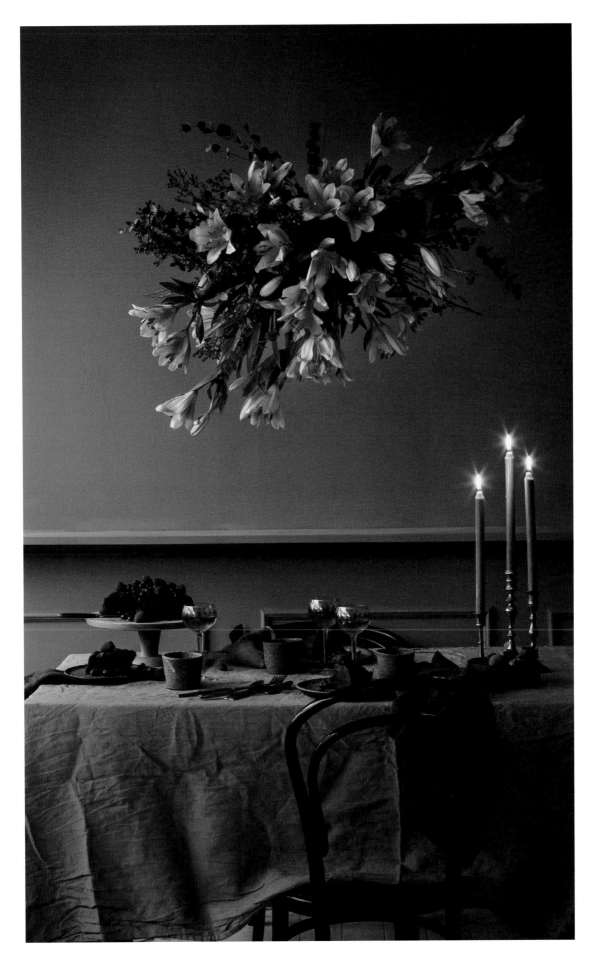

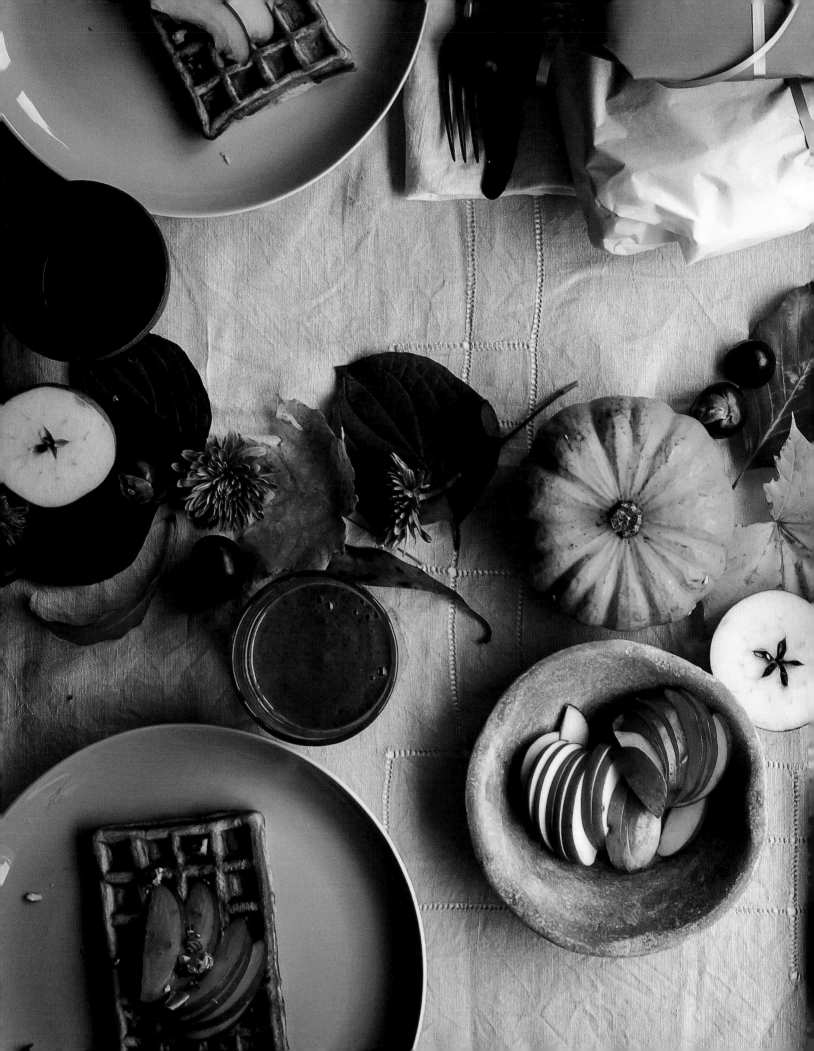

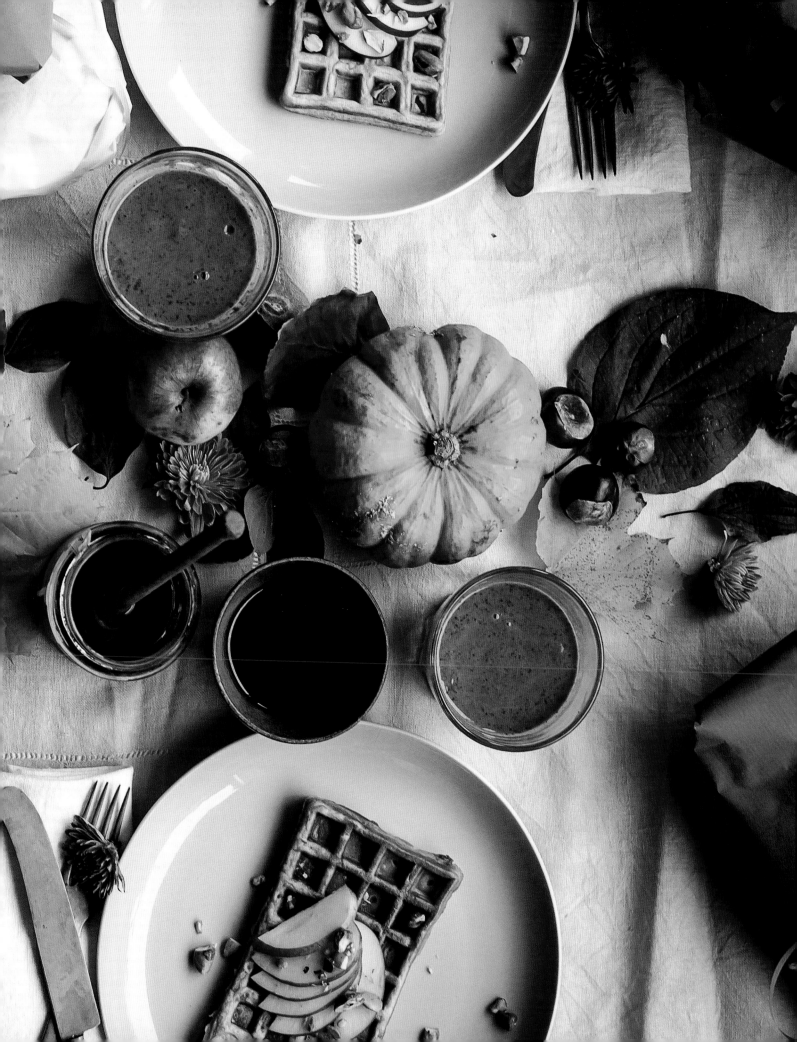

When you ask Signe to describe her personal style, she instantly says 'Nordic feel.' "I find inspiration everywhere, but mostly in nature and in the light that's unique to Denmark, a kind of melancholic light.

> I'm very inspired by natural light and the different moods you can create by working with light and shadow.

These moods create a real Nordic feel." Living surrounded by nature, Signe naturally follows the flow of the seasons. "The mood and colors in my work reflect the changing seasons." But more than anything, a table setting reflects your personality. "It's all about your choice of materials, colors, and of course the decorations, the way the flowers are arranged. All this tells a story - all these ingredients offer a sneak peek of your life. So I guess my table settings hint at my own story and my Scandinavian aesthetics."

HOW TO
TELL *Signe Bay's* STORY ON YOUR TABLE

Consider your table as your business card.
What part of yourself do you want to express to your guests?
What will it tell them?

Even the most casual gathering can benefit
from a tablecloth and some fresh flowers.

A tone-on-tone color scheme lets the decoration and the food pop.

To create a tone-on-tone color scheme try to use tablecloths, ceramics, and chairs
in the same color. You'll get extra bonus points if your wall is the same color!
A tone-on-tone palette works really well if you're serving colorful food.

Always follow the seasons. Seasonal eating is a huge trend.
Try to do the same with your decorative elements.

Not sure which blooms or greenery are in season right now? No problem.
Visit your nearest park or woodland and gather whatever you can find. You can't
go wrong! (But first check whether wild foraging is allowed in the places you visit).

In winter, when flowers are hard to come by, try using
other seasonal decorations like artichokes, nuts, and chestnuts.

Lighting is important - *make sure your table is beautifully lit.*
But avoid anything too bright or artificial.

Ensure your table's ready before your guests arrive. Then you can enjoy a drink with
them whilst putting the finishing touches to the meal.

That Family Feeling

with SOFIE NOYEN

Belgium
@SOFIENOYEN

Anyone who has a sense of style can express that in a beautifully dressed table. And style is something that Sofie Noyen has in abundance. "Even though my job mainly consists of food styling, interior styling is another of my passions. Table dressing brings the two together. And cooking is another love of mine. I was fascinated by food even as a child. I love the ritual of dining, the conviviality, and all the ways you can be creative with food. I might not have a chef's diploma but I'm a fervent hobby cook.
To begin with, I always look for the hero piece of my table. A theme, a color, an object, or an antique candlestick that I bought at the flea market. From there, I start my quest for the right companions and sift through items until I hit on a combination that flows together. At home, I often use our dark-wood table as the basis for my table setting. And I love adding flowers and candles - they always bring such life to a dinner setting.
"The tables I create for publicity clients and magazines are often commercially influenced. My own style is simpler, quite classical. An extension of my interior. Tranquil, with many natural materials and colors.

> I also love the combination of raw, earthy materials and simple fragile textures, or soft shades and structures.

Sustainability is a must, I don't use disposables and have a weak spot for antique objects. I think it is vital to begin with quality basics.
"I love using nice simple tablecloths in neutral colors and matching cloth napkins. Next, I browse my glassware collection - I sourced most of the glasses from flea markets. At family dinners during the week, I always set the table and, although I don't use a tablecloth, I dress it to look inviting. For instance, I always have a candle on the table. I love simplicity, it suits me down to the ground. Thanks to my job I have gathered a good selection of beautiful crockery, so every table looks stylish, and little else is needed.
"Depending on my guests and the occasion I like to have a little etiquette at the table. My parents were born in the 1930s and I arrived as an afterthought. But our family parties and other festive occasions were always based around a certain etiquette. My mother's set tables were impeccable.

→

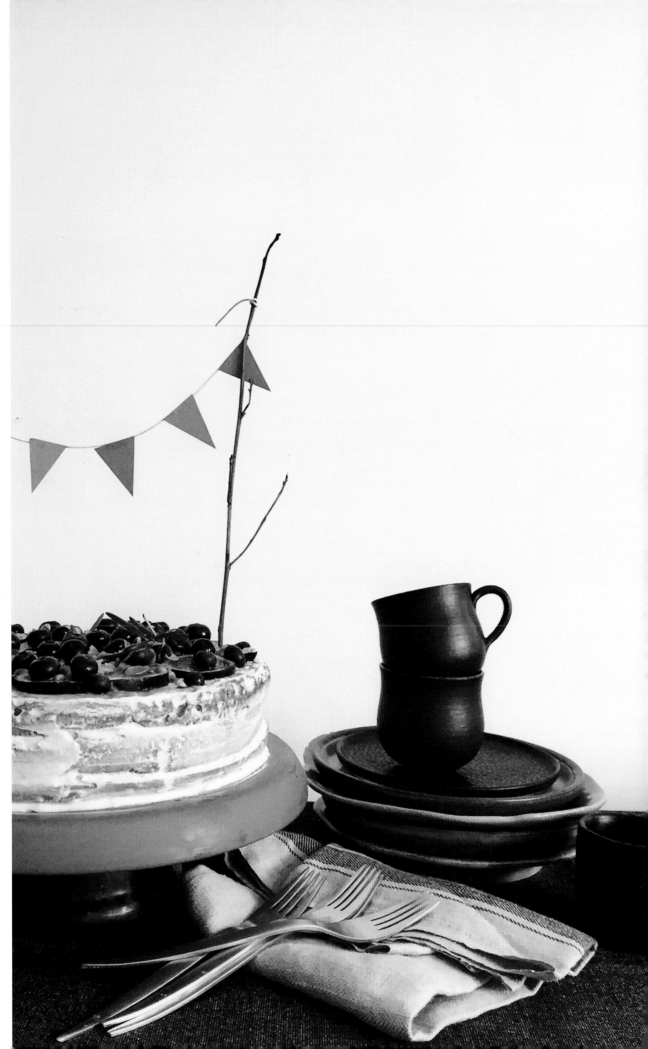

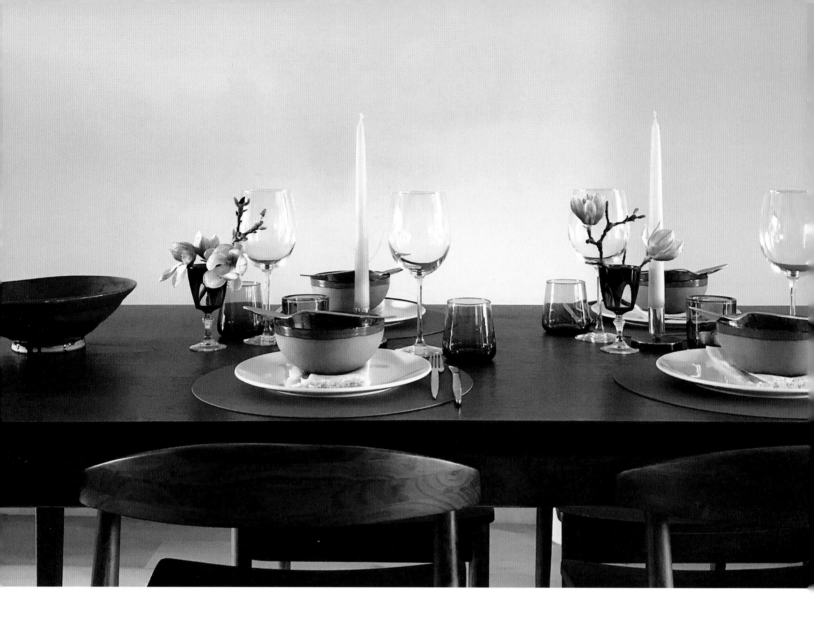

At family dinners during the week, I always set the table, and although I don't use a tablecloth, I dress it to look inviting.

SOFIE NOYEN

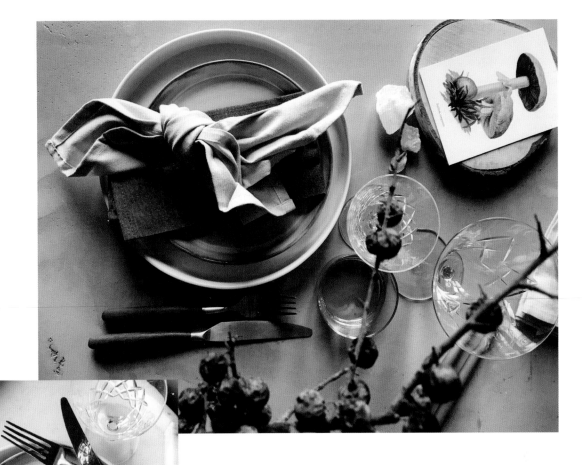

Above all, I want my guests to feel at ease and rules are certainly not always an issue. With a beautifully set table you give your guests a sense of appreciation."
Sofie started her career as an interior stylist for an interior designer, until a good friend introduced her as an art director and set dresser for TV commercials. Before long, that all evolved into food styling. "I still like to stay in touch with what's going on in the interior world and I like to try out new styles, although you can never go wrong with a simple classic table. Sometimes I like to push the limits a little. At Christmas, for instance, it's fun to exaggerate a bit and the Christmas table might even be a little kitschy. Maybe it's the traditions I brought back from my childhood that get the upper hand. But I like that. Because that's what dining is all about: sharing time together and enjoying yourself."
As a mother of three, Sofie dresses a lot of children's party tables as well. "I like to surprise them with an original theme that fascinates them at that age or time.

> The children are more often
> concerned with the cake and food
> than the table dressing.

My eldest daughter of twelve definitely knows what she wants. She is especially interested in interior design and loves dressing her room. And best of all, she loves coming shopping with me!"

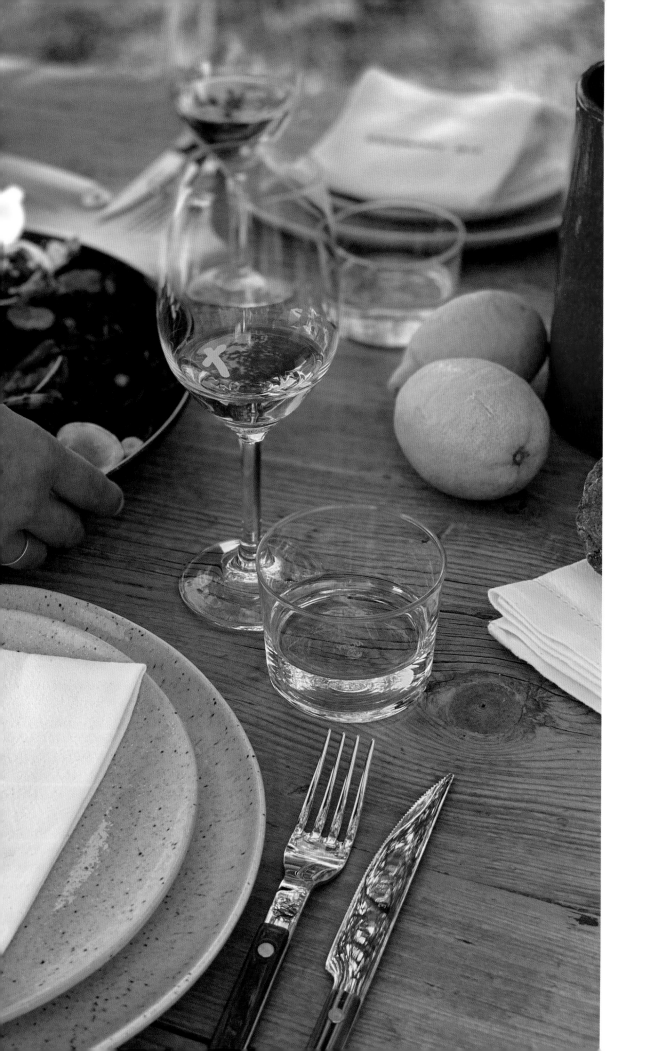

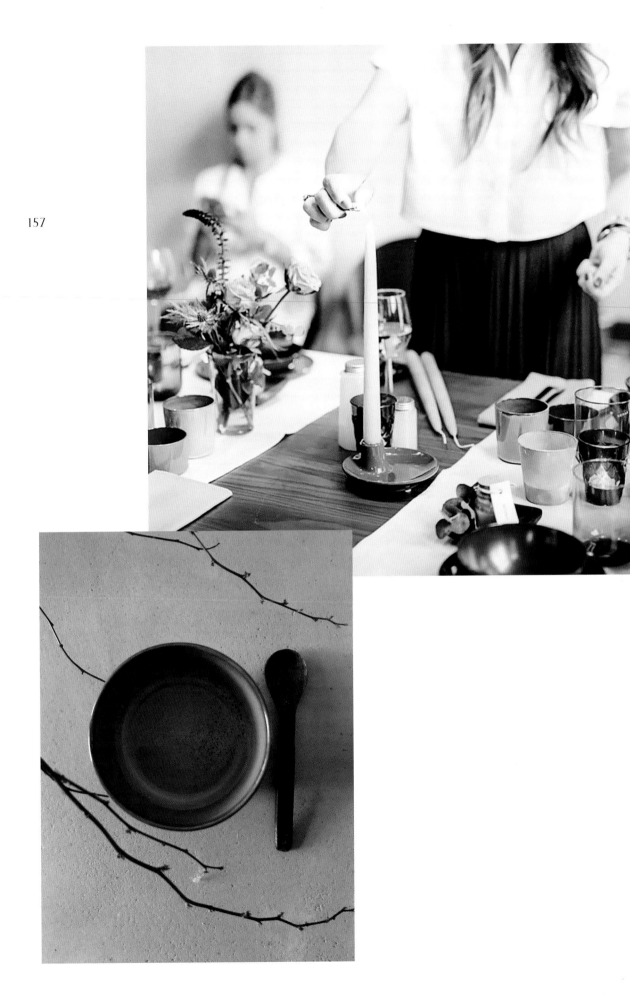

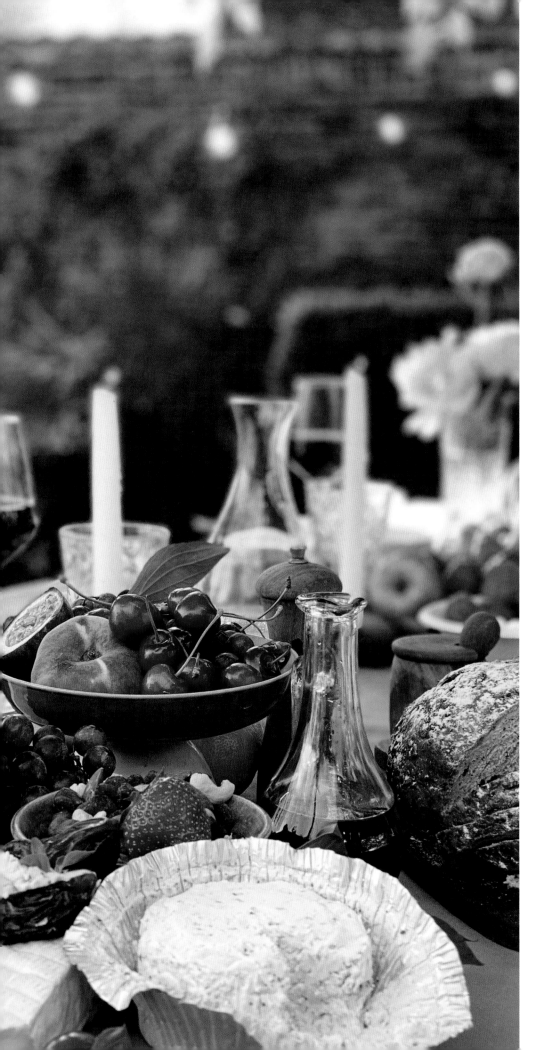

With a beautifully set table
you give your guests a sense
of appreciation."

SOFIE NOYEN

HOW TO
TELL *Sofie Noyen's* STORY ON YOUR TABLE

You don't need a party or celebration to create a beautiful tablescape. *Everyday family dinners can become even more special by dressing the table* in an inviting way. For instance, Sofie always puts a candle on her table.

Whatever the occasion, you can never go wrong with a simple, classic table.

Find the 'hero piece' of your table. It could be a theme, a color, an object, or even an antique candlestick.

For a simple, classic style: use natural materials and colors.

The base for this tablescape is a simple tablecloth in a neutral color and matching cloth napkins.

Consider the sustainable nature of your dinner setting. Don't use disposables and if you're looking for something new, visit flea markets or antique shops. Their 'patine' gives your décor some warmth and personality.

Adding flowers and candles brings life to your table.

The Old, the Odd, and the Unusual

with THE FREAKY TABLE

Zaira Zarotti
Italy
@THEFREAKYTABLE
@THEFREAKYRAKU

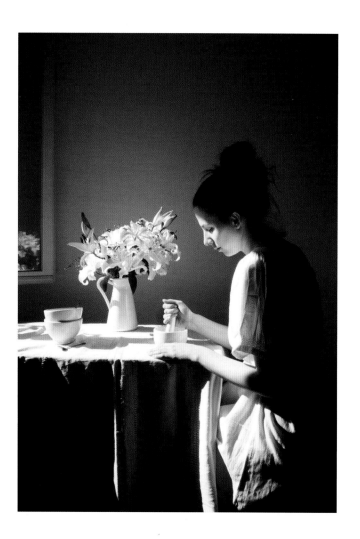

'I fink u freeky and I like you a lot.' This huge hit by South African band Die Antwoord from 2012 played in Zaira Zarotti's head for a long time. "It helped me to conceptualize my idea of beauty and uniqueness. Freaky, in the best sense of the word and the way I personally mean it, is something unusual, imperfect, and a bit odd - like a cracked plate left aside because it no longer matches the others.

> I try to highlight imperfections rather than hide them because I believe they bring added value,

and so 'freaky' has become more than just a word; it's another way of approaching what is around me."

Zaira's blog 'The Freaky Table' offers a view on the most beautiful décors she creates. Always with an aura of nostalgia. Blame it on Venice. "That city formed and shaped me, both as an artist and a human being. My hometown left me an exceptional cultural legacy - I grew up surrounded by thousands of years of history, everywhere I looked. In Venice, you breathe nostalgia. You yearn for the glories of its past and the melancholic nature of its beauty, which is felt by the senses rather than the intellect.

"Just as I always cook with seasonal ingredients, I like to curate my tables by taking inspiration from the season and its colors. I often like to garnish the table with natural seasonal elements I can find in my garden, like wildflowers, leaves and branches, fruits, or vegetables. I choose the elements to capture the emotion I want to convey to my guests and with a nod to the food I will serve. For example, for a Venetian dinner during a cold winter evening, I would probably go for a rich damask velvet tablecloth that might suggest warmth and elegance; whilst for an informal outdoor country dinner on a warm summer evening, I would choose a light raw cotton or linen tablecloth. Usually, I start by imagining the color palette I wish for my table, followed by choosing the fabrics, paired with the flatware, and, lastly, the decorative elements."

In her search for 'freaky' props - the imperfect, the old, the unusual - and not really finding what she was looking for, Zaira thought about producing her own collection of ceramics.

→

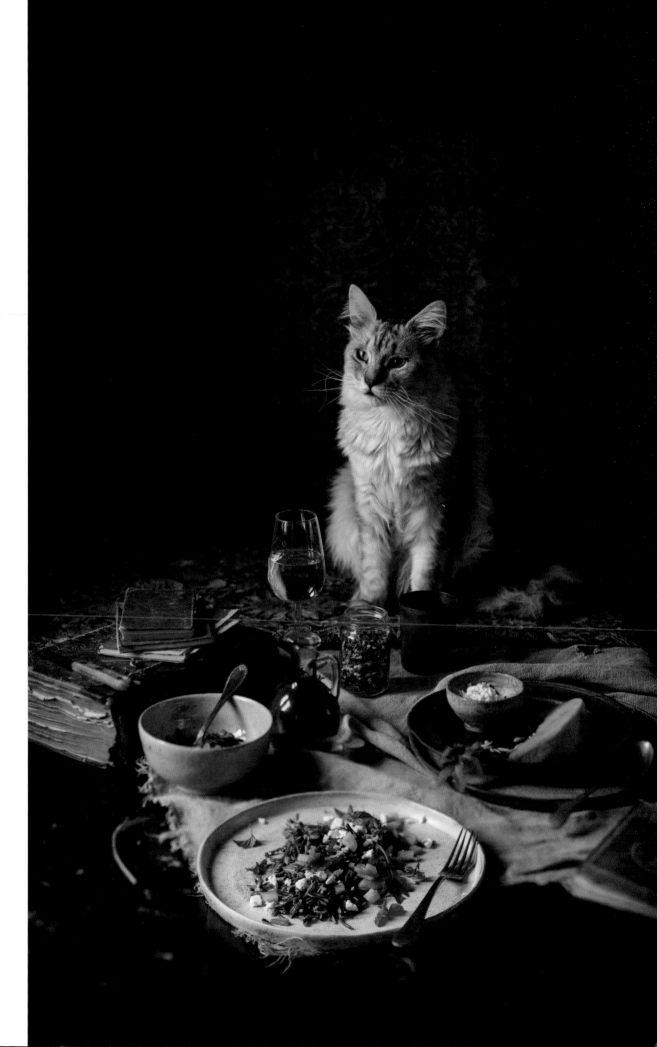

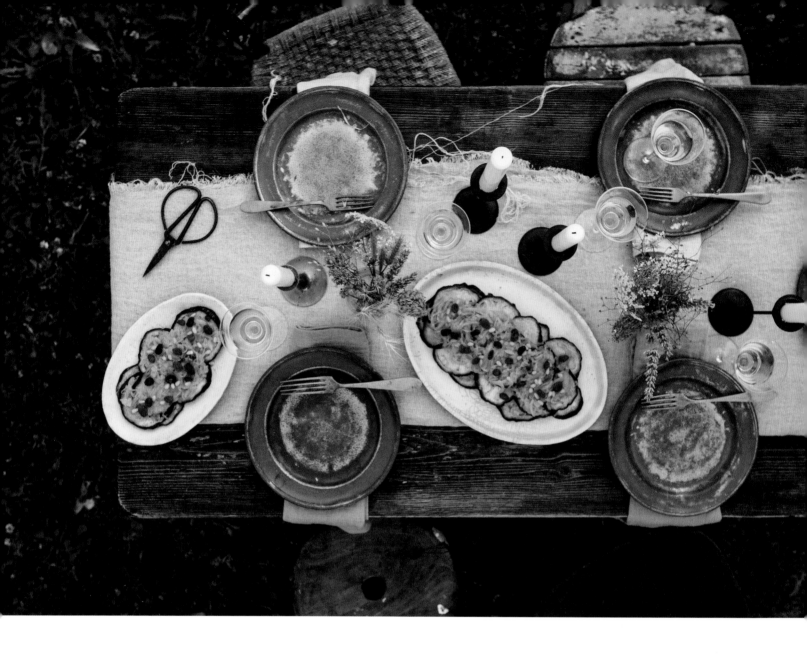

I start by imagining the color palette I wish for my table, followed by choosing the fabrics, paired with the flatware, and, lastly, the decorative elements.

ZAIRA ZAROTTI

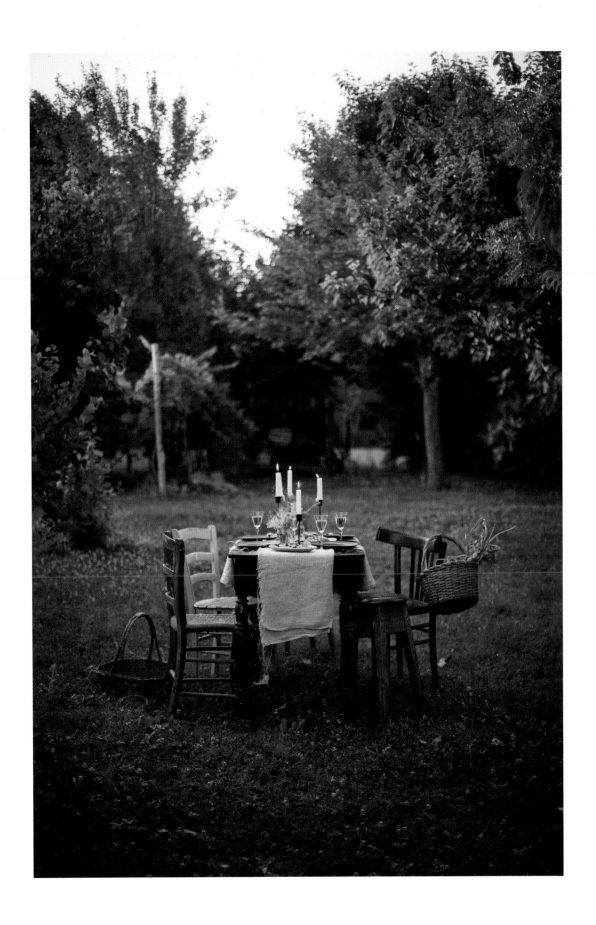

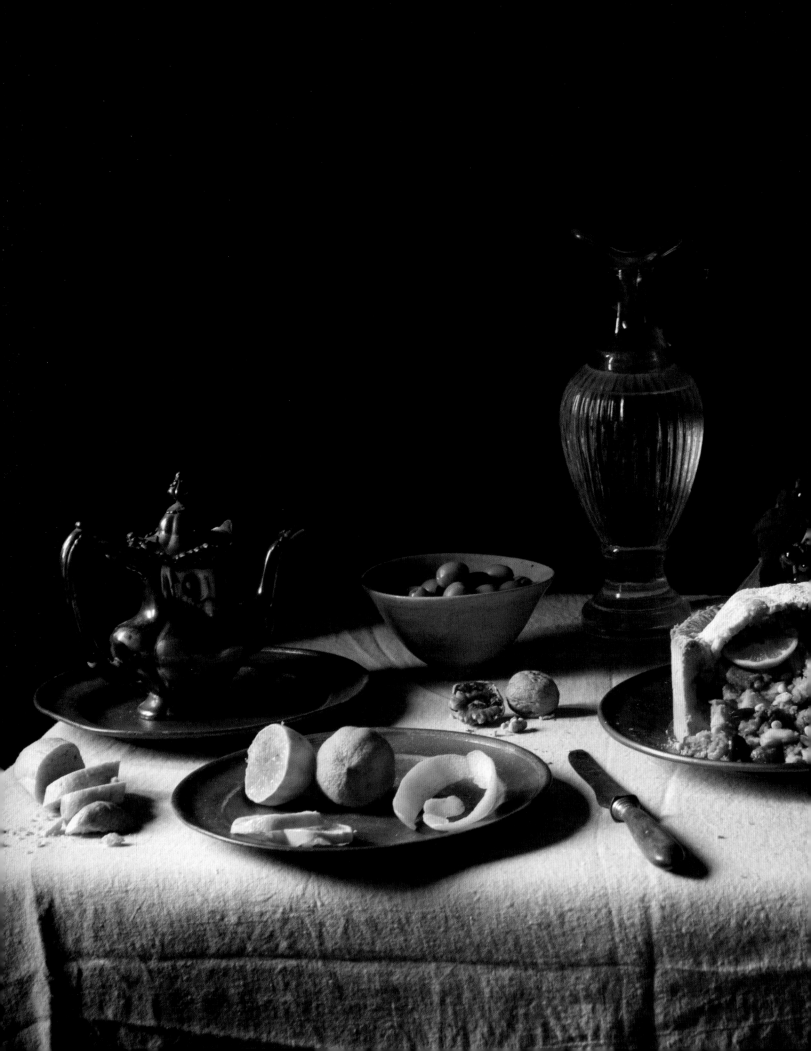

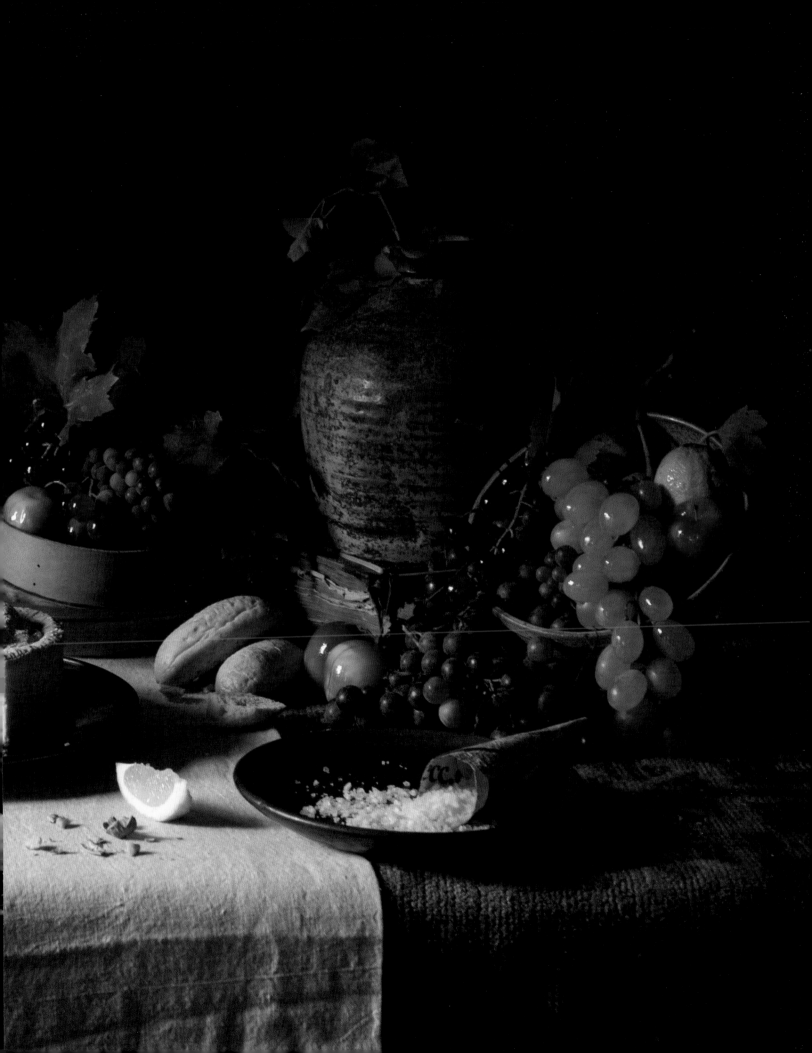

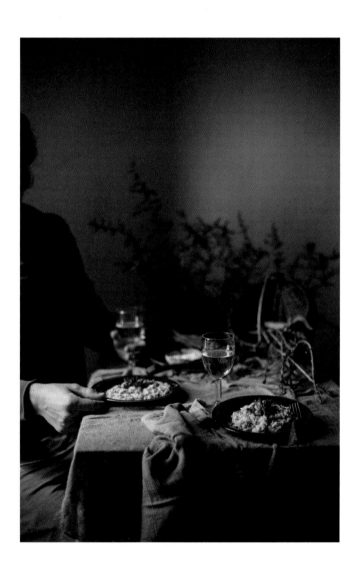

"Together with my partner Francesco, and with the help of my father Luciano who - like my mother - is a multidisciplinary artist, and a professor at the Academy of Fine Art of Venice, we decided to learn more about the art of ceramics. Almost immediately,

> we fell in love with raku, a firing technique whose origins are linked to the ancient Japanese art of the tea ceremony.

In a couple of years, we achieved beautiful results that I started to share with my audience, through my photos. Soon people started to ask to buy our pottery, and so we managed to turn it into a successful business, although this was not our initial purpose!" The design is a contemporary and unique reinterpretation of artisanal pottery, blending elements of the Japanese 'wabi sabi' aesthetic tradition with an elegant and sober style, natural materials, and neutral colors native to Scandinavian design. Zaira and Francesco called their brand The Freaky Raku. "My partner became a full-time ceramist and we sell our pieces through our e-boutique. We share every stage of the process, each of us handling specific tasks from production to selling worldwide."

When entertaining friends or family for real - not just for The Freaky Table - Zaira has some favorite settings up her sleeve. "I really like to match old and new elements like rustic pewter or copper trays and dishes with elegant porcelain or fine Murano glasses," she explains. "In general, I like combining precious things with very odd 'freaky' pieces I find for a few euro at flea markets. I also have a passion for antique candlesticks and old broken-down chairs. I adore the rough linens and cottons my parents use for their paintings, and steal lengths from their studios to use as tablecloths, as well as using priceless Venetian fabrics such as handmade painted or hand-woven fabrics, like Fortuny® or Bevilacqua®."

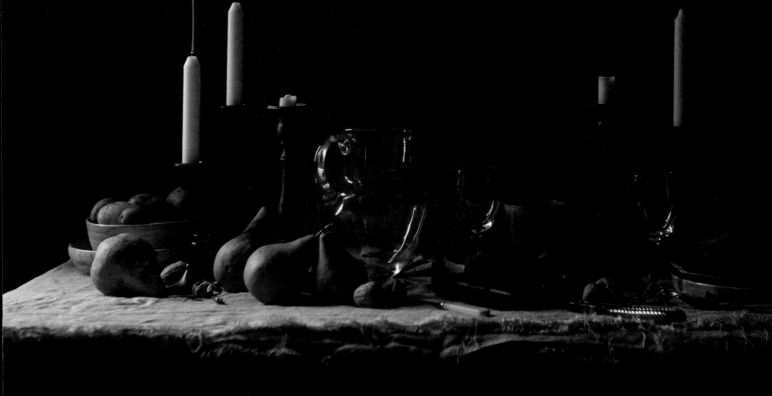

You might say that The Freaky Table bears no relation to real life. But that was never Zaira's intention. "I've always been fascinated by the idea of *mise-en-scene* - telling stories through art. I would say my photography is like an illusion. Everything starts from a vaguely defined idea that only becomes real when I decide to build it. Usually, I follow a stream of thought - everything in the scene is placed there for a specific reason, nothing is left to chance.

> I mentally create a mood board to follow, and sometimes do a few sketches on paper to get a sense of my composition.

All the rest just takes place on the set, where I always feel free to try to include - or remove - elements following my instinct. For me it has always been like a game: I started with the idea of creating small staged scenes where time is suspended, inspiring my audience to imagine a world beyond the borders of the image."

I like combining
precious things
with very odd
'freaky' pieces I
find for a few euro
at flea markets.

ZAIRA ZAROTTI

HOW TO
TELL *The Freaky Table's* STORY ON YOUR TABLE

First of all, *think about the feeling you want to convey* to your guests.
Styling is all about emotion.

Determine the color palette that matches the emotion you want to convey.
Don't forget, dark shades can look stunning paired with colorful food.

Next, choose the fabrics you will use, then the flatware and,
finally, the decorative elements.

Why not try a rough linen or cotton tablecloth, the type of canvas
painters use? There's a world of choice beyond the perfectly
ironed white cotton tablecloth.

Decorative elements don't have to be expensive or luxurious. You can
find quirky, 'freaky' pieces for next to nothing at flea markets.

Garnish the table with natural seasonal elements: from wildflowers,
leaves, and branches to fruits and vegetables.

Consider the Japanese art of wabi sabi: *beauty is in simplicity, authenticity,
and imperfection,* in using *natural materials* and *tranquil color palettes.*

So whatever you do: *don't hide imperfections, they can bring a unique,
authentic feel to your table.*

WINTER

Unpopular opinion: I like winters better than summers. There you have it. I'll choose moon boots over flip flops any day. What many others experience in summer – the extra vitamins triggered by sun exposure – is a sensation I associate with dark winter evenings. I don't recharge my batteries on sunshine, but on the warm feeling of being surrounded by family and friends, and the gratitude that comes with it. Winter is all about celebrating the most precious things in life. And the love we feel for our dinner guests during holiday season is also reflected in the way we dress the table. *If there is any time of year you're allowed to be over-the-top traditional, it is at Christmas dinner.* But it gets even more interesting when you try to push the boundaries of Christmas kitsch. Put every glass bauble you own on the table or go totally overboard with a dramatic table runner made of pine branches. Go wild. Because you know, 'Tis The Season.

A Toast to Happiness

with CHRISTIANN KOEPKE

United States
@CHRISTIANNKOEPKE
@THENORRAGENCY

"Beauty grows as one pursues a life of intention." So for Christiann Koepke, food blogger and creative content creator at NORR Agency, gift-giving happens to be one of her strongest love languages. "For that reason, I love birthdays. I believe that each year should be celebrated even more than the last ... Of course, we don't always need a special occasion to celebrate. I do my best to block off days and nights throughout my weeks for friends and family – to gather, feast, toast, and laugh. Life is not always easy, and one way to stay thriving amidst uncertainty is to seek time with those we love and toast to happiness. I've found that the simplicity of being together and letting time slow is one of the best ways to live a rewarding, beautiful life."
Christiann's career took off when she moved from Montana to Portland in 2014, and she started focusing on the things she absolutely adored doing: curating recipes and dinner menus and designing beautiful table settings. "Simply put,

> I was pursuing a career in bringing people together.

Later that year, I picked up a camera and started a food blog as a side hobby. As I grew in my craft, people started asking me to develop recipes, promote products, style, and photograph food. For the first two years, I focused on food blogging and building my audience through platforms like Instagram and Pinterest. Eventually, I launched my second company, NORR, a creative digital agency focused on premium content production. It's been an exciting journey and incredibly rewarding. I'm blessed to be able to do what I love, and I'm thankful for the brilliant team I have gathered together.
"I believe in taking a natural, unfussy approach to designing each table setting. My design choices are inspired more by the season, natural environment, food being served, and the people sitting at the table than by any strict rules or etiquette guidelines. In fact, I intentionally look for ways to break the rules, step outside the box, and create something new and different. The challenge fuels me and the results keep me coming back for more.
"In both my professional and my personal life, I love the beautiful and unexpected pairing of modern and vintage pieces.

→

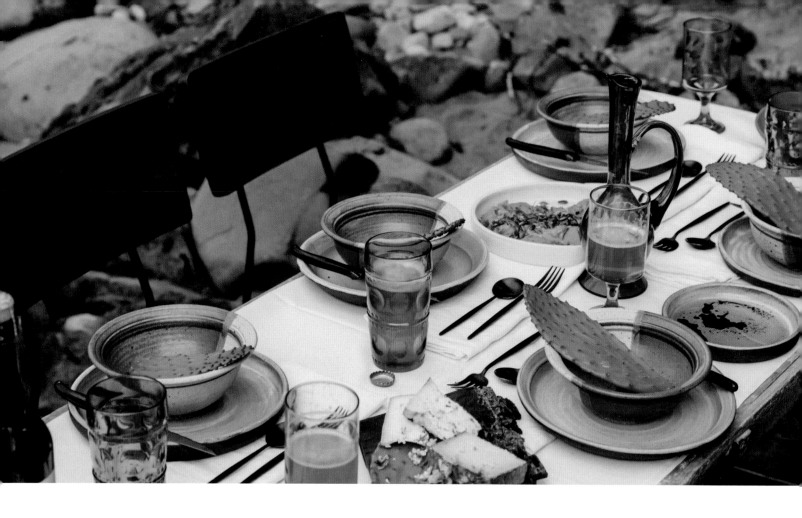

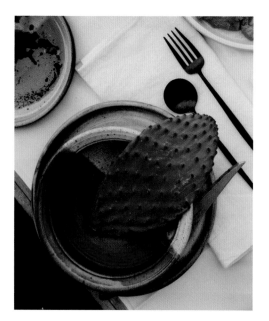

I truly adore the clean, bright, and minimalistic style, with a touch of antique flair. I often build my personal look with a basic foundational color, like white, and then add pops of color, from vibrant greens to hot pinks. As a designer at my core, my style is intentional and focused, with room to play according to the seasons, trends, and my aspirations.
"My advice is to start with the food. Consider how you can best highlight the carefully prepared meal and the thoughtfully selected ingredients you're sharing.

> I always focus on seasonal ingredients.
> This usually starts with a walk through
> my local farmers' market.

We have it year round in Portland! I absorb inspiration from the colors and textures and whatever is currently exciting the local farmers. Their passion is contagious and always sparks my creativity. With a clearer idea of my season and menu, I build from there. I choose tables and chairs, which influence my choice of glassware, silverware, and tableware. Next, I consider the table centerpiece: garland or arrangement? Tall candlesticks or shorter votives? Throughout this process, I'm constantly considering the mood I want to strike. Is it romantic and rustic? Is it modern and bright? At the end of the day, I strive to build each experience with food and the environment at its center."

\longrightarrow

I often build my personal look with a basic foundational color, like white, and then add pops of color, from vibrant greens to hot pinks.

CHRISTIANN KOEPKE

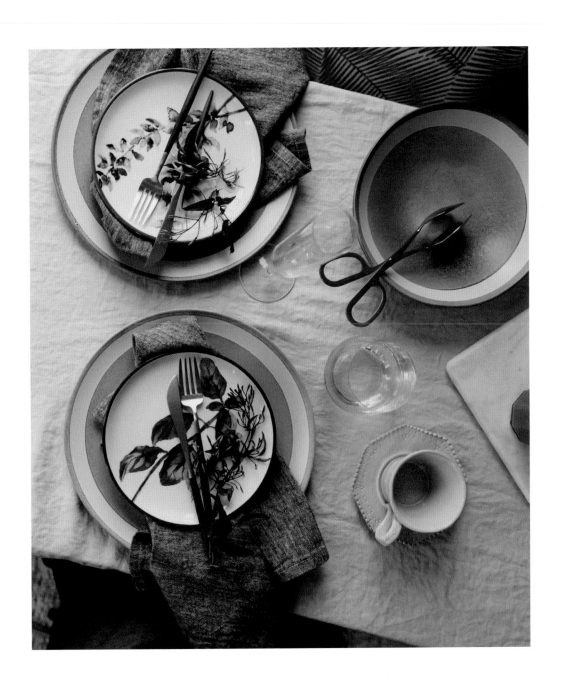

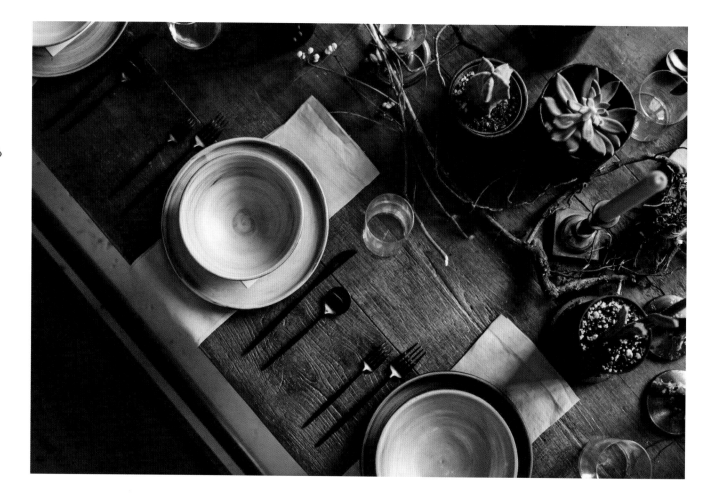

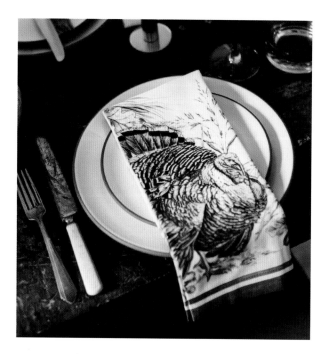

I've found that the simplicity of being together and letting time slow is one of the best ways to live a rewarding, beautiful life.

CHRISTIANN KOEPKE

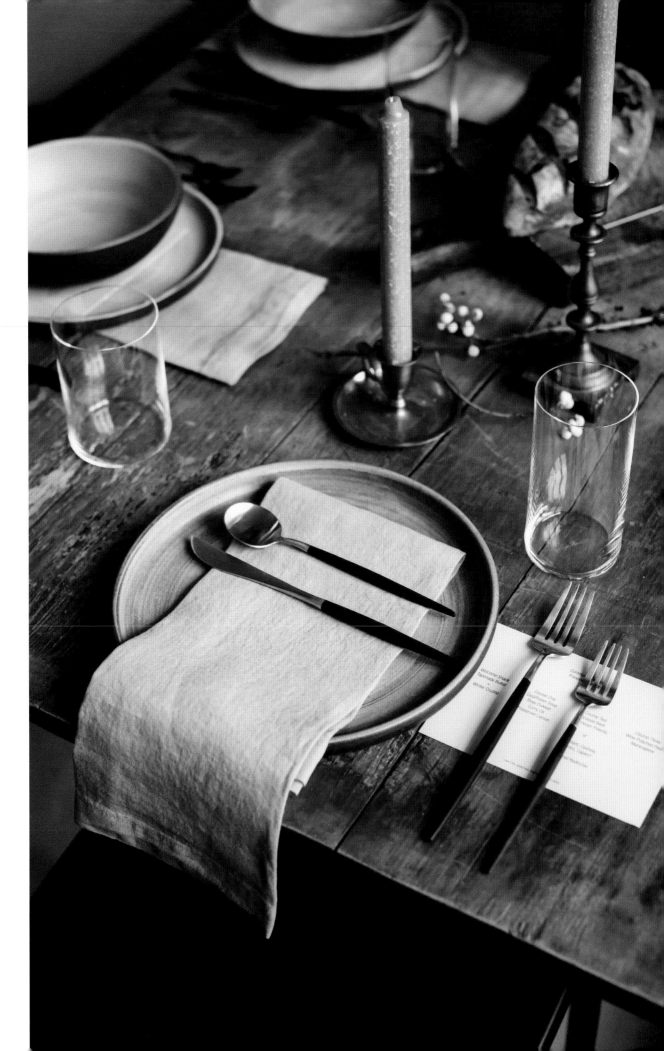

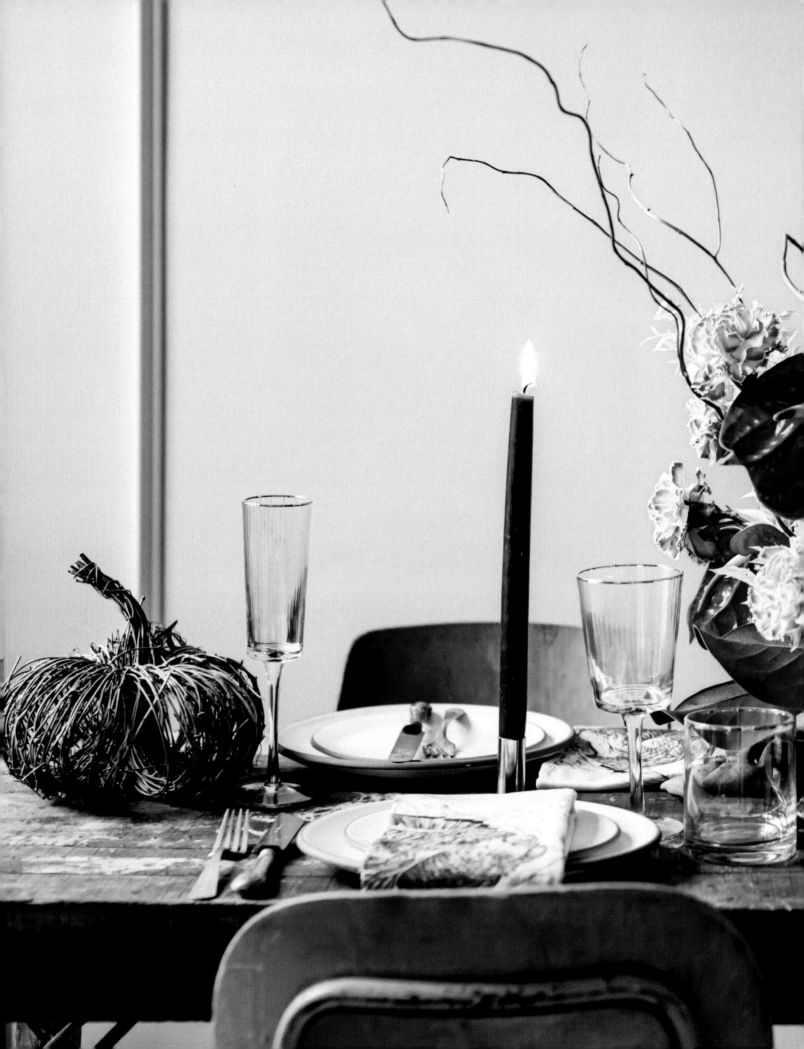

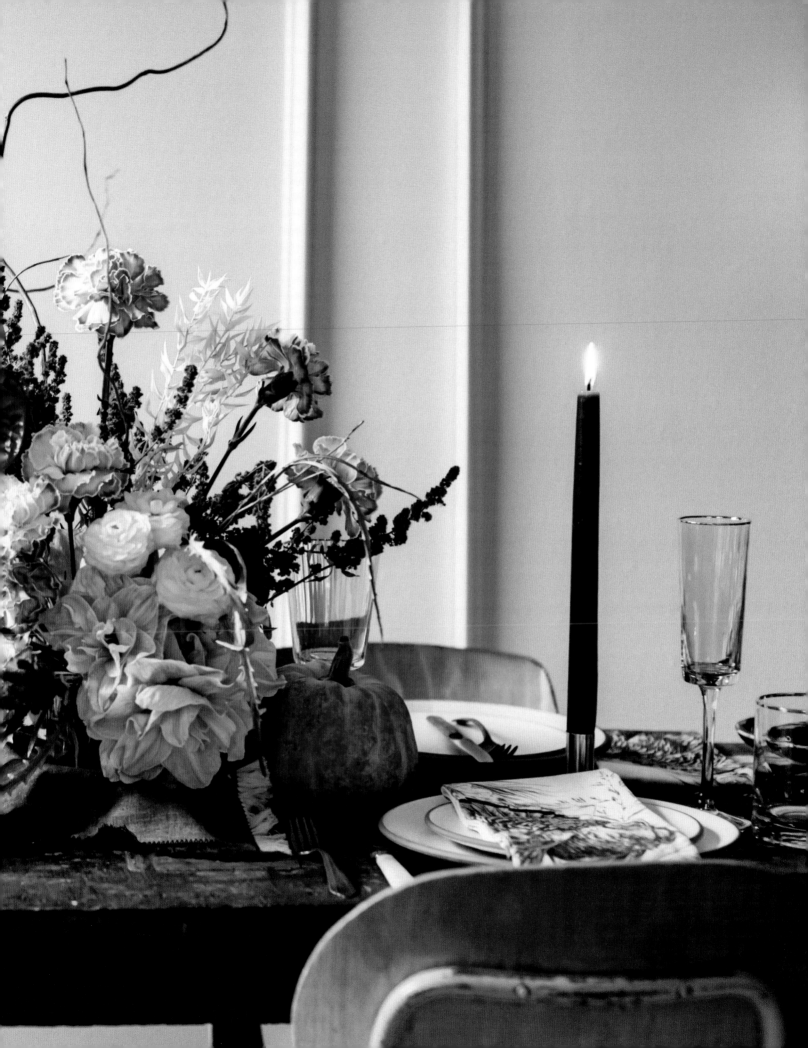

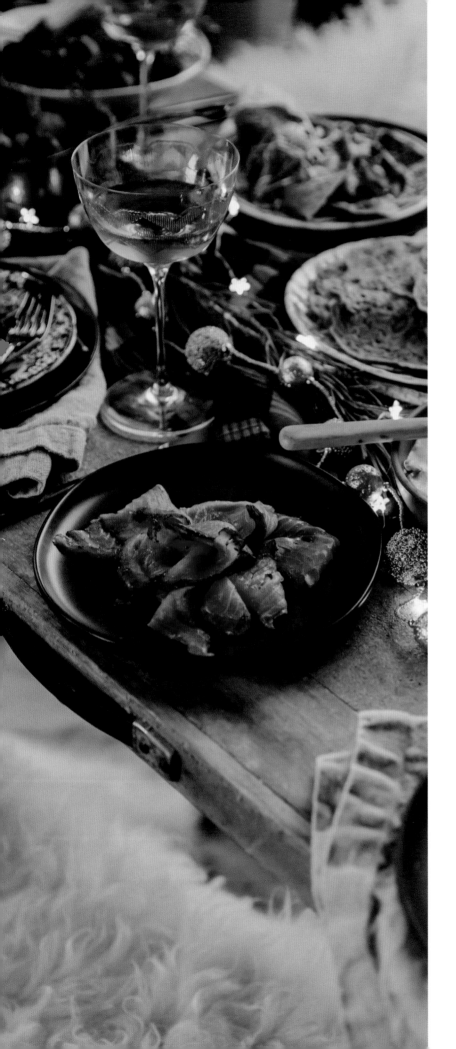

"As people make an effort to spend more time with loved ones and less time looking at screens when they're off the clock, we've seen more of a focus on where and what we're eating. This includes closer consideration of where our food comes from, the specific ingredients, and the environment in which we eat.

There's a new premium placed on the simple pleasure of enjoying a meal in a beautiful place with the people you love.

I am so thankful for that. We need and are built for community and shared moments together where time slows and happiness, heart, and laughter are present and deeply felt."

HOW TO
TELL *Christiann Koepke's* STORY ON YOUR TABLE

Food comes first. Find your inspiration at your local farmers' market.

Consider the mood you want to create. Is it romantic and rustic?
Modern and bright? Once you've decided, try to hold onto that feeling.

Start with a basic foundational color, like white or beige,
and then add pops of color, from vibrant greens to hot pinks.
When the base is good it's easier to experiment with little eyecatchers.

Decide on your table and chairs first, then decide on
your choice of glassware, silverware, and tableware.

Think about the table centerpiece: garland or arrangement? A garland is a great
choice if you have a long table. Centerpieces are ideal for a round table. Make sure
your guests can sit comfortably and have a clear view of their fellow guests.

You can't go wrong with a clean, bright, and minimalistic style.
For extra personality add a touch of antique flair.

Skulls
on a Plate

with OSCAR BRAVO HOME

Oscar Bravo
United States
@OSCARBRAVOHOME

"I am a yes person. I love saying yes." So when clients turn to Oscar Bravo with an idea that might be over their budget, Oscar says yes. "I figure out how we could make it happen and still stay within their budget. There is always a way." Oscar decorates houses, single rooms, and specific party décors. Just to be clear: he loves spending money, but he's also well aware of working to tight budgets when organizing private dinner parties. "The key to making an impactful and beautiful tablescape on a small budget is to use color as a focal point. I created an all-white tablescape that has huge visual impact simply because of the abundance of one color. The table looks elegant even though I used plates, chargers, candles, balloons, paper napkins, and disposable silverware from the thrift store. I didn't have a budget for a beautiful flower arrangement, so we used big bunches of baby's breath, which is very inexpensive but looks stunning."

Although Oscar Bravo loves to say yes, weddings are not really his field of expertise. "Most of the projects I work on are small scale, where a room needs to be furnished and decorated with finishing touches. I decorate all kinds of parties too, but I've never decorated a wedding." Oscar got into the home-styling business after friends and family kept on asking him for decorating advice.

> I'm a fashion design school dropout. I didn't realize how much I hated sewing until I attended fashion design school.

I've always had a passion for beautiful things and was brought up in a home where a well-kept house and thoughtful furnishings were important. My home décor business started after my wife and I bought our first home and I was able to practice my decorating in my own home. Friends and family who visited always ended up asking me for decorating advice. That's when I realized I could be getting paid for this.

"My birthday is December 2. It has always marked the beginning of the holiday season in my family. To this day we have a tradition of putting up the Christmas tree on my birthday." Even though Christmas is very special to me, my favorite holiday is Halloween. I am a huge horror movie fan and when you mix a love for horror movies along with my love for creating memorable atmospheres,

→

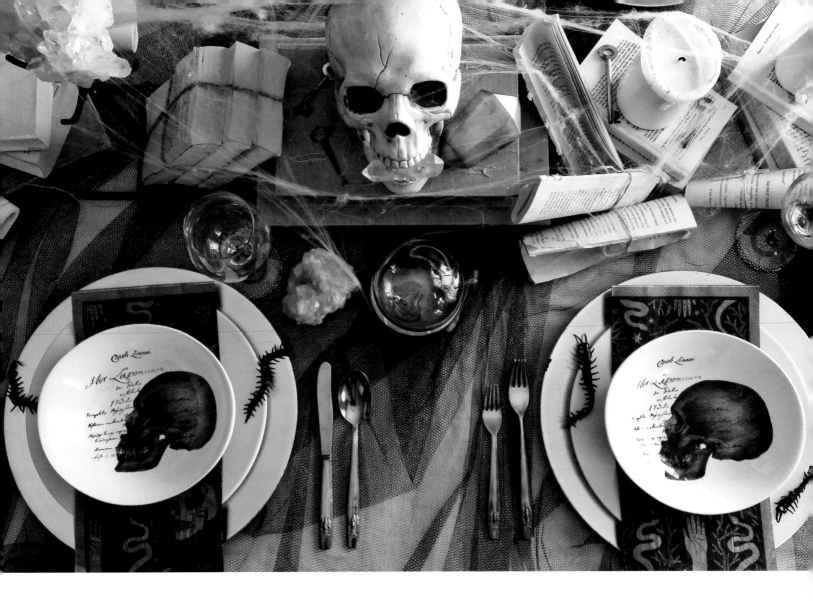

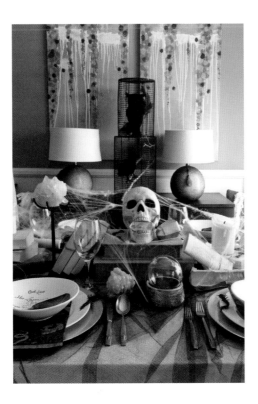

When you mix a love for horror movies along with my love for creating memorable atmospheres, well I just go all out!

OSCAR BRAVO

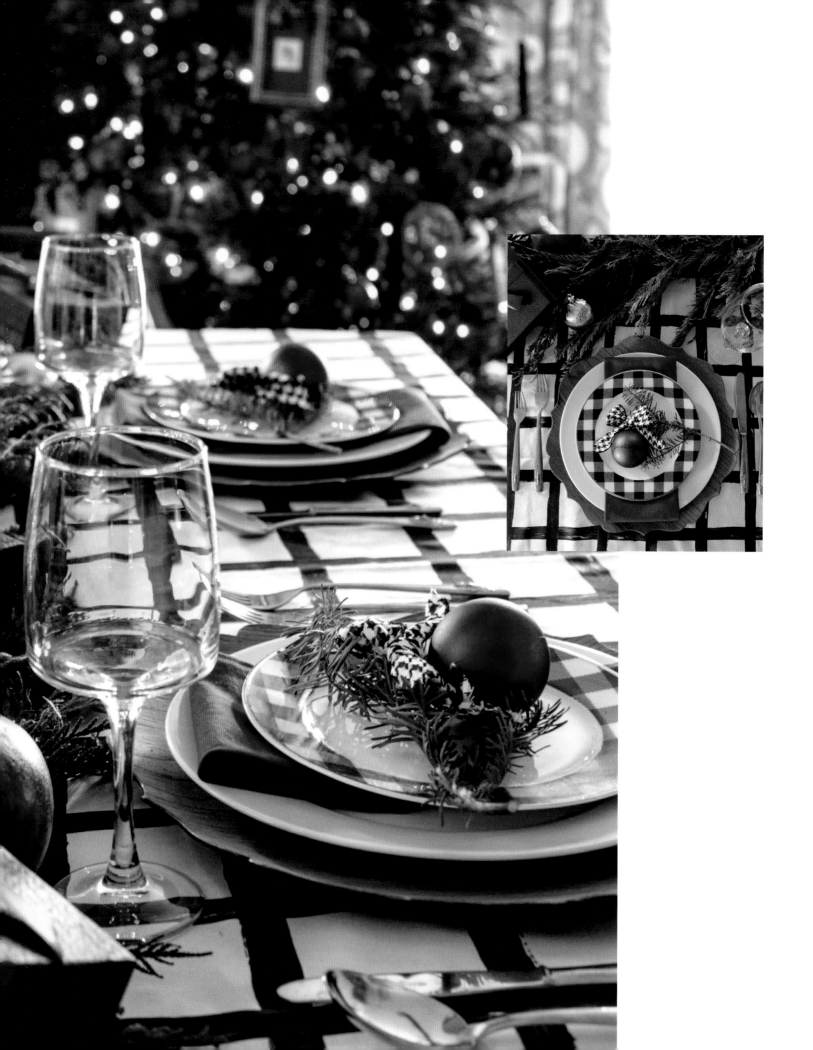

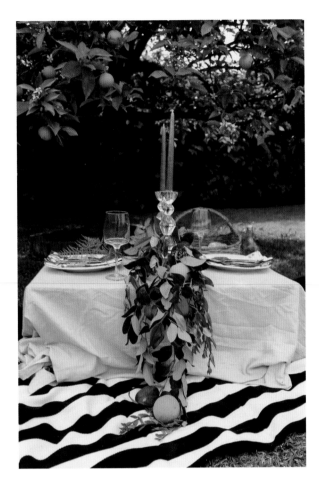

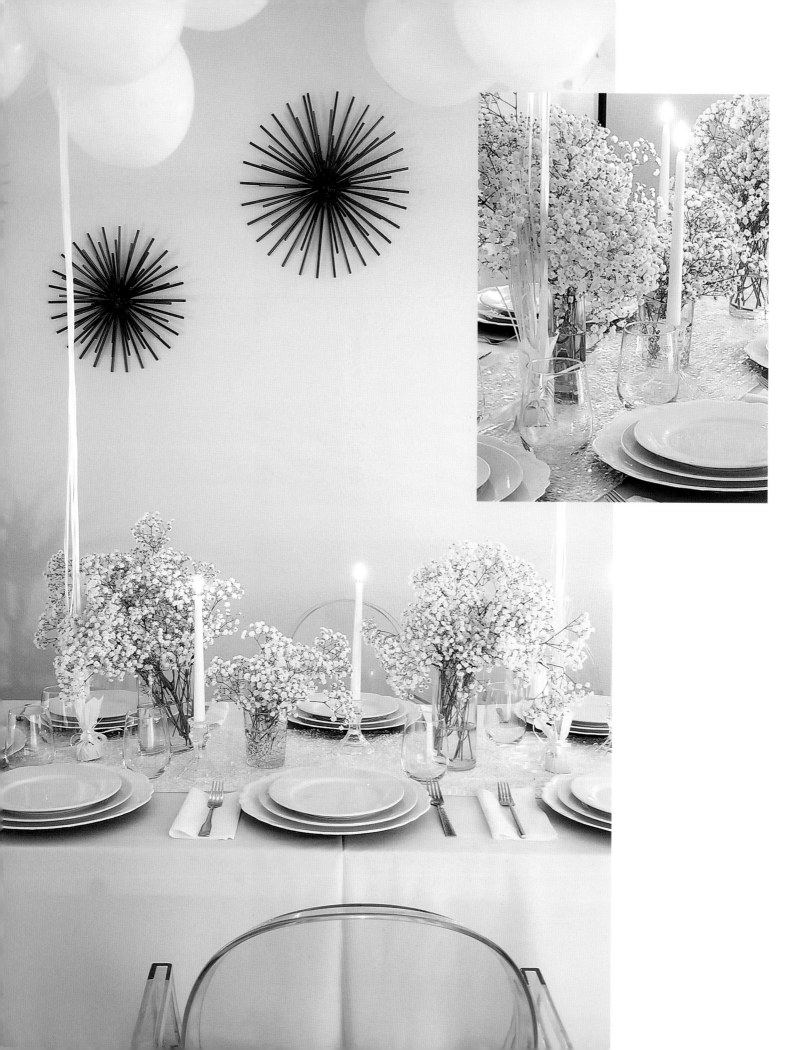

well I just go all out! It is definitely hard to live with Halloween décor so it's only up for a few days leading into Halloween." When friends and family come over to have dinner at the Bravo family - what a cool name, right? - they are not scared away with skulls and fake spiderwebs? "Usually we set the table with candles, flowers, or even branches from the yard and some cloth napkins. We turn down the lights, play some music, and that is all you really need to make a table look and feel festive." To Oscar, a good table is one that triggers all the senses. "From the music playing in the background to the way the napkin feels when you unfold it, it all contributes to the dining experience." For some tablescaping inspiration Oscar's hobby is dining out in beautiful, evocative restaurants. "I always take mental notes on what makes eating there such a joy."

According to Oscar, eating at a stylish table is an important part of the American Dream.

"The traditional American Dream has always been to have a beautiful family in a beautiful home. I think that, for many people, sitting at a well-appointed table with the people you love, enjoying good food, embodies that dream."

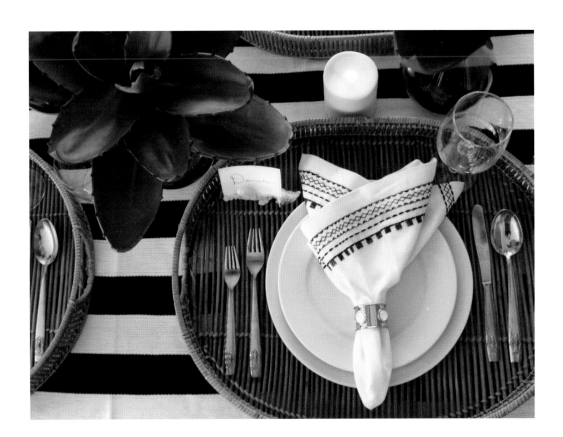

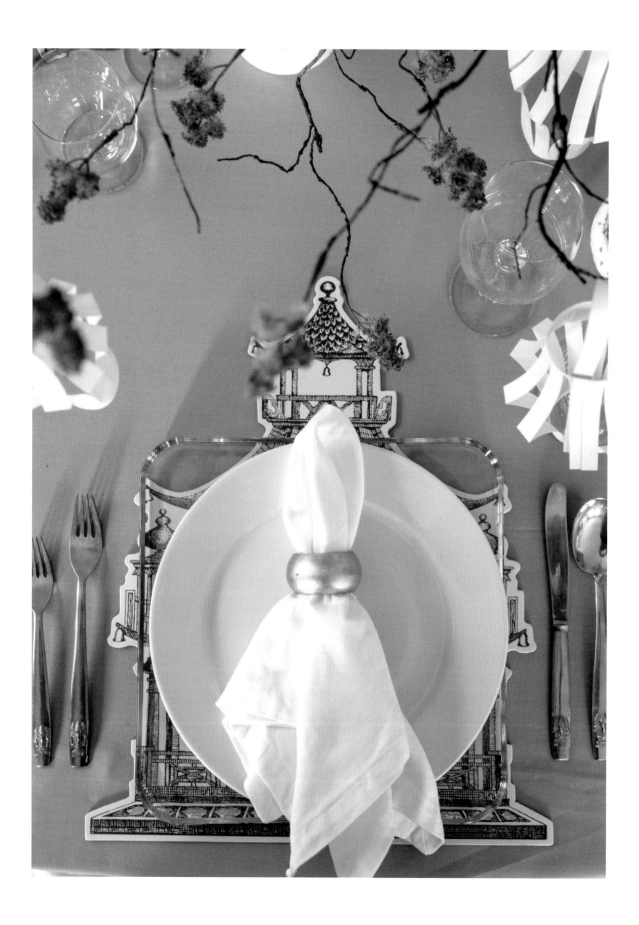

HOW TO
TELL *Oscar Bravo Home's* STORY ON YOUR TABLE

If you don't want to spend loads of money on your tablescape but want your table
to look as if you did - Oscar Bravo is your man.

The key to making an impactful, gorgeous tablescape on a small budget is
to *use color as a focal point*.

The abundant use of a single color can have huge visual impact.
So choose whatever color makes you happy and stick with it.

Natural decorations are fantastic and budget friendly. Baby's breath is really cheap but
why not take a stroll in your garden to pick out some lovely branches and leaves?

*The one investment you should really make is a nice neutral tablecloth
and some cloth napkins*. The right candles and some greenery will give your table
an instant touch of luxury.

Don't forget a dinner party isn't just a feast for the eye, but for *all the senses*.
Choosing the right music, paired with soft, inviting light,
will add ambiance to your table.

When you love themed tables, *indulge yourself and go wild* with skulls, pumpkins,
fake spiderwebs, or Christmas lights. It's important that your table expresses who
you are. And if you're a Halloween kind of person, flaunt it!

Creating Space
to Breathe

with NESSA BUONOMO

France
@NESSABUONOMO

"Simplicity comes first. A simple table leaves us freedom to enjoy conversations and friends. Tables without too much fuss remind me of warm and cozy lunches in the country, shared with family and loved ones. Understated decoration definitely reflects my personal style." On the other hand, Nessa Buonomo's professional life is the opposite of simple. "I love being free to pursue all kinds of activities, at my own pace. For the past ten years I have been writing my own blog 'La Mariée aux Pieds Nus' and in 2011 I started organizing an annual wedding fair: 'Love Etc'. I am also the owner and artistic director of the content creation agency Studio Quotidien. I guide brands in developing a visual identity and help them create the right images. I have my own photo studio here in Lyon, a studio that is open for all local creatives. And there's also a coworking space attached to the office where creative freelancers can spend their working hours. I realize that sounds crazy, but with a little organization I manage to combine all those professions and enjoy my personal life as well. "I really enjoy creating an inviting ambiance around a table. I want my guests to feel welcome and special at a table that was uniquely created for them. When I start decorating my table I usually start with the menu. The food sets the tone for the table.In general it is my husband who is in charge of the culinary aspect. The ingredients he uses, or the seasons, inspire my table décor.

> Based on the meal I first choose the tableware, then the textiles like tablecloths and napkins.

I use flowers as kind of a finishing touch to pull it all together.
"My Jars collection of dinnerware is often the base of any personal table I create. It is a French collection of off-white tableware that goes with everything. It is really an all-rounder when it comes to different seasons or events. The longer you look at it, the more it reveals pretty textural and structural details. Then I'll start to play with other, more contrasting flatware. Why not add some green, blue, or gray-tinted glasses or some pretty wooden cutlery? It adds a little depth to the table. I would definitely advise investing in some nice everyday tableware. Simple but good.

→

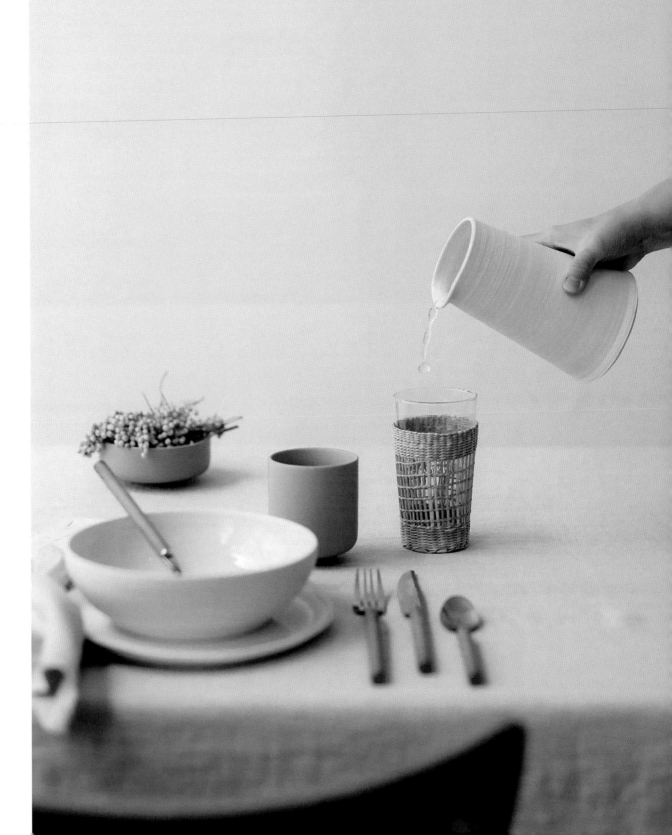

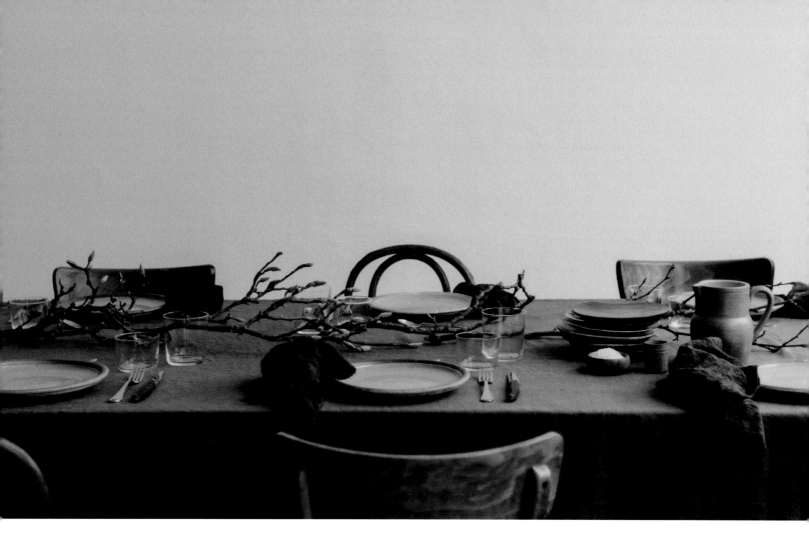

I would definitely advise investing in some nice everyday tableware. Simple but good.

NESSA BUONOMO

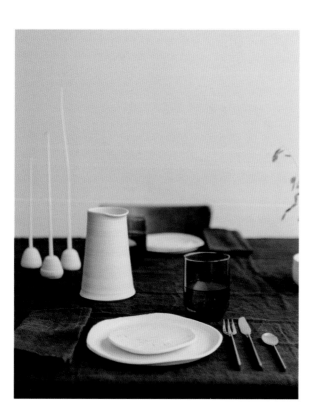

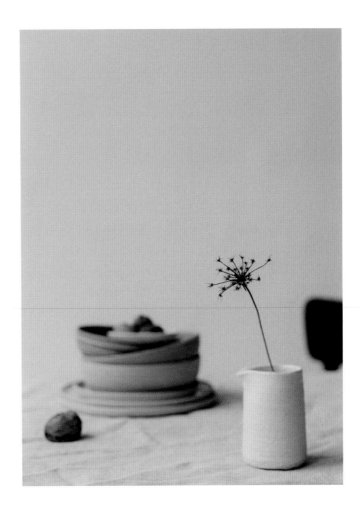

It can also be a good idea to have some linen napkins in different colors, to match the time of year or the mood. A few sprigs of dried flowers can be a nice touch, as well as some twigs or foliage. When I don't have time to visit the florist, I often pick a few sprigs of lemon balm or honey-suckle from our small patio garden. It is an effortless, less expensive, way of creating a tasteful décor."

Life is not perfect.
Why should tables be?

At Nessa's tables there is room for imperfection. Napkins are not folded all alike, candles are not straight. "I don't want the people who sit at my tables to feel intimidated by a décor that is too polished or too perfect. We have to be able to use gestures when we talk. You know how passionate French people are and how much we love to speak with our hands. I don't want them to worry about spilling wine on the tablecloth. The table and its décorum are not the main thing, the important thing is the moment we share around it. Moments of sharing where we no longer remember whether the tablecloth was or was not perfectly ironed, or whether the fork was on the left or right side of the plate, but where we focus on conversations and moments spent together."

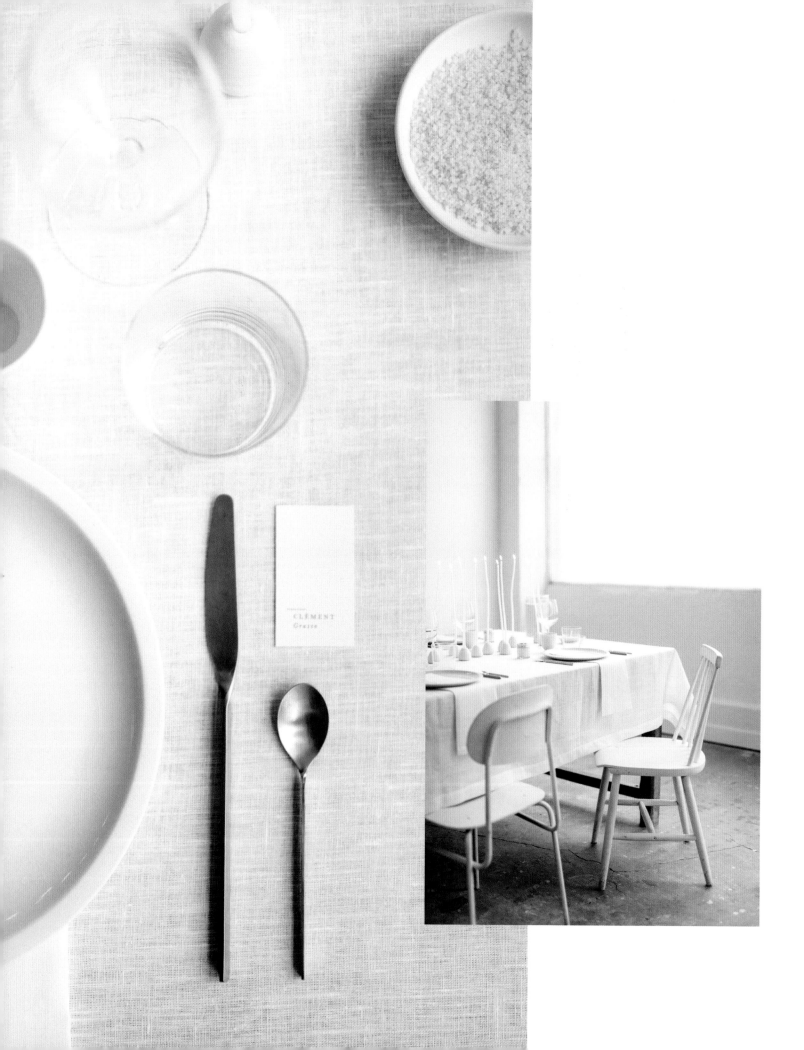

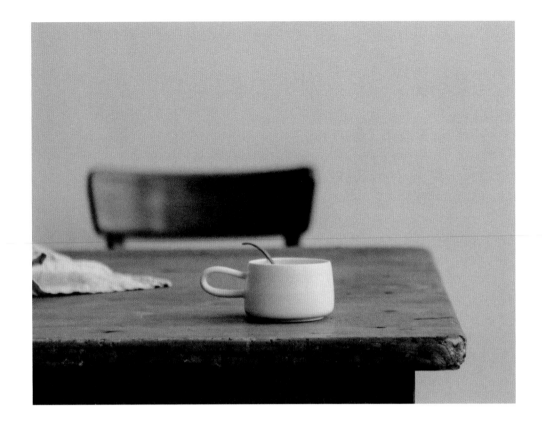

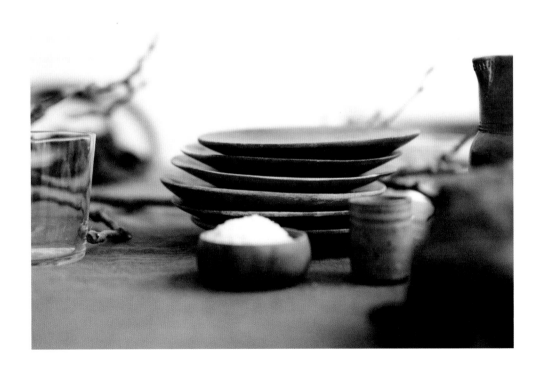

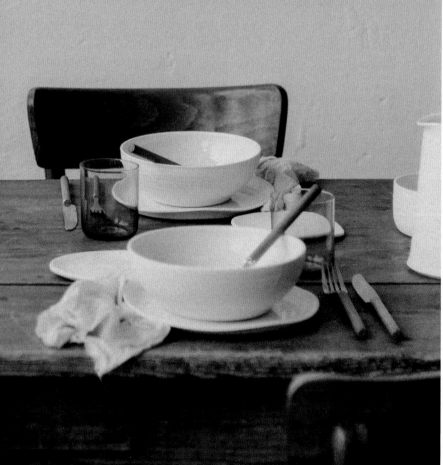

The food sets the
tone for the table.

NESSA BUONOMO

HOW TO
TELL *Nessa Buonomo's* STORY ON YOUR TABLE

The food sets the tone for the table. *Nothing inspires more than
the different seasons and their ingredients.*

For Nessa Buonomo, table dressing *begins with the choice of tableware,
then napkins and tablecloths.*

Consider flowers as the finishing touch, pulling the design together.

The perfect base for Nessa's tables is her French collection of
off-white tableware. Goes with everything, you see.

To add some depth to the table: use green, blue, or gray-tinted
glasses or some pretty wooden cutlery.

To create this kind of table, *your best investment is a basic set of quality tableware and
a set of linen napkins in different colors*, so you can complement the different seasons.

To create a minimalist style, there's *no need to use huge bouquets of flowers.*
Just pick a few sprigs of lemon balm or honeysuckle from your garden.

Make room for imperfection: don't fold the napkins identically,
and let the candles be a little crooked.

It Starts
with Food

with BURP

Erik Vernieuwe
Kris De Smedt
Belgium
@BURPPHOTO

Out of the ordinary. Those four words sum up the work of food & prop stylist Erik Vernieuwe and photographer Kris De Smedt - partners in life and partners in crime at BURP, the colorful collective they created to visualize their craziest food ideas. 'Bio Pop' is how they both describe their work. Because when you take a close look, there is always a hidden detail waiting to be discovered. Something you didn't see immediately. Something that puts a smile on your face. "We want to trigger all the senses, not only the purely visual", Vernieuwe explains. "We refuse to be pinned down to one style or one chapter of food history. We just follow our gut feeling. Who says a Golden Age still life cannot be served with a slice of sixties?

"Food is the base of so many things in our life. We met thanks to cake and eat our way through every holiday destination. We design our own recipes and experiment like crazy." That experimental and almost naïve sense of adventure is a definite asset to their work. "We don't draw inspiration from a menu, nor do we turn to Instagram or Pinterest to look at what others are doing. We hate to break it to readers, but everything has already been done. Don't mind trends, just work with what you have, and add more drama.

> There simply is no
> right or wrong when it
> comes to setting a table.

"We do have kind of a basic setup when inviting friends over for dinner. It is a diverse mix of things we love. That's the one thing keeping that décor together: our mutual taste in design and tableware. We tend to combine old and new stuff with scatterings of seasonal blooms." Kris is a passionate collector of vases, so the Burp team has a whole library full of them, in every size and color. Depending on season and style, they choose whatever ends up at the dinner table. "Sometimes three peonies do the job, on other occasions we choose thistles, some small branches, or brightly colored florals. The secret is in finding a florist that understands your style and doesn't shrink from your wild and wacky ideas.

"I wouldn't go as far as calling our setups a 'color palette', we mainly use natural materials with kind of a 'brutal' look to them. Colors vary from bright blue to pale pink and dark brown.

→

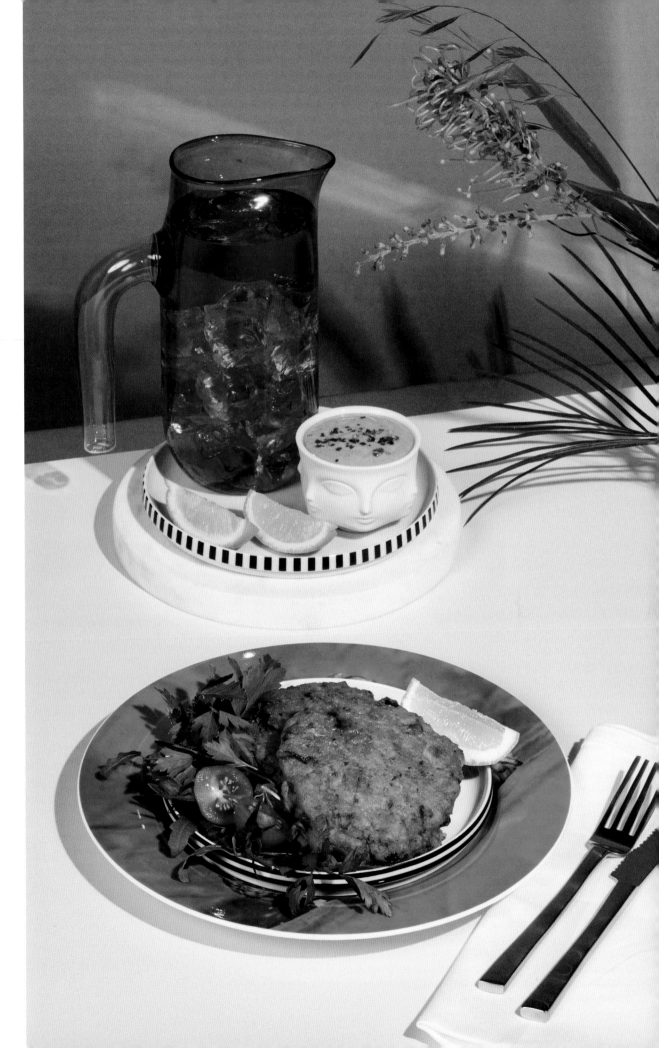

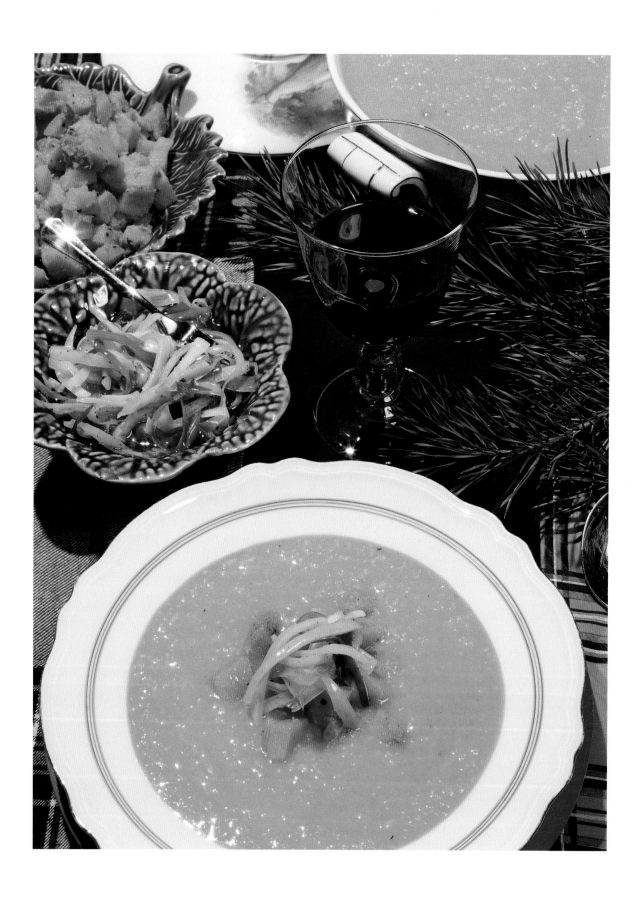

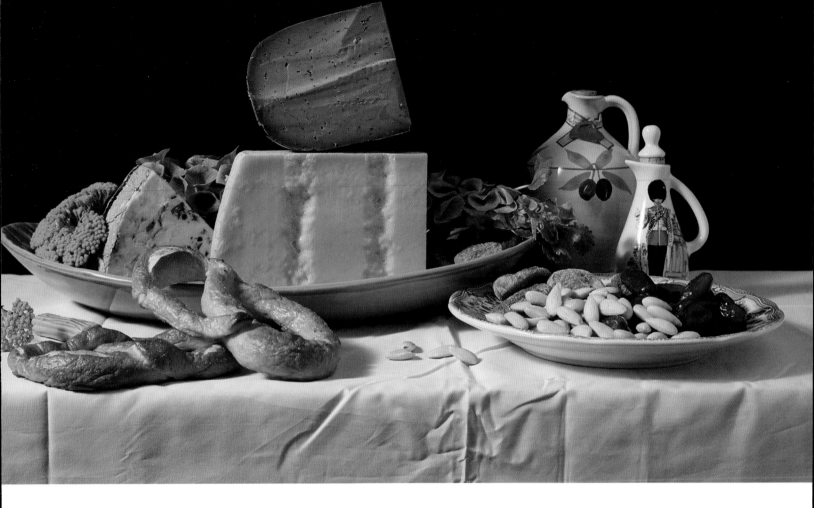

We don't do
things halfway.

ERIK VERNIEUWE

TABLE STORIES

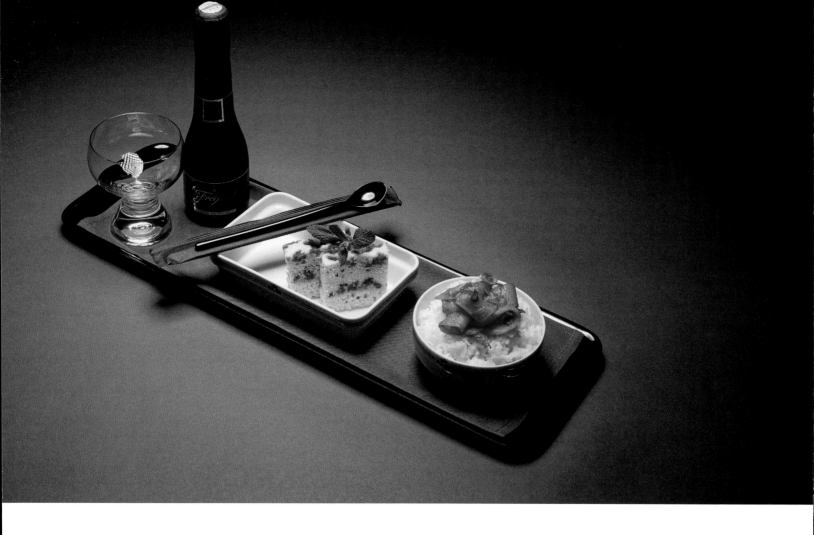

We want to trigger
all the senses, not
only the purely visual.

ERIK VERNIEUWE

We throw stuff together from all over the world. Cutlery from Korea, French plates, designer napkins from Issey Miyake, and Danish glasses." The 'throwing together' can be interpreted quite literally, since Erik admits he doesn't win any prizes for his caution. "I am not the most careful person in the world, so I like my tableware to be robust, like Libbey glasses." Other requirements for ceramics wanting to enter the BURP world: being dishwasher proof and not being a serving platter. "I'm mildly allergic to serving platters and objects like soup tureens. An issue I solve by cooking in vintage pots and pans. Through the years we have bought quite a few items from the La Mama collection at thrift stores. That series of pots and pans was designed by Enzo Mari for Le Creuset. They look so good it would be a shame not to use them on the table. At the center of the table, we use thick wooden platters as coasters. All our serving spoons are wooden too. Wood doesn't only look beautiful, it also avoids damage to your tableware."

There are of course exceptional events where we go to great lengths to surprise our guests. Christmas for instance has a different theme every year, including a new menu, a décor, and costumes. We don't do things halfway."

But when Erik and Kris are invited to dinner, the excuses often fly. "Friends frequently talk about how their original idea didn't quite work out the way they wanted. But little do we care. When you're entertaining the cliché is so true: the most important feature at your table is the people, not the styling." Did they just tear this entire book down?

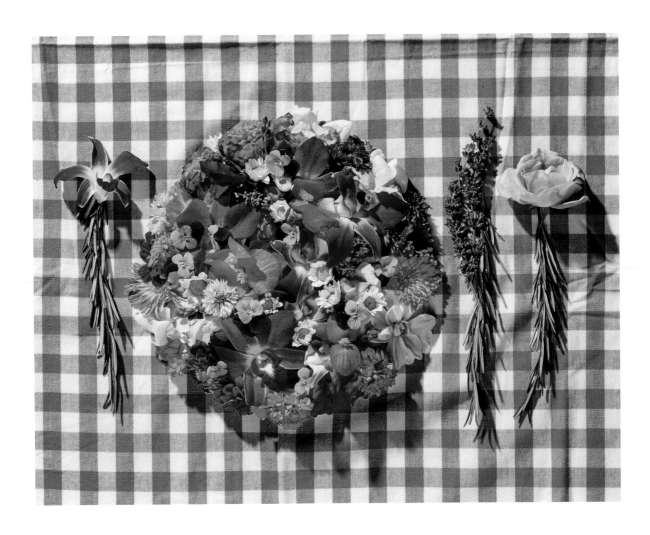

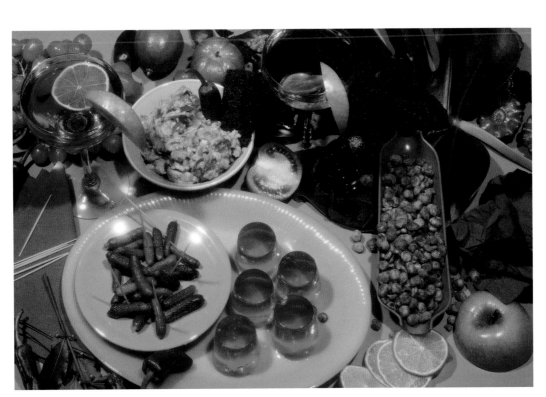

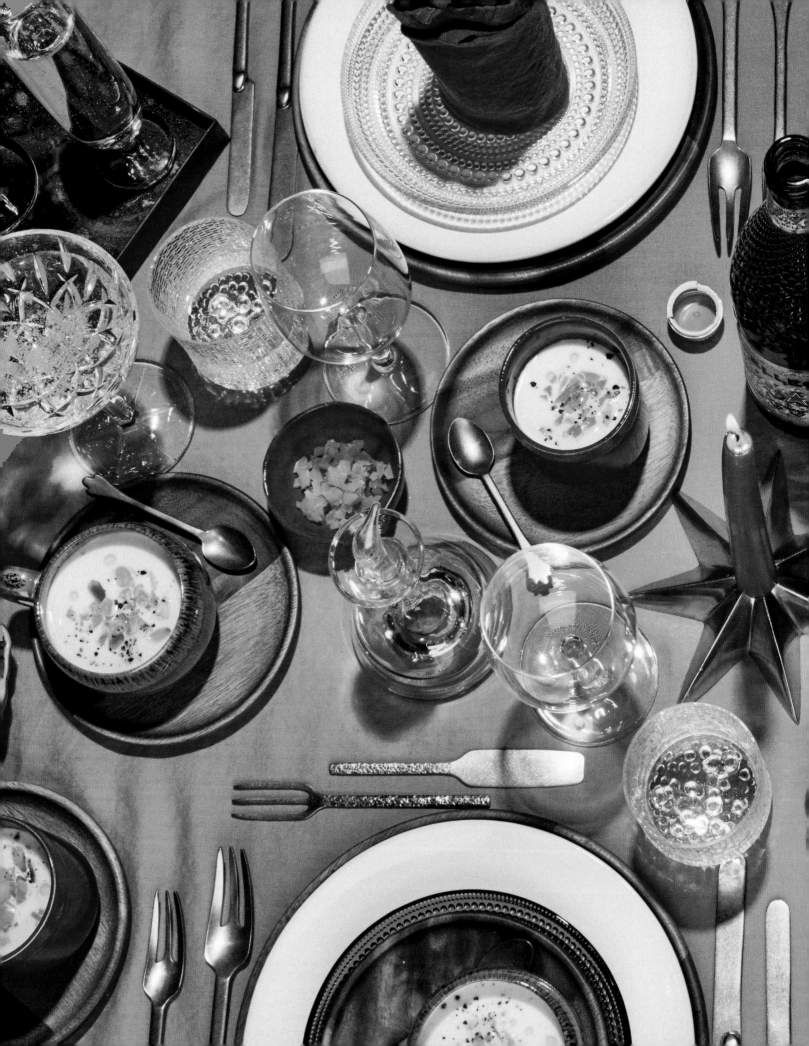

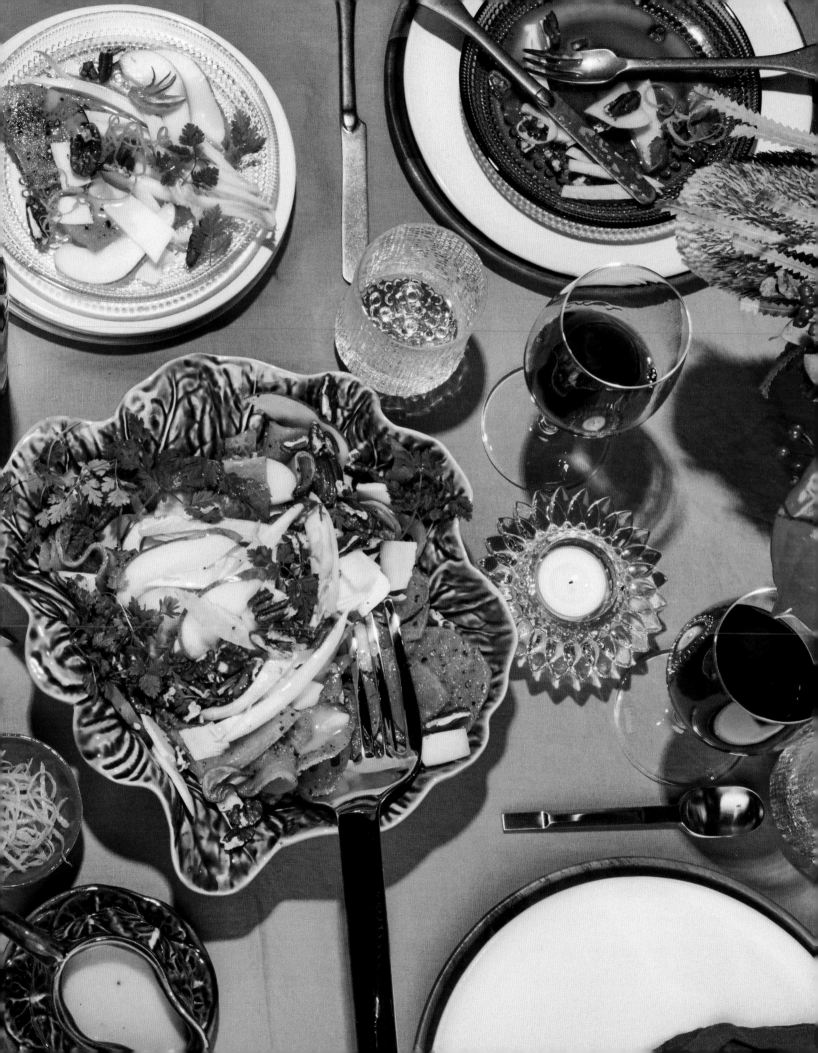

We throw stuff
together from all
over the world.

ERIK VERNIEUWE

HOW TO
TELL *BURP's* STORY ON YOUR TABLE

It's difficult to come up with ground rules for this style of tablescaping,
because the first rule would be: *there are no rules.*

But let's try anyway.

Instead of looking at other tablescapes for inspiration,
why not open an old art book or browse through a seventies style
cookbook? Maybe your local museum has a great exhibition going on.
Don't always turn to the obvious inspiration platforms.

Start with the food you will be serving. It might have all the makings
of the perfect décor. It's amazing what you can create from tomatoes,
roast chicken, or cake.

Replace serving platters by vintage pots and pans.

Try creating a robust *base using natural materials*
with a 'rough and ready' vibe.

Color is key: sometimes a cleverly chosen pop of color
can evoke that 'wow' factor.

Don't be shy when you're creating this kind of exuberant table setting.
This style *is all about defying convention.* Get creative.
Tickle the senses. Add drama.

What if: you're done but the table doesn't look quite as you'd planned?
Remember what Kris and Erik say: *"The most important feature at your table
is the people, not the styling."*

Please
Add Drama

with MIKKEL KURE

Denmark
@MIKKELKURECOPENHAGEN

"To me, the traditional idea of good taste is very boring."
Whilst a lot of creatives in this book are inspired by a
typical understated Scandinavian style, this Scandinavian
interior stylist, Mikkel Kure from Copenhagen, does quite
the opposite. "Don't get me wrong, I love the minimal
Scandinavian style. I love true simplicity, but often
simplicity becomes an excuse for not taking chances.
Although being Danish, it doesn't come naturally to me in
the same way as the more, opulent, playful, and theatrical
style. It may be difficult to put a finger on, but I am certain
my style of theatricality is still very Nordic in its nature.
"Even as a child, I was very aware of my surroundings and
had a clear idea of what I felt was beautiful,
or less so. I am a very visual person, which
can be quite annoying sometimes. I tend to
notice every detail in a room and redesign
it in my head from the moment I walk in."
Mikkel doesn't like to get pinned down to one
particular style. "Often I cannot explain my
choices, but over the years I have learned to
trust my gut feeling. And even more important:
I have learned to edit and start over when it
is not working." But what defines the good
and the bad? What makes a beautiful décor?
"Working with taste is always tricky. Following
your intuition takes a lot of confidence. But
the format of dressing a table suits me. A table
is a mini universe. I like the idea of elevating
everyday items to an expression of art.
"I love historical references and adore the 18th
century. That period is an endless source of
inspiration. That's why I often approach a table
as it were a Dutch still life.

> Don't ever be afraid
> to add some drama.

Use lots of flowers and fruits. Don't bother
about the practical aspects. Regular tableware
can easily look like royal china if the styling
is good." But it helps of course when the
tableware is very posh to begin with. For the
homeware department store Tanagra in Dubai,
Mikkel created the most luxurious settings
imaginable. "It was such great fun. The brands
they sell are all extremely high end. It was
a magical mix - an open-minded client and
excellent products together with a photo-
grapher who is highly skilled both technically
and creatively."

→

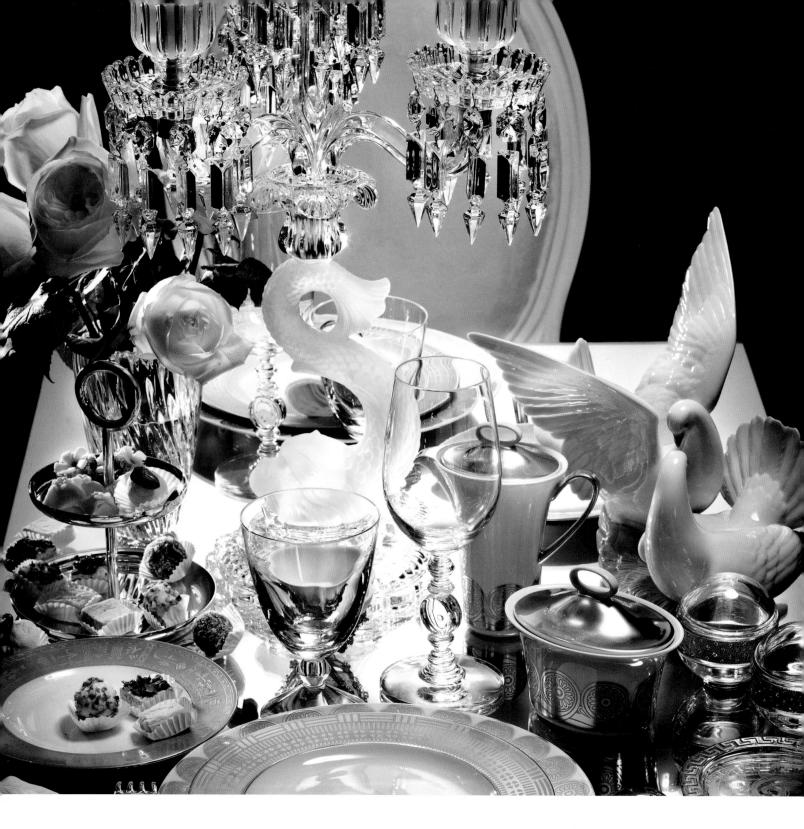

Of course, this is not the décor friends and family are treated to when they receive a dinner invitation from Mikkel. "It is all about balance to me. Guests have to feel welcome and feel that you have made an effort without it becoming stiff and formal. The goal is effortless style. I know that is easier said than done. Never feel you have to reinvent your setting every single time. Go with what works and what comes naturally to you: a favorite vase, a special kind of flower, or a certain tablecloth.

→

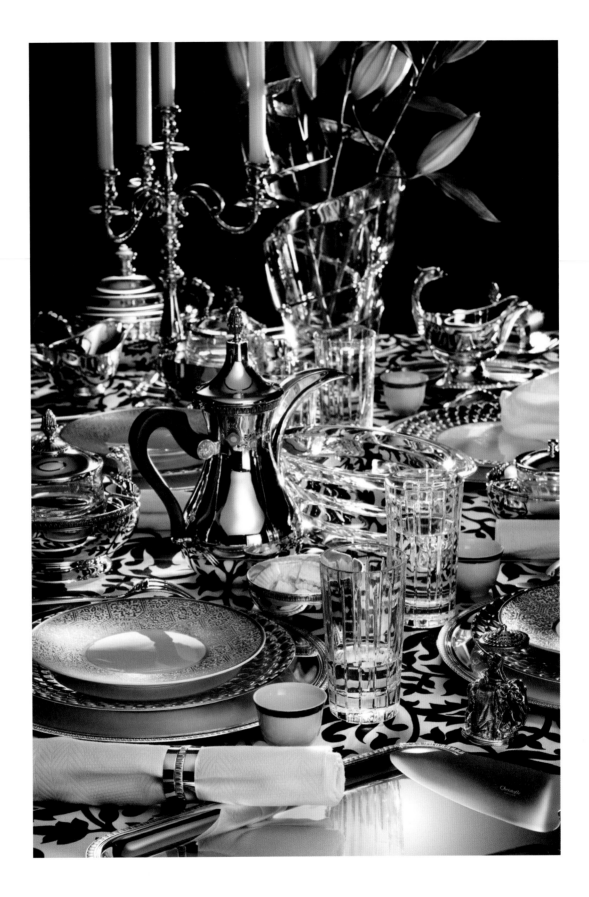

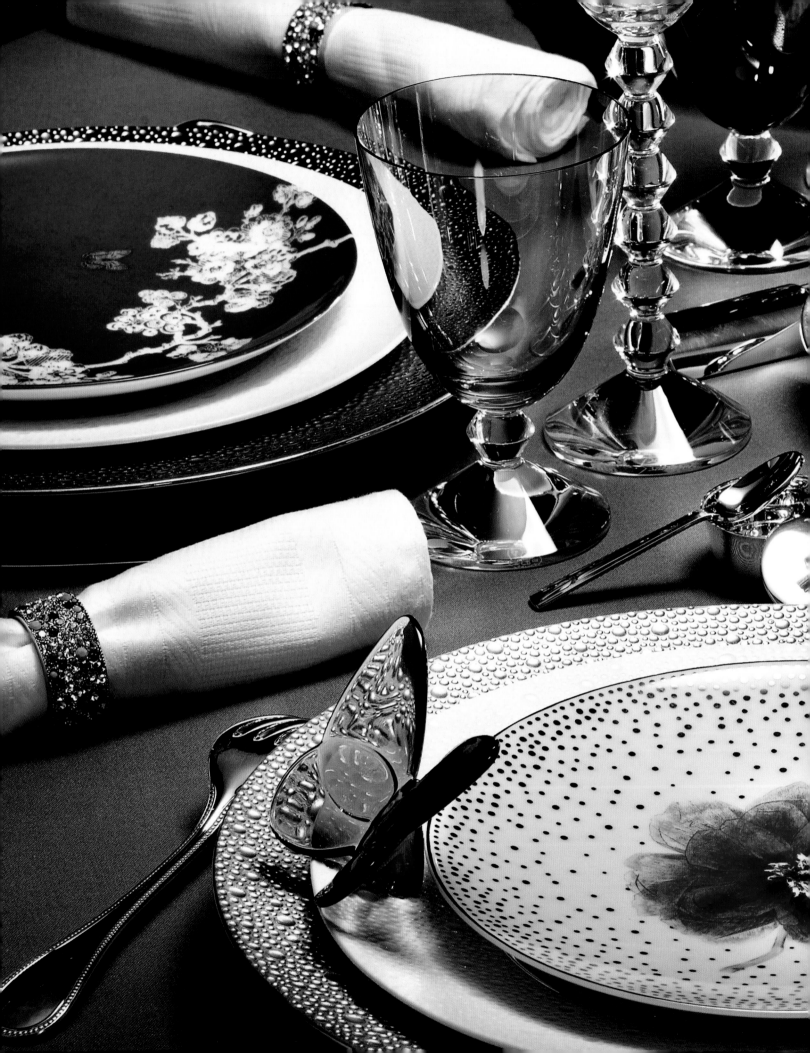

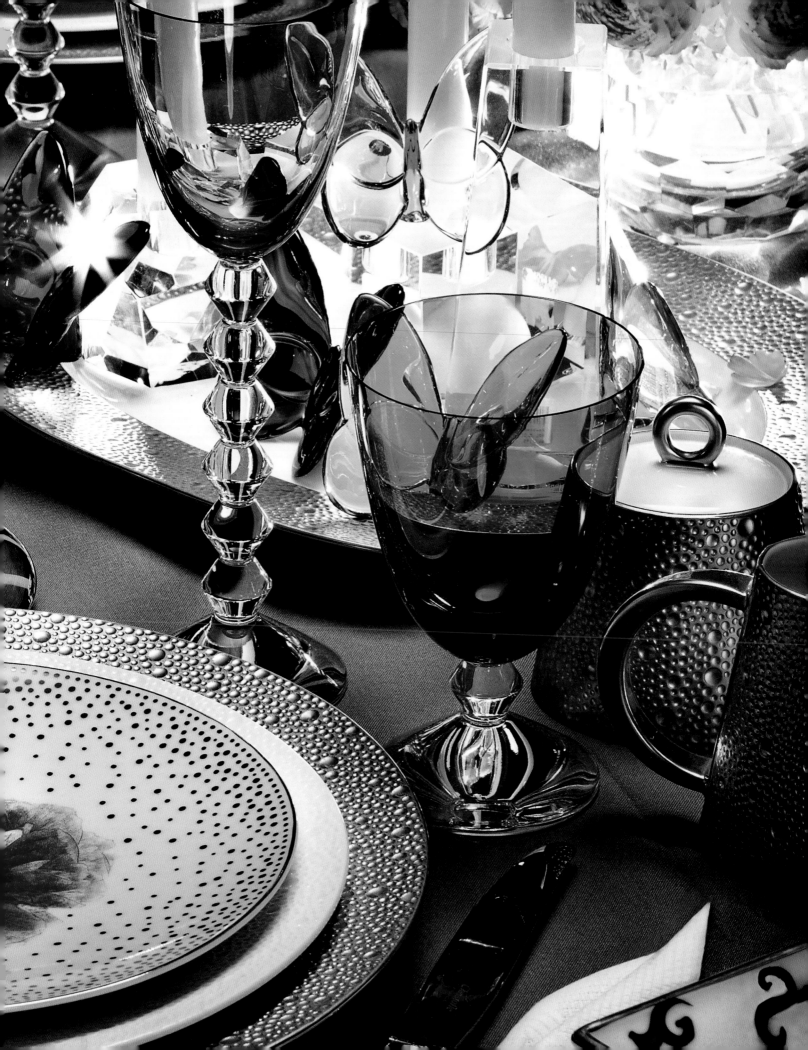

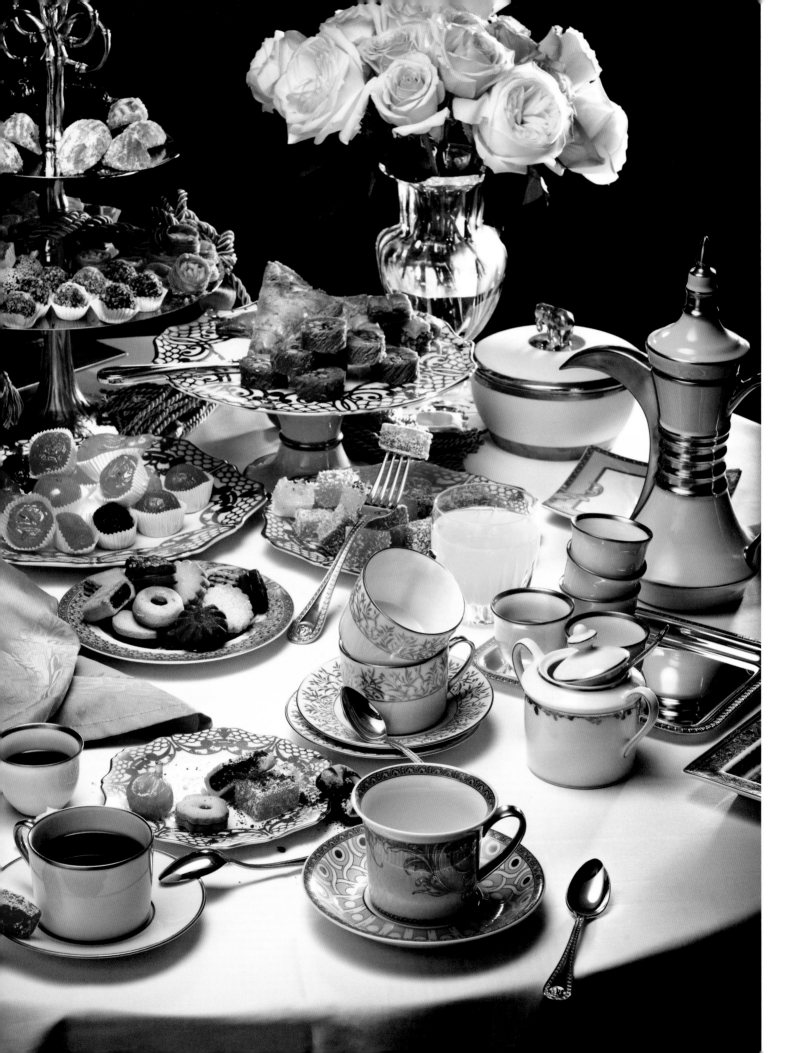

A table is a mini
universe. I like the
idea of elevating
everyday items to an
expression of art.

MIKKEL KURE

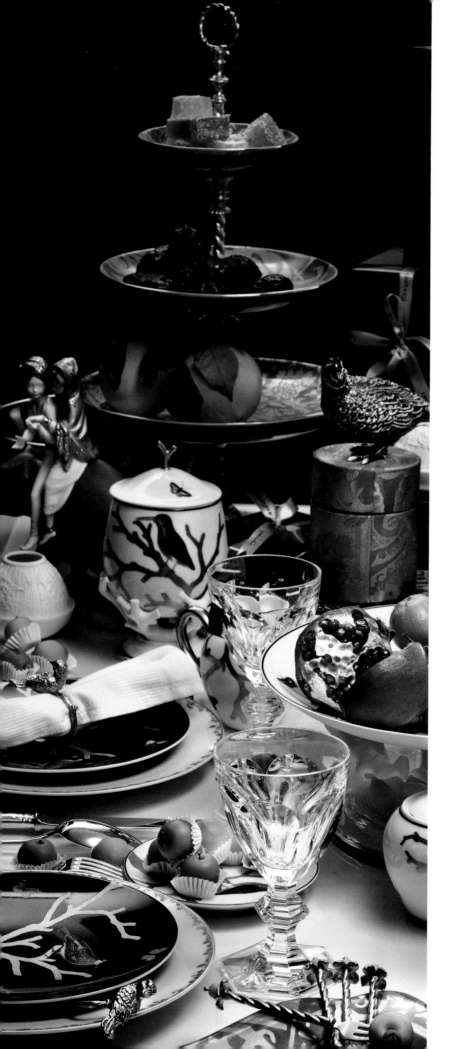

My ideal celebration is a regular dinner with friends and family turned into something extra festive for no other reason than the fun of it."

So no over-the-top Christmas tables or scary Halloween-scenes for Mikkel. "Holidays and celebrations tend to stress me out. Often expectations run high, which kills the fun. I don't even like celebrating my own birthday and I don't decorate my home for Christmas. I am blessed to have a family that is very skilled at celebrating and a mother who is a natural hostess. So for most holidays I trust their talents more than my own, which gives me a chance to relax and enjoy."

HOW TO
TELL *Mikkel Kure's* STORY ON YOUR TABLE

Consider your table *a work of art*.

More is more when it comes to creating this style.
Don't ever ask: is this too much?

Look beyond Pinterest for sources of inspiration.
Why not look into some historical references?

Don't ever be afraid to add drama. Use lots of flowers and fruits.
Don't think about the practical aspects.

With the right styling, everyday crockery can be elevated
to the status of royal china.

These tables *don't* really *have a focal point.*
The over-the-top effect is created by combining a variety of as many
different shapes and decorations as you can find.

Choose your colors wisely. Go for a palette of pure glamour:
silver, gold, deep red, black, and white.

This is obviously not a tablescape for a casual dinner for two.
Save this idea for a special celebration with friends and family.

You might want to tone it down a bit to remain practical whilst eating.
Be careful not to oversimplify. *This style is all about opulence
and theatricality!*

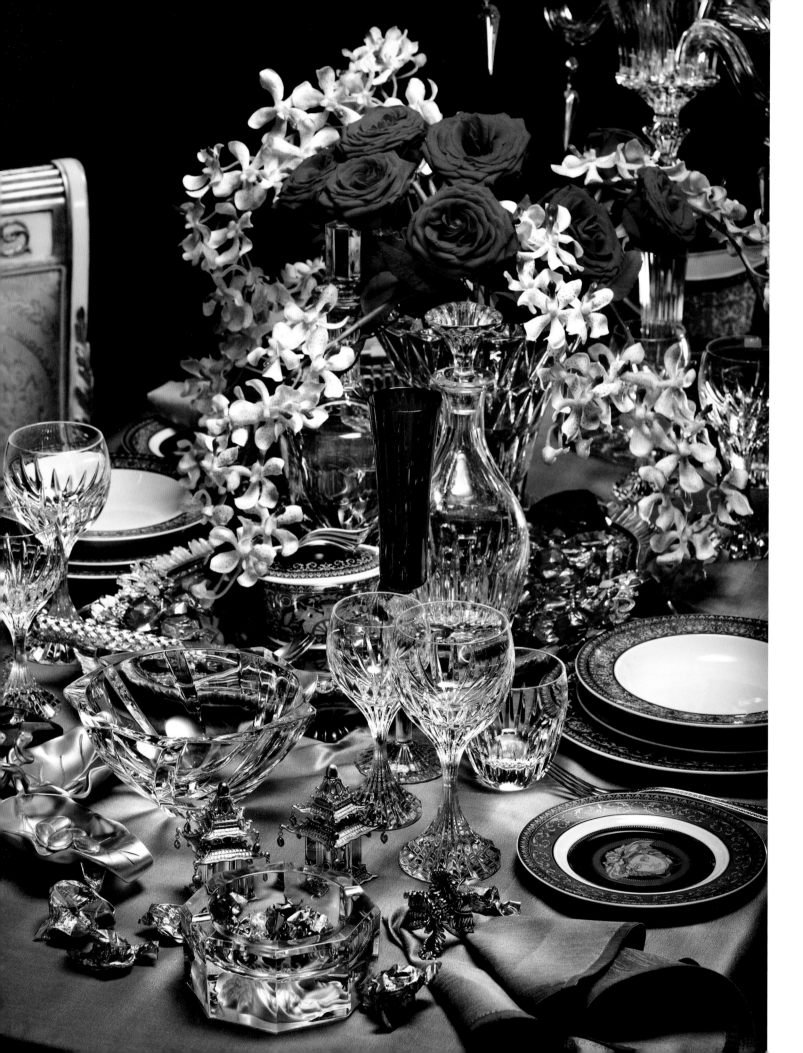

THANK YOU
FOR SITTING AT MY TABLE

by AN BOGAERTS

219

A table can look as mind blowing as you want - and I sincerely hope after reading this book it does - but there's no doubt that what makes or breaks a dinner party is the interaction of the guests. All creative contributors I spoke agreed on this: that without friends and loved ones, a table is nothing but a table. Throughout the journey of writing *Table Stories*, I had the absolute honor to invite the most talented people I know to my table. First of all, the stylists, photographers, designers, and influencers who shared their creative process and allowed us to see how they create their gorgeous tables. Their passion and sense of style were the core inspiration for creating this book. So thank you Mateja, Zaira, Oscar, Laura, Nora, Signe, Marie, Erik, Kris, Ana, Claudia, Mikkel, Anne, Beck, Jess, India, Sasha, Nessa, Titi, Mariangela, Melanie, Katie, Ashley, Tiffany, An, Sofie, and Christiann. I could not be prouder of what we have accomplished together in these strange times during a global pandemic.

If this were a party table right here and I was giving my speech - because that's what this feels like - I would definitely raise a glass to my publisher Lannoo. I am forever grateful for their trust in me, and for following my ideas. One person in particular at Lannoo has motivated me throughout the whole process, and that is Viktoria De Cubber. It is so refreshing working with someone whose glass is always half full. Cheers to you, Viktoria. And cheers to Fran and Saskia from the graphic studio Superset. When we sat at their table, nervous to see the first impressions of the *Table Stories* ideas, we were completely blown away. It has been an honor working with so many strong and creative women, not forgetting Lisa who corrected my texts with utter respect.

And last but not least I am thanking a table here. Not just any table, but the large one made from scrap wood that stands in my parents' garden. Without a doubt, it's my favorite table in the whole wide world. My mom always makes sure it is graced by flowers, and the greenish placemats and ceramics look amazing (although sometimes they're impossible to see amidst the overload of food my mom always provides). But ultimately, it is the people seated at that table who make me happy. My fabulous husband Evert and our children Lou and Jack, my sister Tine with her family: Ken, Josephine, and Rosie. My parents Denise and Willy. Apart from the occasional wasp acting as a party pooper, it is the ultimate place for finding inner peace. **THANK YOU.**

/OCCASION

⩘ CHILDREN'S PARTIES

⩘ WEDDINGS